T0196208

A LIFE OF TRAVEL AND ADVENTURE

MARTHA MARINO

iUniverse, Inc.
New York Bloomington

A LIFE OF TRAVEL AND ADVENTURE

The views expressed in this work are solely those of the author and do not necessarily reflect the views of the publisher, and the publisher hereby disclaims any responsibility for them.

iUniverse books may be ordered through booksellers or by contacting:

iUniverse
1663 Liberty Drive
Bloomington, IN 47403
www.iuniverse.com
1-800-Authors (1-800-288-4677)

Because of the dynamic nature of the Internet, any Web addresses or links contained in this book may have changed since publication and may no longer be valid.

ISBN: 978-1-4502-5996-5 (sc)
ISBN: 978-1-4502-5997-2 (ebk)

Printed in the United States of America

iUniverse rev. date: 10/14/2010

ACKNOWLEDGEMENTS

I wish to express my appreciation to my deceased mother who was always behind me in all the "crazy things" I wanted to do and also to my two sons who encouraged me write about my life because they thought it was so interesting.

Contents

INTRODUCTION

As long as I can remember I had the strong desire to see the world and to learn different customs, cultures and languages. For example in the 50's I lived on the left bank in Paris and in the late 60's I studied yoga in an *ashram* in India.

Luckily, my life was blessed with a lot of good fortune and my strong determination, fearless nature, and love of adventure.

To tell about it, I have divided my memoirs into four sections: Number one is about my beginning trips and living in Germany, France Japan, India and Africa. Numbers two and three are excerpts from my journals, newspaper articles and books. In these sections I tell about backpacking in the Middle East and Africa, and teaching English in Thailand for Peace Corps and in China for the government. Then in the last section, number four, I describe my bike touring in the States, Canada and Europe which I began in my late 60's.

A DETAILED ITINERARY

A MEMOIR OF A LIFE OF TRAVEL AND ADVENTURE

SECTION ONE
BEGINNING TRAVELS & EVENTS-1944-1972

PART 1 (SINGLE)
1944 & 45--TEENAGE SUMMER TRIPS: MEXICO & THE
STATES
1950—GERMANY Working with Special Services
1952 & 54--Studying in GERMANY and FRANCE
1954--Returning home

1955—JAPAN
Working for Special Services again & Teaching

1957--LEAVING JAPAN ON A FREIGHTER FOR INDIA
Visiting: Hong Kong, Indonesia, Bali, Singapore, Malaysia,
Thailand, Cambodia, & Myanmar

1958—INDIA
Living in Mumbai, Meeting Rashid, Summer in Kashmir, Travel
with Rashid, Studying Yoga in an *Ashram* & Returning Home for a
Year, & Back to Rashid

1960—SUDAN
Khartoum & teaching in Omdurman & Farewell to Rashid

SECTION ONE

BEGINNING TRAVELS
1944-1972

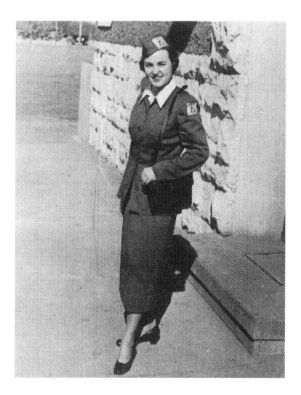

Author in uniform for Special Services in Germany in 1950

Part 1: (Single Years)

TEENAGE SUMMER TRIPS

To Mexico by truck (1946)

My first long trip was to Taxco, Mexico while I was a student at Compton Community college in 1945. Fifteen of us took a summer YWCA tour, riding in the back of an enclosed truck with bunk beds. I paid for this trip by working as a part-time milliner, making hats in L.A. I learned to sew in school, and it became my hobby.

Around the United States by Greyhound bus (1948)

My next summer trip was traveling around the States by myself in a Greyhound bus. I earned the money for this excursion by taking one semester off from college and teaching second grade in Shafter, a migrant family community near Bakersfield. My mother had been an elementary school teacher and encouraged me to try teaching. She drove me to Shafter for the interview and helped me move when I got the job. She was always supportive of my adventures and used to say: "your desires are my desires". She also convinced my overly protective father that this trip was a good idea. He thought I was just going to Chicago to help a family friend in her nursery school. Only part of this was true. I stayed with her for two weeks, before I continued to New England, New York City, Washington D.C, the South and visiting historical places along the way.

Unfortunately, I didn't go to Florida, since I was anxious to return home to Compton to see a boy friend. When I saw him again, however, he no longer interested me and I regretted coming home early, because it took me years before I could visit Florida. After this incident, I made a resolution: "Be careful about changing plans because of a romance Some times it doesn't last!"

WORKING IN GERMANY

My globe trotting began one year after I graduated from college I quit my first job as a social case worker in Long Beach, and through an employment agency found an overseas job with the army as a civilian. I left with a group of 25 girls on an Army ship from New York to Germany with Special Services. We docked in Bremerhaven and rode a train to Nuremberg for a two week training course. It was the Christmas season, a magical time to be in Nuremberg. The town and hill-top castle were covered with snow. Church bells rang out, bakeries displayed special pastries and the famous Xmas market was full of toys.

When our training course was finished, they assigned us to service clubs on different army bases throughout Germany. I was chosen for the one near Heidelberg, a choice assignment, because Heidelberg was not only an attractive university town but it had not been bombed during WWII because it was chosen to be the army headquarters.

I lived in single room in the *Roter Hahn* (red rooster) hotel on the *Hauptstrasse* (main street) in the center of town and my service club was in Schwetzingten, a small town nearby, famous for its asparagus. Daily I rode the street car from Heidelberg, and an army jeep met me at the station to take me to the nearby army base. At the service club I planned the recreational programs for the soldiers. I worked in the afternoons and evenings which I liked, because I could study German in the morning. At first I had a private tutor, Dr. Defieber, and later took courses in the *Dolmetcher* (translator) Institute at the University.

Heidelberg had a well known student bar called the *Roten Oxen.* (red ox), Here the students gathered at night to drink mugs of beer and sing drinking songs. It was a perfect place to meet young people and spend lively evenings.

While living in Heidelberg, I always traveled on my two days off. I could easily take the train to the scenic towns in Germany, Switzerland,

Luxemburg ,Belgium and Holland. Train tickets were cheap for employees of the armed services. During my summer vacation I visited other countries farther away like: Italy, Scandinavia, Austria, Greece, Spain and Yugoslavia.

After a year in the Schwetzingten Service Club, I was promoted as a director to another service club located in Mannheim near Heidelberg. I continued to live in the *Roter Hahn* and just took a different street car. In looking back at this experience, I wish I had been more accepting and less critical of the way the army worked. To get anything done, we had to go through departments and channels, a time consuming process.

When I completed my two-year contract with Special Services, I registered as a full time student at the university. I had always saved half of my salary so I could study and travel. I moved into a private room with a roommate from India, named Roda. Though she spoke fluent English, we only spoke German together for practice.

Roda, loved to hitchhike. On weekends we would stand along the *autobahn* (freeway) and hitchhike rides in trucks. We traveled all over Germany, staying at youth hostels along the way. Our longest summer trip was to the Riviera in France.

We never thought of hitch-hiking as being dangerous. The people in the 1950's who had cars, were usually nice, rich, elderly men with Mercedes.

As we stood along side the road, wearing our backpacks, I remember how happy I felt. At that moment I had an epiphany: I realized that the key to my happiness was adventure and freedom, not having beautiful clothes or security.

STUDYING IN FRANCE

After I studied one semester at the University of Heidelberg, I moved to Grenoble, France, to study French. I chose this university because it was near the Alps, and I liked skiing which I had learned in Germany. A close American friend, who worked in Nuremberg for the US government helped me move.

It was fun living in Grenoble. I had an excellent teacher, a pleasant room in a lady's apartment, a cute, half Vietnamese boy friend and ate my meals at the student canteen, where I met lots of students. Two days

a week I skied. The school ran ski tours and bussed us to nearby slopes where we paid special rates on the ski lifts.

After I received my diploma from the University of Grenoble, I transferred to the Sorbonne in Paris to study more French and to live on the Left Bank, the center of bohemians and free thinkers. Luckily I found a room in a small hotel on Rue du Buci in front of an open fruit and vegetable market in the Latin Quarter, near the Seine River. The hotel was old and primitive. It had only one toilet on the third floor for all the tenants and no shower or bath, only a sink and bidet in each room.

Most of the tenants were permanent residents, like me. The concierge, a middle aged woman, usually wearing a sloppy bathrobe, rented the room below mine to young foreign tourists. Since I often translated for her, I met all of them. If they asked me to show them a good restaurant, I would accompany them to the expensive ones, which I couldn't afford. Thus, I had many delicious dinners. But none of the tourists lasted long, though. When they discovered our limited facilities in the hotel they left. I still remember the time I sent an American tourist across the street to the bathhouse for a shower. When he returned, he asked me "What does *jeudi* mean?" I explained it meant that it wouldn't be open until Thursday. There wasn't enough business for it to be open every day.

I kept my old, dilapidated bike, which I brought from Grenoble, in the cellar and rode daily to the my classes at the Sorbonne. Living in Paris, was just like I imagined. There were plenty of things to do: meeting friends in sidewalk cafes, strolling through parks, visiting museums and monuments and attending the theater.

After I took the semester exam at the Sorbonne, I had to return suddenly to the States because my Mother became seriously sick with a heart condition.

WORKING AND STUDYING IN JAPAN

When I returned home after four years in Europe, I suffered from cultural shock and couldn't adapt to the States. I felt lost and every thing seemed strange to me. Then one day, by chance I received a letter from Special Services, offering me a job in Japan in a service club, like I had in Germany. My mother saw how unhappy I was and suggested I

accept the offer. So in 1955 I left from San Francisco on a government ship for Japan.

The first service club I was assigned to was in Sasebo on the island of Kyushu. We planned recreational programs and tours for the soldiers returning from Korea. Sasebo, was an isolated seaport, with a beautiful, rocky coast, but in a desolate place. For my recreation, I studied Japanese with a private tutor.

After six months, all the soldiers were called back to Korea, so we closed the service club. I was transferred to Honshu, the main island, to a service club on a Marine base in Okubu, near Kyoto. I liked working with the Marines. They were a spirited, proud group, and the officers insisted that my colleagues and I eat our meals in their mess across from our small house on the base.

On my days off I used to ride my bike into Kyoto, about 12 miles away and stay at a small Japanese inn along a creek. I loved sleeping and sitting on the *tatami* (straw mats) on the floor and sightseeing in Japan's ancient capital. Later I was transferred again to the main service club near Kyoto at the army headquarters. While I was here, my mother became seriously sick and the Red Cross arranged for me to fly home. When I was at her bed side in Laguna, she died at the age of 61. Her death devastated me because I loved her very much. I was only 27 and felt sorry for myself that I had lost a mother so early in my life. I grieved for a whole year.

After the funeral I returned to Japan on a Navy ship from San Francisco. When I returned to Kyoto, I was promoted as the director of the service club which meant that I had to do everything a certain way, because the headquarters was nearby. I began to hate my job. I could no longer stay in my Japanese inn on my days off. They didn't even want me to ever leave the army base on my days off in case a general came by for an inspection. Finally I quit Special Services and moved into a room with a Japanese family in Kyoto.

Every morning I ate breakfast with the family. They served soup, a bowl of rice with a raw egg and seaweed on top and green tea. As you can imagine, I never looked forward to this meal. For dinner I used their kitchen, often cooking potatoes that I kept in a closet in my room.

One day a hungry rat ate through the outside wall of my upstairs room and chewed them up. From then on, I tried to outsmart the rat.

I moved my sack of potatoes to a cupboard on the opposite outside wall. But it happened again. Another hole in the wall! Not giving up, I bought a large wire trap and daily put a piece of fresh tofu inside. After two weeks, I finally caught the "little critter"! Was I happy! My landlady gave me a bucket of water to drown it in. However, the bucket was too small for the entire trap. The rat simply ran to the top of the cage which was out of the water and didn't even get its feet wet. But I didn't give up. I had an idea. "I'll just open the cage and push the rat inside the water with a broom." As I tried this, the rat jumped out and darted away never to return. I guess it learned its lesson!

In this Japanese household, the husband was the boss. No one could even take a bath until he bathed first. The bath water was heated by a fire underneath the round tub and the same water was used by everyone. To keep the water clean, we washed outside of the tub before getting in. Being a foreigner, as well as a woman, my turn was always last. By then the water had become lukewarm.

To keep busy, I took lots of lessons: I studied flower arrangement, Japanese dancing, tea ceremony, and Japanese in a missionary language school. I also wrote articles for magazines called: A Japanese Inn, An American girl in Japan, Making a Japanese Kimono, and Japanese Restaurants. Most were published in the magazine, called *This is Japan*. My brother, Del Nett, who studied writing at a prestigious writing school at the University of Iowa, was my mentor.

One of my friends from the service club knew the director of the women's college at Doshisha University in Kyoto and introduced me to her. They needed an English teacher in her department and she hired me. I taught English there for one year.

LEAVING JAPAN ON A FREIGHTER FOR INDIA

I felt sad to leave Japan after living there for 2 ½ years, because I loved its customs and beauty as well as my Japanese boy friend, Hiroyuki. But I wanted to see the world, especially India, and I knew it was time to be on my way.

From Kobe I took a freighter to Hong Kong in 1957 where I stayed in the YWCA. When I was there Hong Kong had a water shortage and they frequently turned off the water. One day I opened the faucet and since no water came out, I forgot to turn it off. While I was sightseeing

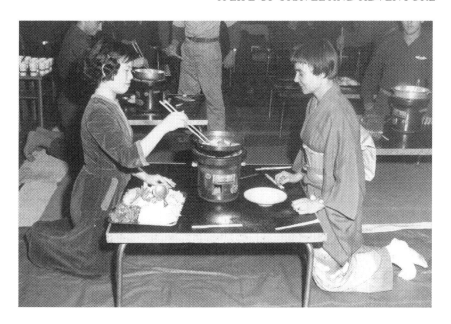

Author in a kimono eating sukiyaki

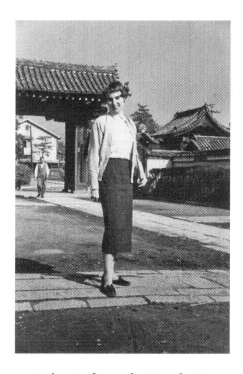

Author in front of a Temple Gate

the water came on again. Not only did it fill my basin, but ran out of my room and down the stairway like a waterfall. Naturally the administration was very upset with me when I returned.

I liked the bustling spirit of Hong Kong and its spectacular harbor filled with islands. I stayed there a week until the shipping company called me about a room cancellation on a freighter to Thailand that I had tried to take before.

This trip was lots of fun. The captain was extremely hospitable and before each meal he invited five of us passengers and some of the crew to his cabin for "happy-hour."

VISITING THAILAND AND CAMBODIA

When we arrived in Thailand, I stayed at the YWCA in Bangkok, located in a large house on the outskirts. An English crew member from the ship visited me daily and we had a great time together, riding boats down the river, cruising around in bicycle rickshaws to elaborate temples, and visiting open markets and restaurants to sample Thai food.

I shall never forget my first night at the YWCA. I had never used a mosquito net before and in pulling it down from the top of my bed to tuck it around my mattress, I trapped an army of mosquitoes inside the net. In the morning I looked like I had the measles and felt miserable.

My roommate, Pat, a thin, middle-aged woman with a wrinkled face, had just returned from Cambodia and raved about Angkor Wat, a huge stoned carved temple. "You must see it." She said. "It is easy to get there and worth the trip. You just take two trains and a bus." After hearing her enthusiastic recommendation, I decided to go. I followed her instructions, but they were inaccurate and I got stranded in a small village. Here's what happened: First I took a train to the Thai-Cambodia border where I stayed one night in an old wooden hotel to wait for another train in the morning.

Before dinner I decided to walk to the open market. While wandering along the dirt streets, I met another American. "What are you doing here?" He asked, surprised to see me. I explained about my trip, and he told me he was on a border mission for the American government, which I didn't quite understand. Since we were both staying in the same hotel, we dined together that night.

The next morning I took an early train into Cambodia and got off at the designated station. But there was no bus waiting as the lady had said. Not knowing what to do, I walked a short distance into the center of the village and asked about the bus. But no one knew anything about it. Feeling perplexed, I sat down in an open café to think about my plight of no bus and no hotel. After an hour, a Cambodian army officer came by and I told him in French about my situation. He listened without saying a word, then left. Shortly he returned with a second jeep. "I'm going to give you this jeep to take you to Angkor Wat," he said. "These soldiers will take you."

Was I relieved! I hopped into the jeep and while one soldier drove, the other one sat in the back seat, holding a rifle ready to shoot in case we were attacked by bandits. For over an hour we drove through the barren countryside. When we reached a town near Angkor Wat they dropped me off in front of an old, framed hotel and left.

The following day I rented a bike and cycled to Angkor Wat. I had planned to return to the hotel for lunch so took no water or food with me. But the temple was much farther and larger than I anticipated so I stayed the entire day, never seeing a soul. For many years it had been completely covered by jungle and only recently was it rediscovered.

Leisurely I pedaled from temple to temple, frequently stopping to exam the interiors and Hindu stone sculptures, of the 13th century. The temple's size and stone carvings were spectacular.

When it came time for lunch, I didn't want to return to the hotel. All I found was a vendor sitting under a tree, selling something oblong and green which I didn't recognize. Hoping I was something I could eat, I bought one. The vendor grabbed an ax and removed the outer shell. To my surprise a brown coconut was tucked inside. He drilled a hole in the brown shell and handed it to me with a straw. I drank the refreshing coconut milk and then he cracked open the coconut and motioned for me to scoop out the cool coconut meat. This was my lunch.

In the late afternoon, weary from sightseeing, I returned to the hotel and stayed another night. Early the next morning I had to catch the bus to the train station. When I came down the stairway to the empty lobby, I saw about twenty large, brown rats scoot across the tile floor. Thank goodness they hadn't been in my room!

A rickety, dilapidated bus stopped for me in front of the hotel, jammed full of peasants with their chickens, goats and baskets full of vegetables and fruits for the market. The thoughtful driver gave me a front seat next to him. As we chugged along, we frequently stopped for more passengers who loaded their wares on the roof and who managed to squeeze into the back.

I reached the station in time for the train back to the Thai border where I transferred to another train. After one more night in the hotel, I returned to Bangkok by train. When I returned to the YWCA. I wanted to tell Pat about her misleading instructions but she had left. Nevertheless I was glad I had made the trip.

VISITING SINGAORE & MALAYSIA

From Bangkok, I rode the train for two days through Malaysia to Singapore, a modern city with lots of diversity. For example one section had Indian temples, shops and restaurants, and another section was entirely Chinese.

As usual, I stayed at the YWCA where I made some interesting contacts: One of the girls introduced me to her wealthy aunt from California who was staying at the famous, expensive Raffles hotel. The aunt invited both of us for a scrumptious dinner at the hotel. Another girl introduced me to a reporter of the Singapore English Newspaper. He found my life so interesting that he wrote an article about me for the front page with my picture. Another girl, who was Chinese, invited me to visit her parents in Penang, a town up the coast. For two days I stayed in their mansion overlooking the bay and was treated royally by their servants.

VISITING INDONESIA & BALI

After I returned to Singapore, I took a ship to Indonesia. From Jakarta I rode the train across Java and from a port I boarded a ferry to the tropical island of Bali. Here I stayed in an inn near the beach. The surrounding landscape was beautiful with terraced hills covered with green rice fields and tropical forests surrounding clusters of round, thatched huts. At night in the compounds young girls, wearing elaborate costumes and headdresses, danced to the rhythm of the musicians. It was magical. With all this beauty, I could understand why Bali was so famous.

One night, at the main hotel they held a banquet for a visiting government official of Russia, Voroshilov. I wasn't officially invited, but I managed to attend it anyway. I sat at a long table near the dignitaries, feeling proud that I was there. Next to me was a young journalist of Chinese decent from the English newspaper in Jakarta. He befriended me and on this idyllic island we had a short romance: jumping waves while holding hands, riding bikes together along quiet lanes and watching the village dancers at night. Everything was perfect.

Without my knowledge he wrote an article about me. Strangely enough, my third grade teacher from Compton who was working for the American government in Indonesia, saw the article. She wrote some mutual Compton friends about this and I indirectly heard about it. Sometimes it's a small world!

On my way back to Jakarta, I stopped at Borobudur to see a famous Buddhist monument of the 9th century. It was smaller than Angkor Wat, but impressive and I was pleased I made the effort to see it.

VISITING MYANMAR

When I returned to Jakarta, I took a ship back to Singapore. From here I boarded another freighter to Calcutta, docking first in Myanmar (Burma). On the ship I met a passenger from Yangon, returning home on diplomatic leave. He invited me to stay with his family while the ship was in the harbor. It was a privilege to be their guest and be treated so royally. The family lived in a large framed house surrounded by a veranda. Daily they showed me temples and the open markets. The town seemed poor, with dusty streets. Nevertheless I was glad to see it.

LIVING IN INDIA

From Myanmar we sailed to India, my destination and the country I had always wanted to see. In Calcutta I stayed in the Calcutta hotel in the center of town. It shocked me to see so many people in the streets, including beggars squatting and sleeping on the sidewalk outside of the hotel.

After sightseeing for a few days, I tried to get a train ticket to New Delhi, but none were available. I went numerous times to the station and finally one day the ticket clerk, I think to get rid of me, sold me a

first class ticket in a VIP compartment. I didn't understand exactly what that meant, but I was glad to be leaving Calcutta.

That evening when I entered my compartment I was surprised to see a man sitting on one of the couches that faced one another. He was a kind-looking man with white hair, dressed in a white *dhoti* (a piece of cloth pulled up between his legs). The compartment had an individual toilet and sink in a separate room, but no corridor, only two outside doors, one on each side of the train that opened directly onto the tracks. Once inside the compartment, you stayed there until the train stopped. Unknown to me, we were suppose to bring our own bedding, water and food. All I had was a small overnight case. My luggage had already been forwarded to Mumbai.

After the two of us finished staring at one another in disbelief, we introduced ourselves. His name was Gopal, a MP (member of parliament) from New Delhi. I explained that I was a tourist on my way to Mumbai, via New Delhi, to visit my friend, Roda, whom I had met at the University of Heidelberg in Germany.

That night Gopal generously shared his food and water with me, and gave me a sheet to wrap up in. When he heard I was going to New Delhi, he said, "You must first stop at Bodhgaya. That's where Buddha received his enlightenment under the bodhi tree." I knew very little about this, but Gopal offered to be my guide.

The next day at Bodhgaya, we got off the train together. He first made train reservations for the next day and for two rooms in the station rest house for the night.

Then he showed me the temple, built in honor of Buddha, and the famous tree. I felt fortunate to have met Gopal, and we remained friends for many years.

In New Delhi, I stayed at the YWCA, then took a train to Agra. From my hotel I rented a bike and one afternoon pedaled to the Taj Mahal and the fort. Not a soul was on the streets. I wondered why. Later I learned everyone was avoiding the afternoon heat, which I didn't realize I should have done too.

The Taj Mahal, built of white marble, was beautifully designed with minarets and ponds and radiated love. The ruler built it as a mausoleum for his favorite wife. He was so in love with her, that when he sat on the throne, she stood behind him with her hand on his shoulder, concealed by a curtain.

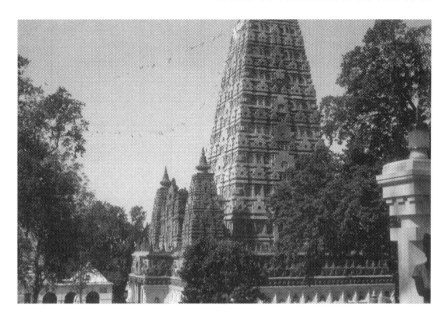

The tree where Buddha became enlightened in Bodhgaya many years ago

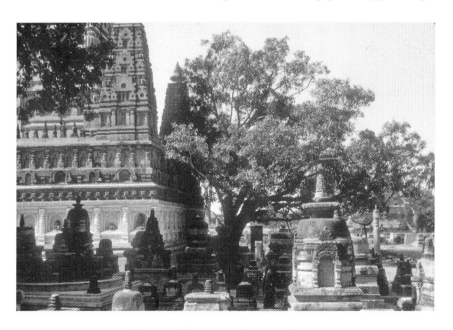

The Buddhist temple at Bodhgaya

When I returned to New Delhi after Agra, I began feeling sick, and realized it was from the being out in Agra's afternoon heat. To feel better, I boarded a train to Mumbai where it was cooler.

After an overnight train ride, I arrived in Mumbai. It was wonderful to see Roda again, after four years. She lived in a huge house in New Worli, a suburb in the outskirts. Her house was surrounded by a wall and large garden and had metal bars on the windows. I knew that she was from a wealthy family but never could imagine how affluent. They had a crew of servants: a cook, a chauffer, a gardener, a general servant, an untouchable who came only to clean the toilets, a house cleaner, and a little old woman who took care of their poodle and gave massages. Most of them lived in separate servant quarters at the back of the property.

Living here taught me one important lesson. No matter how wealthy you are, you still have problems, just a different kind: They still had family relationships to deal with, worries about their investments, and fear of losing their wealth.

Roda's family was not Hindu, like most people in India, but Parsi ,(except for her grandmother who was Muslim, originally from Afghanistan). The Parsis follow the teachings of Zoroaster, a prophet from Persia. In Mumbai they worship in a temple where a fire is always burning, and only Parsis can enter. In fact you have to be born a Parsi, conversion isn't allowed. Another unique custom is the way the Parsis bury the dead. In Persia, they would place the body on top of a mountain and let the vultures eat it. It was considered a sanitary method. Today in Mumbai they put the body at the top of a tall tower, and after the vultures have eaten it, the bones are dropped down in a pit and disposed of.

Roda's parents originally came from Lahore, in northern India. After India was petitioned, this area became Pakistan. At that time the family had to decide in which country they wanted to live. Roda's father had an ice making business in Pakistan and became a Pakistani. Since Roda's grandmother owned this house in Mumbai, her mother took Indian citizenship. As a result, Roda's mother and father, in order to live together for more than three months at a time, moved to London to a small flat near Hyde Park. Here they stayed most of the time.

I became very fond of Roda's grandmother, an elegant woman, with an erect posture who always looked beautiful in her sari, changing it several times a day. She had married Roda's grandfather, an engineer, who built the railroad from Calcutta to Mumbai. He obviously made lots of money.

I expected to find a job teaching English in Mumbai but since everyone already spoke fluent English, this wasn't possible. I almost got a job at the American library, but Congress failed to appropriate money and I wasn't hired.

One day, I heard that a documentary and advertising film company needed someone, so I applied for the job. The director, Rashid, interviewed me. I didn't get the job, but he fell madly in love with me. He had me chauffeured around in his black Rolls Royce, showered me with presents, and frequently invited me for elaborate lunches. I probably wouldn't have continued this relationship, because he was married and 25 years older than I, but Roda's grandmother encouraged it. She was impressed that such a wealthy, important man was interested in me. All over India, wealthy families know one another so Rashid knew of Roda's family.

RASHID & ROMANCE

Rashid was the most interesting, wealthiest and influential man in my life. He was born in Moradabad, north of New Delhi. His grandfather had been a *nebab*, (same as a Maharaja but Muslim, not Hindu). and ruled a kingdom, until he lost it when the English conquered India. Rashid was raised in opulence and educated by private tutors. For the university, he was sent to the United States.

Rashid had many unusual jobs in his life: He was an editor of a magazine, the controller of the household of the Maharaja of Mysore, the richest maharaja in India, and an organizer for Yogananda, the famous Yogi, who wrote the book:"*Autobiography of a Yogi*. Rashid was responsible for setting up all his self realization centers in the States. The one in Encinitas, California still exists. When India was divided into Pakistan, Rashid was asked to become an ambassador in Pakistan, but refused because he wanted to live in India. He also had had three different wives: an American, an English, and an Indian one. The Muslims are allowed four.

One of the most remarkable things about Rashid was his self confidence. He was also kind, considerate, generous, charming and well versed in history and religion. His main fault was jealousy, a trait that drove me crazy.

ON A HOUSEBOAT IN KASHMIR

While living with Roda's family, in the summer I traveled to Kashmir with her grandmother to avoid Mumbai's heat. They owned an almond orchard there and a houseboat on the river. We took three servants with us. At the train stations they followed behind us in a line, carrying our belongings just like in the movies. When we arrived in a town above New Delhi, we stayed in a rest house, until we could arranged a jeep to take us over the Kyber Pass to Srinagar in Kashmir.

Our chauffer drove us like a maniac, going fast around curves and taking wild chances. It was the scariest ride of my life. On the narrow, winding dirt road there were often huge rocks or large army trucks that we had to pass by backing up to a wide place in the road. If we went off the road by mistake, we would fall into a valley hundreds of feet below.

In Srinagar our long houseboat, built like a mountain cabin, was docked along the shore. From the roof terrace we could see the mountains in the distance. If we wanted to go to the village or market, we took a *shikara*, a small gondola-like boat, with a man who would paddle us down the river.

Frequently on the weekends, Rashid would fly up from Mumbai and rent a houseboat across the river from us, equipped with a cook and servants. Then he would fill a *shikara* with presents: like silk saris, sandals, and gold jewelry. and his *shikara* padeler would row him across the river to our houseboat. I would climb into his boat, and open all the presents. I felt like a princess. It couldn't have been more romantic. Some days Rashid would take me to the tailor or shoemaker. Once he asked me if I would like gold buckles on the shoes that he was having made for me.

Rashid was well versed in history and religion. He used to tell me interesting facts about India or stories about his life, as a former prince. But I liked best hearing about his experiences living and traveling with Yogananda, the famous Yogi, and the Maharaja of Mysore.

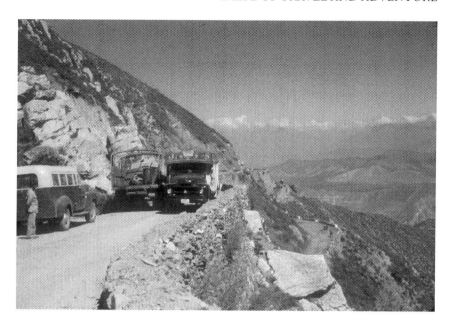

Trucks on the road to Srinigar, Kashmir

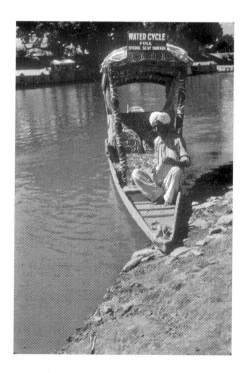

A shikara *(boat taxi) by our houseboat on the Jammu River in Srinigar*

Roda's grandmother and I stayed all summer in Kashmir. When we returned, Rashid met us at the New Delhi train station, to ride back to Mumbai with us. In his compartment, he again showered me with presents he had brought from Mumbai. When I look back on these experiences, I wonder how he could have been so in love with me to be so romantic.

TRAVEL WITH RASHID

Rashid liked to show me India. Once we rode a rackety train to a village above New Delhi to a famous holy Hindu temple, dedicated to an important saint. Inside the temple Rashid, performed the rituals of chanting and walking around the tomb, even though he was not Hindu but Muslim. I waited outside since I had studied psychology and didn't believe in God. I remember sitting in the patio and praying, "if there is a God I need proof.." At that time, I had a severe cold, and asked for it to go away quickly.

The next morning as we were leaving on the train, Rashid commented. "There is something different about you today. You don't have your cold any more." Suddenly, I realized that was the sign I had asked for. From that moment, my faith in God gradually grew.

Rashid took me to other places in India, too. I saw his family home in Moradabad, in Northern India, and in the south, Bengalore and the Palace of Mysore, where he used to work as the controller for household of the Maharaja of Mysore. We also traveled together all over Europe. On our way back to India, we toured the Middle East: Syria, Lebanon, the Holly Land, Palestine and Israel. When we stopped off in Beirut they were having a revolution in 1959 and tanks were roaring down the street at night. It was frightening.

I insisted we also go to Baghdad, because it had such a romantic name, but I was very disappointed. For the capital of Iraq it was uninteresting and run-down. While I was there, I stayed with a family, since Rashid left first for India. One day, the husband told me that the secret police had come to his office to ask who I was. "They have been surveying our house since you arrived," he said. "They suspect that you may be a spy, but I assured them that you were only a tourist. Maybe your camera and typewriter, make you look suspicious."

STUDYING YOGA

When I returned from our trip, I enrolled in a Yoga School outside of Mumbai to take classes in Hatha Yoga. I adored my teacher. She looked 20 years younger than she really was, so I vowed to do Yoga the rest of my life. In fact, I never eat breakfast until I have done my exercises and meditation. After I graduated from the school, I wanted to study further, but my teacher's husband, the main Yogi, told me I wasn't ready for more spiritual study.

Therefore, I traveled to Rishikesh, in the Himalayas, above New Delhi to a well known *ashram* (Yoga Monestary) where they had a course for foreigners. Rashid's brother escorted me there.

At the *ashram* I had my own room and our vegetarian meals and water were delivered to our rooms. Every morning at 3:00 a.m., I was awakened by a loud gong to remind me to go up on the roof and meditate with the others. I never did get used to getting up so early, and was tired, most of the time. After breakfast we had classes, on the Upanishads and the Gita, and then sat silently in main Swami's office. They say to be in the presence of a holy man, aides you in your own spiritual development. In the evening we had *satsung*, chanting and worshiping ceremonies.

I liked living here, but occasionally on the week ends I would ride a rickety train back to New Delhi to meet Rashid who flew from Mumbai. We stayed in a luxurious hotel for several days. My existence here seemed almost unreal, after the austerity of life in Rishikesh.

In the *ashram*, the more I studied Hindu scriptures and meditated, the more, I began to have *siddhis* (unusual happenings). Once I heard the sound of OM in the universe. Also I would often know what was going to happen in the future. When I asked one of the swamis, if I could prevent this event from happening, he said no, because it had already happened. I never understood this, but I think it has something to do with "there is no time".

In addition, I had the same recurring dream. I dreamed I had to help an Isreali girl, named Liz, who was bedridden in the *ashram*. Everyone said she had a heart condition. I had visited her only once, but knew I had to help her because my dreams were interrupting my sleep.

Pete, another American student in the Ashram, agreed to help me and share the expenses. I arranged for a taxi to take us to Dehra Dunn

and made an appointment with a doctor. After he examined Liz, he said she was very sick and needed to go to the hospital immediately. Fortunately there was an American Missionary Hospital not far away on top of a mountain and he arranged for her admittance. When we reached the hospital entrance below, we phoned and they sent us a jeep, equipped with oxygen, to take Liz up the mountain. By the time we arrived at the hospital it was late so all of us spent the night there.

The next day, the doctor told us that Liz, had amoebic dysentery which had affected her liver. As a result, Pete and I decided to take the same tests , and they discovered that we had amoebic dysentery, too. I was really surprised because I had only a few symptoms: dysentery only once and a noticeable loss of weight. After Pete and I bought the antibiotics, we left for Rishikesh but Liz had to stay in the hospital another month before returning to Israel.

Pete and I returned to the *ashram* to pack up and left for New Delhi. It was probably the water and food that caused our disease. I checked into the hotel, where Rashid and I had previously stayed, and he came from Mumbai to be with me.

The first thing he did was to take me to an ayuvedic, Indian doctor. By simply feeling my pulse, he diagnosed my illness, which I found amazing. He prescribed that I eat only rice and yogurt, for one month. Just to be on the safe side, I also continued my antibiotics and eventually got well.

Rashid stayed with me in New Delhi. He rented an apartment and after a while he decided to get a divorce, so we could get married. His wife was a famous movie star who had recently received India's equivalent of the academy award for the best actress and she was also a partner in his film business. To avoid publicity he suggested I return to the States. He also wanted me to start an importing business with crafts from India, like jewelry, sandals, saris, etc.

RETURNING TO CALIFORNIA

Though I knew it was best not to be in India at this time, I was sad to leave Rashid and India. I flew home to California and lived with my father for a year while I started an import business, which I called Rekha Imports. My father loaned me $2000. I sold some things to local stores and at many trade fairs, including one in Toronto, Canada. My father

advised me: "You can't mix love with business" and he was right. My business failed. To pay back the $2000 I got a job at the local telephone company as an operator. I disliked this boring job, because I hate sitting for a long period of time. Nevertheless I learned two important lessons: Whatever I do in life, I can't sit for 8 hours and I also need to go back to school for a proper teaching credential.

BACK TO RASHID

After a year in California, Rashid sent me a ticket to return to India. I quit my job, paid back my loan and my father and I drove across the country to Pittsburg. Kansas, to visit his sister. Then I flew from Chicago to London. I remember how sad I was saying "goodbye" to my father. I felt that I might not see him again and I was right. He died a year later while I was in Omdurman, Africa.

Rashid met me at the London airport and we traveled around Europe for awhile. I remember that we never could take an early train, because, being Muslim, he had to say his prayers first. His divorce was taking longer than he thought, so he decided that we should visit his niece and her husband, both doctors, working in Khartoum, Sudan.

TEACHING IN OMDURMAN, SUDAN & SAYING GOOD-BYE TO RASHID

Rashid and I stayed in Khartoum for a while, then traveled around East Africa. When we returned from our trip Rashid's divorce still wasn't final . To occupy my time, Rashid suggested that I apply for a teaching job. Every morning for several weeks I would sit in the Ministry of Education office. One day, while I was there, they received a resignation from a high school English teacher and they offered me the job in a girl's high school in Omdurman, across the river from Khartoum. The first time I saw Omdurman, with its dirt streets and shacks on the main street, I thought it was the ugliest town I had ever seen, never imagining that I would someday live there.

The ministry gave me a room in a large vacant girl's dormitory in an isolated area of the desert with nothing around it. Since I was all alone at night, I tried not to be scared, because no one was nearby who could help me in case I screamed. Then one night I heard foot steps outside

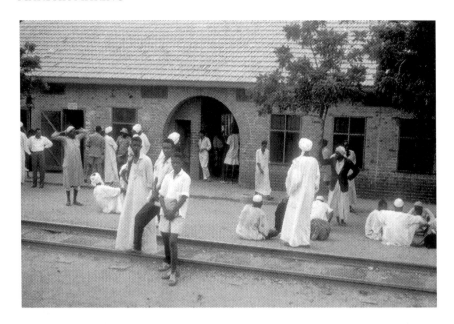

The train station in Omdurman, Sudan in 1960

Students I taught in the El Mahdi girls high school in Omdurman

my room. I was frightened to death, even though my door was locked and there were bars on my windows. With my heart pounding, I waited in suspense until the foot steps faded away. Later I discovered that the "honey bucket" man was making his weekly visit to empty my outside toilet. He carried the contents in two wooden buckets, balanced on the end of a pole and poured them into a tank hauled by two horses.

Everyday I rode my bike across the sandy desert to school. I couldn't always see the mounds of sand on my path so I just clung tightly to my handle bars and pretended I was skiing on uneven terrain.

The school was originally started by the El Mahdi family, the ruling party in the Sudan. They wanted a place to educate girls because there were no public girl's high schools at that time. In our school the girls wore uniforms: green skirts, and white blouses with short white scarves draped around their shoulders. If the principal walked near the classroom I always knew in advance. Immediately the girls would cover their heads with the scarves. The back of the neck was considered very sensuous, even though it was partially covered by their pencil- thin, shoulder-length braids.

School began at 8 a.m. with a mid- morning breakfast snack served in the patio. It usually consisted of a half of a pita bread, stuffed with egg, meat or cheese. By one o'clock school was over because it was too hot in the afternoon for anyone to work.

I taught English grammar and Shakespeare. Since I had read only two Shakespeare plays in my life, this class took me hours of preparation.

Eventually the ministry of education rented me a large unfurnished house on the edge of the desert, only two blocks from the Nile River. It was a typical Sudanese house, surrounded by a tall, white concrete wall with two metal doors: the front one, used mainly for men and the side one for women. The house was divided into two sections, one for men and one for women. I occupied the men's section because it was the nicest with a living room, bedroom, and two patios. The kitchen was in a separate building in the back of the lot, next to the servant quarters. It had a sink and butane stove. My cold water shower and basin were in a separate room in the patio and my pit toilet was located in a separate room in the corner of the lot with a water faucet and hole in the floor. The outside wall had an opening, so it could be emptied weekly by the

"honey-bucket" man. Since the toilet usually had an offensive odor, I was glad it was far away from the house.

The Ministry of Education gave me a bed, chest of drawers and cupboard for my bedroom, and I furnished the rest, mostly in Japanese style with cushions and grass mats, the cheapest way. I preferred sitting on the floor anyway.

One day a workman came to repair the sink in my kitchen. Casually he mentioned that that the house had been vacant for a long time and that his parents almost rented it, but they had heard it was haunted. "Why is that?" I asked, curiously. Then he told me the story: "The previous renter's son, who was about to be married, suddenly died. One morning about 5:00 a.m. just as he was leaving to go to the mosque for prayers, he opened the tall metal outside door. An electric cord from the light above it had fallen on the door and charged it, causing him to be instantly electrocuted.

This story made it clear why the first night I spent in the house, I felt like someone else was there with me. Since I had lived in India, where everyone believes in ghosts, I knew what to do. I just sat down and talked to the ghost. I told it the house was now mine and it could live in the women section. After that it never bothered me again, but it bothered someone else. The Ministry sent over another teacher to share my house. She spent one night in the women section, and left, never to return.

For the first month, to save money, I lived without a servant. Daily after school I'd ride my bike to the open market. No women were there, only servants. I liked shopping, even though everyone stared at me. Later, one of the English missionaries at the local hospital, sent me one of her extra servants. His name was Tata, coal black, tall and skinny from Southern Sudan. He cooked, cleaned and shopped for me and lived in my servant quarters in the back near the kitchen. He could neither read nor write, and in the evening his friends would come by and they'd talk. I felt sorry that he had no other recreation.

In one of my patios I made a garden. I filled the large wooden pots with scrubs that Tata dug up for me from the desert. I thought they were interesting and especially liked the fact that they needed no water to survive. However, my landlord wasn't pleased. "They look awful," he said and "one is even poisonous." I assured him that I wasn't going to

touch or eat them, but he made me remove them and brought me rose bushes to plant instead. They, of course, died quickly from the heat.

In a small plot of dirt, I planted a lawn. Every night, I had Tata dig up clumps of grass from in front of everyone's outside toilet wall. It grew there because near each toilet was a faucet and without pipes or plumbing, the water emptied in trough in the wall to the outside. When Tata returned every night with a small clump of grass, he would plant it for my lawn. Soon, I had a hardy plot of green grass that needed very little care.

There wasn't much to do in Omdurman. For my entertainment, I enrolled in the Arabic missionary language school. Every afternoon I would cycle across the desert to the school for private classes in Arabic. I eventually learned to read and write Arabic up to the 4th grade level.

Most of the Europeans who lived in Omdurman were missionaries. All the other foreigners lived on the other side of the Nile, in Khartoum, where the embassies were. Occasionally, I'd be invited to an embassy cocktail party. At first I liked them, then they became boring with the same people and the same shallow conversations every time.

While I was living and teaching in Omdurman, I decided that I didn't want to marry Rashid, because of many personal reasons. This was a hard decision to make because he had gotten a divorce for me and gave up his film company. When I told him about my decision, he asked for all the gold jewelry and diamonds he had given me. I still remember the afternoon I sat on the Khartoum Hotel veranda and handed him the jewelry and said goodbye. In my heart I felt it was the correct decision, but I still felt remorseful. I guess some decisions are not just black and white. For many years afterwards I dreamed about Rashid and our fairytale romance. I felt that he had truly loved me.

After our break-up my life continued as usual. Then one day I went to the Ministry of Education and offered to teach during my summer vacation if they'd send me to a school in the South. I wanted to live in the jungle where the seasons were different. Sudan is divided into two parts: the Muslim Arab north which is desert and the Christian south where the African natives live in the jungle. I had heard about a school there from other teachers.

The Ministry flew me from Khartoum to Juba, the capital of equatorial Sudan. At first I stayed in the Juba Hotel, where all the

tourists stayed, while the Ministry arranged a truck to take me to Maridi, the village where I would live. While I was at the hotel, I met Dick, an American photographer, going on a safari to film the wild animals. He invited me to go along. It was the weekend so I wrote a note to the Minister of Education to tell him I'd be gone for a few days. Then I accepted Dick's invitation.

On the safari we took a whole caravan of jeeps and trucks, carrying all our camping equipment, as well as a cook, servants and a white hunter. We drove out to an isolated area in the savanna and after setting up camp with cots covered with mosquito nets, we went looking for animals to film and shoot. We first came to a group of small deer roaming across the plains. Dick shot one and then the servants slit it open and ate the liver while it was still warm, considered a delicacy. Later in the middle of river, Dick filmed a group of hippopotamus. As we drove around looking for more animals, we saw many monkeys.

My first night at our camp I could hardly sleep. Africa comes alive at night. The black sky was filled with twinkling stars and I was enthralled with the animal calls and the chirping insects. I was 27 and this was the first time I had ever been camping. In the morning to wake us up, one of the servants played a melody on his reed flute.

When I returned to Juba, after the 2 day safari, I heard that the minister of education had been looking for me. He hadn't received the note I had taped to his door.

I really didn't want to leave Juba because the hotel was full of interesting people. One was a good looking Spaniard who traveled around Africa, hunting elephants for their ivory tusks.

Before I disappeared again, the minister of education told me I was leaving the next morning in a truck for Maridi, the village with a middle school where I was to teach. I had no idea how primitive the ride would be, so took no food or water. The only thing I found on the way to eat were bananas which the natives sold along the road. In the evening we stopped at a guest house with cots for beds. For my dinner, a man in the village brought me some food from his house.

TEACHING IN MARIDI IN SOUTHERN SUDAN & MEETING ALBERTO

The next day we continued bouncing along the rutted, dirt roads to Maridi and arrived in the late afternoon. For the first few nights I stayed in a house, occupied occasionally by an African American who worked for the U S government in the agricultural department. Then I moved to my own house across the road from the school, originally built by the English as a missionary school. In 1958, when the Sudan became independent, most of the English left and the Sudanese government took over the school.

I loved teaching here. I taught English and math classes in a girl's middle school. The students came from different tribes of a wide region and spoke various languages, but not Arabic, like in the North. They had learned English in elementary schools in their villages. When they arrived at the school, they were not wearing cloths, only a cluster of leaves. The first thing we gave them were loose fitting blue cotton dresses with a belt around the waist. The girls lived in a nearby dorm and carried everything on their heads, including books and soap. As a result they had excellent posture.

Classes were held in the morning until one o'clock with a breakfast break about 10:00 a.m. A few times a month I had night duty, mainly at full moon. The girls used a wooden desk as a drum and chanted and danced in a circle. Their rhythm was fantastic.

It was interesting teaching these girls. Once one of our vocabulary words was "electricity" and no one knew what it was. Even Maridi didn't have any. I tried to explain what it was, but my explanation sounded like I was describing something supernatural. The only thing that bothered me about teaching was their placidity: I never knew if they understood the lesson or not. Once I became so frustrated that I threw a piece of chalk across the room and not one girl looked surprised or reacted in any way.

Our school had three other teachers: two young Northern Sudanese girls of Arabic decent, and an Egyptian man, married to the principal from England.

My two room house was across from the school. It had a screened veranda that faced the African plains and running water, but no flush

toilet or electricity. My servant cleaned, shopped, washed and cooked for me and at night he lit my kerosene lanterns. It was a comfortable life.

Shortly after I move in, I noticed that I was being bit by bugs. When I was teaching, I'd see them crawling up my arms. Even though I sprayed with disinfectant, I couldn't get rid of them. Finally I requested to have the entire house painted .and that helped. After that no more bugs.

I was never lonely living here, because I was so thrilled to be living in the middle of Africa. In the cool evenings, I used to take walks along the paths in tall, waist high grass, passing clusters of *tukels*, round,. mud, thatched huts, where the natives lived. The silence was beautiful. I was also never afraid because there were no wild animals, At night, I would listen to the drums beating in the distance In the village center, under the mango and palm trees, the locals gathered nightly to dance, chant and drink their local brew, made from fermented grain.

Only a few Europeans lived in Maridi. A family of Greeks ran the grocery store, two English missionaries preached in the church, an English couple helped the natives grow tobacco, and Alberto Marino, a stocky, well built Italian who was in charge of the public works department. I met him because of my bed bugs. He authorized his workers to paint the interior of my house

Occasionally Alberto invited me to go paddling down the small river that ran in front of his house or to have dinner with him. He would then tell me many stories about his experiences having lived in Africa for 30 years: Sometimes he had been the first white man in isolated areas. Once when he was inspecting the roads he noticed that they needed maintenance. "Why aren't the roads in better shape?" he asked his driver, noticing how hard the crews were working as he passed. "Just listen," his driver said. "They have a special drum signal for you. When the next crew hears this, they know you're coming and they all get to work."

Another time he told me his workers wanted to be paid only in coins so they could bury their money because they didn't need to buy anything. They grew their own vegetables, wheat and rice, raised their own chickens and picked the mangoes, bananas and papayas that grew wild. Because the climate was always warm they didn't wear clothes, only clusters of leaves. and made their huts from mud and straw. With

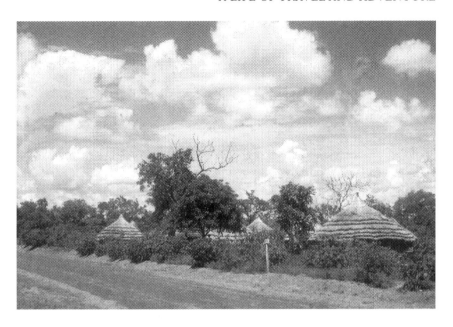

An African village near my house in Maridi where I taught

this easy life, it was understandable why the Africans were unmotivated to change.

There were several disadvantages, however, that interrupted this tranquil life: One was disease. Without screens on their windows, they were plagued with mosquitoes and malaria, and since they drank unclean water they suffered from stomach problems. Another problem was their superstitions. They lived in a state of fear, worrying that someone might put a curse on them, or that an evil spirit would cause them harm. Once my servant's son had a stomach aliment. I wanted to give him medicine, but he preferred money for the witch doctor who would kill a chicken and release the evil spirit which he thought caused the disease.

After two months in Maridi, I received a telegram from Khartoum telling me to return to Omdurman, because school was about to begin again in the North. I was unhappy about leaving because by now I liked living in Maridi and I was in love with Alberto. The ministry sent me a plane ticket, instead of a boat ticket as they had promised. Originally they said that I could return by boat down the Nile River, famous for its beauty.

Alberto and I continued our relationship by letter and when he had a two months vacation, instead of returning to Italy, he stayed in Khartoum and visited me daily. Since I love Africa's wilderness, on the weekends we would hire a taxi to take us to a desolated area along the Nile or near a village where we could camp for a few days. We always brought all of our water and supplies and instructed the driver when to return to pick us up, hoping that he wouldn't forget where we were. Fortunately, that never happened.

Once we camped in a round area protected by dried bushes. Not knowing what the clearing was really for, we were surprised when we woke up in the morning to find that we were surrounded by the local villagers. They had come to see the foreigners in the opening that they used to keep their cattle in at night!

LEAVING THE SUDAN AND STUDYING IN ITALY

After Alberto returned to Maridi, I discovered to my dismay that I was pregnant. This presented lots of problems since Alberto was already married and there was no divorce in Italy. To survive this frustrating

situation I decided to do what I like to do most: travel and learn a language. First, I resigned from my teaching job and in Omdurman. Then I had a dressmaker make me some maternity clothes for traveling, including a wool coat, big enough for a tent.

Next, I arranged a trip to Italy to study Italian at the University in Florence. From Khartoum I took the train to the border of the Sudan and Egypt. Then I boarded a ship down the Nile River to Luxor to see the ruins of Egyptian's ancient civilization, including Tutankhamun's tomb. Afterwards I continued to Cairo, which is one of my favorite cities for its vitality, mosques, museums and nearby antiquities. From here I booked a passage to Italy on a ship from Alexander, a port city on the Mediterranean Coast, stopping at Syracuse, Sicily and Pompei for sightseeing and on to Genoa.

I rode the train to Florence where I registered at the University, I stayed in a hotel until I moved into a room with a private family. While a student, I ate all my meals in the canteen which not only served decanters of red wine at every table, but also had a bar attached to dining room where I met many students.

I liked my Italian language classes especially the art appreciation class. Every Saturday morning we would meet at a different museum and a docent would explained the paintings to us. To survive this period of my life, I said to myself: "I don't care how I get through it, just do it." First, I bought beautiful, expensive maternity clothes. Then I imagined Alberto was someone, whom he really wasn't, and thirdly I lied. I told people that I was married. In fact I lied so much, I eventually couldn't remember what the truth was. Lastly I ate tons of *gelato* (ice cream). I knew almost every ice cream parlor in Florence. But all this worked; I was quite happy.

TO SWITZERLAND & CLUDIO'S BIRTH

About two weeks before my delivery I left by train for a hospital in Bellinzona, Switzerland, that Alberto had recommended.

Bellinzona was a beautiful town in the alps where they spoke only Italian. I had hoped that Alberto would arrive in time for the birth of Claudio, but he couldn't get leave, so I went to the hospital by myself. I knew that the word "spingere" meant push, but when the doctors

told me "spingere" I didn't know which way to push. Therefore I had a difficult and painful birth.

Claudio, was born on May 14, 1962, exactly one year from the date I met Alberto in Maridi. I was all alone, because Alberto was unable to leave the Sudan at this time. The doctors required that I remain in the hospital for two weeks after the birth, because that was the custom in Italy. When I was released from the hospital, I stayed in another hotel near town and ate my meals in a nearby restaurant.

Claudio was a pretty baby, with even features and black hair, which later turned to curly blond hair. I knew nothing about taking care of a baby, but nursing him, helped make it easier. While he was asleep during the day, I often walked to the castle on the hill, or to the open market to buy delicious black cherries.

In Bellinzona, they only speak Italian. The owner and patron of the hotel often called me to her office to translate for her when she had foreign guests. Nevertheless it was a sad time in my life. I didn't know when Alberto would arrive and had no idea what I was going to do with Claudio. Being an unwed mother in the 60's was greatly frowned upon. I wanted to return to the States and get a Masters Degree while staying with my brother and his wife. They were both students at the University of Iowa, but I didn't know what to do with a baby

At last Alberto arrived "on leave" from Africa. We moved to a small town near Bellinzona . While there, I invited Maria, my German girl friend from Heidelberg, to visit us. When she heard that Alberto planned to put Claudio in a children's home in Switzerland, she was very much against it. She had worked in such an institution and told me the children are well taken care of except they do not receive enough love. Finally, she convinced me to take Claudio with me to Iowa. As a result, I had to write my brother and his wife the news that I was arriving with a baby, not easy to explain to someone with rigid Christian values. Both of them belonged to the strict Church of Christ. My religious views were very different from theirs, having studied Vedanta in India, a more spiritual aspect of religion.

FROM SWITZERLAND TO THE STATES

A Student in Iowa

In spite of all the obstacles, I got Claudio, then 2 months old, a passport and we said good-bye to Alberto, boarded a ship from Genoa for New York and rode a train to Iowa City. My brother gave me a small room in their student housing apartment We told all his friends that I was married, and no one at the university knew that I had a baby. Every morning I would put Claudio on my back in a carrier to a baby sitter, who took care of him while I was in class.

The dean gave me special permission to get a MA with a major in education and French, and at the same time to take classes that I needed for a California teacher's credential. It was a very demanding year. In the evening and on the weekends I spent most of my time in the playpen! Why? If Claudio, five months old, sat in the playpen he cried all the time. If he was crawling around the house, he would grab my book. My solution, was to trade places with him. He was happy with his freedom and I could study in peace. In the summer I fenced in our yard and moved my playpen outside. I looked silly, but it worked. By the end of the school year I graduated with my MA. However, I was so tired I could hardly talk.

Back to California

After school ended I got a ride to California with another student to check on my house that had been rented. I left Claudio with Del, my brother, and his wife who put Claudio in a full time nursery school while they worked. This was one of the big mistakes of my life, which I regretted for a long time. I should have taken Claudio with me When he joined me again after three months, he didn't look like the same happy child I left. For a long time, I wondered what psychological damaged I had done, leaving him for so long.

Part 2 (After Marriage)

ALBRTO'S ARRIVAL

Finally, Alberto got a three-month leave from the Sudan Government. He flew to Iowa and stayed with Del a few days to get acquainted with Claudio. Then he and Del brought Claudio to California. By now I had moved back into my house and figured out how we could get married. First we went to Tijuana. A lawyer managed to get Alberto divorced without his wife in Italy ever knowing because there was still no divorce in Italy. After we waited for three weeks, we returned to Mexico and the lawyer married us in Rosarito. Now I was officially his wife and we could live together in the Sudan.

MOVING BACK TO THE SUDAN

After Alberto returned to the Sudan he sent me a ticket. I rented my house again and joined him with Claudio. I had been reading about the civil war in Southern Sudan and was hesitant about leaving. The Africans in the South, wanted their freedom from the Northerners, who were Arabs and who were in charge of the government.

When Claudio and I arrived in the Khartoum, Alberto met us. We flew to Juba, then took a truck for several days on rough dirt roads to Torit. I would have been happy here, because I loved Africa, its silence and nature, but there was a lot of tension in the air. In fact I felt like I was living in the middle of a war. The Sudanese government thought if they had one big army maneuver they could win the war against the rebels. During this time war planes landed and took off from the airfield in front of our house and tanks roared down the road behind us. This maneuver, however, didn't work. The rebels just stood behind

the roadside trees and ambushed everything that passed, shooting the guns that they had stolen from the previous ambush.

Finally, the government decided that Torit was too dangerous for us, and we were transferred to Maridi. We were excited about this because, that's the village where we met in 1961. From Torit an army convoy of trucks accompanied us on the dirt toads for two days. When we reached the Nile River we crossed over on a ferry.

In Maridi we occupied the same house where Alberto and I had met before, but the village atmosphere had changed because of the surrounding civil war. The servants stole everything, even a bar of soap and it was dangerous to leave the house for fear of being shot. Food was also scarce. The grocery store shelves were bare because trucks no longer brought supplies and the Dinka's stopped herding their cattle to market because it was too dangerous. Once it took our servant, a tall, thin, lanky black Dinka, an hour to search for an egg. We survived mostly on peanuts. Our servants pounded them into peanut butter, and we made peanut soup with it, adding meat broth, cloves and cinnamon. (When I left Sudan, I carried a jar of homemade peanut butter, everywhere I went. It meant survival to me.) Sugar was also a scarce commodity. Alberto and I each had our secret stash. When we wanted to give one another a treat, we offered to share our hidden sugar. None of our friends or relatives knew of our plight because the mail trucks, afraid of being ambushed, never arrived. Living with this stress affected my health and I developed all kinds of pains, including headaches and tooth aches. The only thing I had to read was my cook book.

Our social life stopped all together. The area was considered too dangerous for anyone to come. Only the Belgiums passed through who were escaping the war in the Congo. No longer did we meet interesting people like before: scientists, researchers, government supervisors, and coffee and tobacco growers.

Our only diversion was having dinner occasionally with the English principal at the middle school and her Egyptian husband. Even walks in the jungle or rafting down the creek was considered unsafe.

The first time I lived in Maridi, I thought it was paradise and now it was "hell". Having house arrest was terrible, besides Claudio, age 2, had malaria twice. I gave him daily preventive medicine, but as he

grew, I needed to increase the dosage. I never knew exactly when that was until he got sick.

Alberto had spent most of his life in Africa and didn't want to leave. He was even born in Africa when his father worked on the Aswan Dam. Only for his education did he return to Italy. His first job was working on a heightening of the Aswan Dam and later he became a civil engineer for the Sudanese government.

Finally, Alberto decided to leave the Sudan, after 30 years, because it was becoming too dangerous. We couldn't move to Italy to his uncle's orchard in Avila, Sicily because Alberto had an Italian passport and there was no divorce in Italy. Our only option was to go Laguna Beach, California where I had inherited a house. But obtaining the correct papers for Alberto to enter the States was a complicated affair and took time.

In order to leave Maridi we had to wait until an army convoy of fifty trucks could escort us to Juba, the capital of. Southern Sudan in Equatorial. The journey was considered treacherous because in the last convoy someone was shot and killed in a rebel's ambush.

Nevertheless I was glad to be finally leaving. But my ecstasy didn't last long. During the two day trip Alberto's passport was stolen and I discovered that I was pregnant. We had always talked about conceiving a child in Maridi --where we had met and once our favorite place-- but now I was unhappy. This was not the time for more complications in my life.

In Juba we stayed in a house, where I felt safer, but we still faced the danger of the rebels burning down our house at night while we slept. Finally our flight was arranged, and we flew to Khartoum where we stayed with friends, while Alberto arranged for his entry visa to the States. He had to wait for proof from Egypt and Italy that he had no police record and I had to verify that I had a house and could support him until he got a job. This process took longer than we expected, so I left before him. Kelvin was born July 11. 1965 in Newport Beach, Ca. Alberto managed to arrive just in time for the birth.

BACK HOME, KELVIN'S BIRTH & TEACHING

Alberto took his retirement from the Sudanese government in one lump sum. It wasn't a lot of money because of the low exchange rate. So three

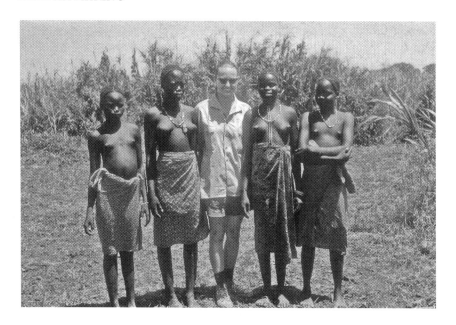

Girls I met when I went on an African Safari

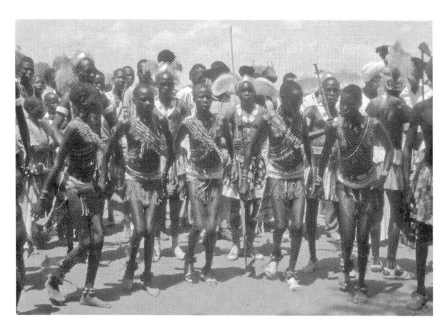

Dancers at a festival in Torit, Sudan in 1964

months after Kelvin's birth July, I began substituting while Alberto took care of the children, not easy for a man who had been in charge of 2000 men in the Sudan. Most of my assignments were teaching Spanish which I didn't know very well. Once a Hispanic student told me, "My father said you are teaching us Italian and not Spanish." When I didn't know a Spanish word, I substituted an Italian one.

To improve my Spanish, I registered in an adult education Spanish class at night. Here, in another class, I met a Mexican girl studying English. We became friends and she arranged that we stay with her relatives in Mexico City during the summer. We rode the train and bus to Mexico and for two months lived with this family to improve my Spanish. When we went sightseeing in Mexico City, I wheeled the children around in a stroller.

Teaching in Anaheim

In the fall of l967 I was hired in the Anaheim school district to teach German. Eventually my assignment turned into a part time Spanish teacher as well. Therefore the next summer we went back to Mexico City to live with the same family again. When we returned to Laguna I also taught French and German in the evenings for the adult education program. I enjoyed this assignment….never any discipline problems and serious students planning to travel in Europe.

Teaching in Germany

In 1972 I got a job in Germany with the National German Association. We rented our house in Laguna Beach and I took an unpaid leave of absence from the Anaheim school district for a year.

In Germany I taught English in a girl's high school in Gladbeck, a coal mining town in the Ruhr area near Essen. Our children attended a local Catholic elementary school with other neighborhood children. Kelvin was in the first grade and Claudio in the third. They learned German quickly. In fact, Kelvin's teacher said that he was the best reader in the class, even though he didn't know what he was reading. Once he came home crying and asked me, "Mama, what does *schulfrei* mean?" I explained that he should be happy because it meant 'no school'.

Everyday by one o'clock school was finished. Then it was time for lunch and homework. On Saturday morning they also had school. One

of the things that bothered me, was that all of Claudio's home work, including math, had to be done in ink. Ball point pens or pencils were unacceptable. If he made a mistake, he had to write the whole page again in his notebook.

Living in Germany with my family was very different from my student days in Heidelberg where I drank lots of beer and partied all the time with the university students. Therefore, I was not prepared for all the strict regulations and seriousness of life in Gladbeck. Alberto used to say, that they didn't need any policemen, because everyone acted like one, always correcting you if you were 'out of line'.

Can you imagine hating Sundays? We lived in a two room apartment above the landlady, and on this day the children were not allowed to make any noise, or even play outside in the street. They had to be kept quiet all day. On TV they even discontinued the program Tarzan because it made the children too rowdy.

Another thing that bothered me were the neighbors informing me when I needed to wash my windows and the front door steps. My school regulations weren't much better. Since education was controlled by the minister of education, we were told how to grade and how many exams to give a semester. Pop quizzes were out of the question. But what annoyed me the most were the girls cheating. They were masters at it! I found cheat sheets tucked under their watches, under their nylons, or pinned to their neighbor's back. When I complained to the principal, a serious looking man, he gave me no support. "We all did it to get through school," he commented. Eventually, I solved this cheating problem by giving all my exams in the language lab that had booths, divided my petitions. Then I stood on a chair in the front of the room and surveyed the students like a general.

During our spring break in 1973, our family took a quick train trip to Sicily to see where Alberto had lived as a child in Avola. Then in the summer we moved to France so I could take classes in French at the University of Caen. It was a relief to be in France again where life was more relaxed.

In Caen we rented a house, across from a castle and nightly the children and I would cycle around the moat. Once our path was blocked by barriers and a sign said *defendu d'entre* (not allowed to enter). But no one paid any intention to the restriction. They simply moved the sign

and continued on. When I asked someone why, he replied, *C'est defendu, mais on le fait quand meme.*" (It is not allowed, but we do it anyway).

HOME TO CALIFORNIA FOR A WHILE

After France, we returned to Laguna Beach for two years and I continued to teach in Anaheim. Then I applied for a year sabbatical leave from my school at half salary so we could live in France. We leased our house again and drove our old car across the States for two months. No one thought our car would make it but we only had to stop twice for repairs. Along the way we camped and visited the national parks as well as Chicago, New York City and Washington DC. It was a good trip.

In Long Island we stayed with friends while we sold our car, easier than we anticipated. We simply parked it with its California license plates in a super market parking lot on a Saturday morning and within an hour it was sold. The buyer probably thought it must be in good condition if it made it all the way from California. And where else could you buy a car for $200?

Teaching in France

In New York we boarded a ship for France. The children loved the cruise….movies and games all day long. From Le Havre we took a train to Flers in Normandy (northern France) where we stayed in a friend's apartment for a few weeks, until we got settled.

In Flers we sent our children to French schools. Kelvin was in the third grade and Claudio in the first year of middle school. I was impressed how easily they learned French. They would ask me the meaning of whole sentences, even using the subjective tense without difficulty. Their accent became better than mine.

Kelvin was in a unique class. On Monday afternoons he had sailing lessons on a nearby lake Then in the winter his entire class went for two weeks on *Classe de la neige* (Class of the snow). Their teacher went with them and taught them regular subjects in the morning. In the afternoon, they skied with an instructor.

Claudio's schedule was unusual too. His classes changed daily. To be sure he took the right books to school, we kept his schedule on the frig and looked at it daily. His foreign language class was German,

not English like the others, because he spoke English better than his teacher.

Both schools lasted all day so they ate lunch at school. Their meals were always gourmet and served in courses. The first thing I asked them when they returned from school was not "How was it?" but "What did you have for lunch?" Their menu always impressed me.

After a few weeks in Flers, we got our own apartment in the town housing section. It was unfurnished so we bought foam cushions for beds which we put on the floor and we covered sturdy, card board boxes with plastic for small tables. Alberto cooked with our camping equipment and our used furniture came from the flea markets

We also bought bicycles and a used 404 Peugeot sedan. The insurance cost the same amount as our car, about 500$. I understood why. The French drivers drove like free spirits, seldom following the traffic rules. I especially hated the roundabouts. Whichever car arrived first from the side road to the roundabout had the right of way. (not the car on the right). Before someone explained this rule to me, I almost had several accidents.

In Flers, I applied for a job at the local high school. They didn't need an English teacher, but a German teacher because the regular teacher was having a baby. Fortunately, I was hired. I spent a lot of time preparing my lessons because I had to be able to translate German into French, in order to explain the lesson to the students. You can imagine what accent, my students ended up with!

If any student gave me problems, I assigned him to Saturday school where his punishment was writing out verb congregations. At night I also taught a few English classes to adults at the community center.

We usually traveled in our school vacations. In the winter time we went skiing in the Alps. We could afford this, because we stayed in *a maison familiale.* (house for families) We shared a large house with other families, where everyone had a job to do: either cooking, setting the table, washing the dishes etc.

The activates at the m*aison familiale* were well organized by the director. At each meal, we sat at a different round table with our seat marked with our name card. In that way we met different guests each time. There were also free child care and special children programs, like group ski lessons. As the children progressed, they passed special ski

exams and were put into new groups.. Adults received special lift rates too. It was an outstanding program.

For another vacation we drove back to Gladbeck, Germany to see where we once lived and to visit our former neighbors. Another time we stayed with friends in Chinon, to take a tour of the castles along the Loire River. Also during spring vacation we drove all the way to the Riviera. Unfortunately, it was the windy time on the Riviera and we almost froze to death in our small, flimsy tents. The French had large, two room tents with heaters and even curtains on their windows.

For Claudio's birthday in May, we invited the neighborhood children for hamburgers, which I grilled on a hibachi on our balcony. In 1975 no one had ever had them before. (Now Mac Donalds is everywhere in France.) The occasion turned out more complicated than I expected: First, there were no hamburger buns, only long, skinny loafs of French bread. Secondly, the ground meat had no fat in it and wouldn't stay together to make flat paddies. I had to convince the butcher to grind up some fat so I could mix it with the meat. He was very hesitant about doing this mainly because he thought the fat would ruin his grinding equipment. I finally convinced him to grind some regular meet after he ground up the fat, to clean out his machine.

Travel & School in Spain

When summer came we packed up and drove to Spain in our old Peugeot. I wanted to show the family this country as well as to study Spanish. I had a list of all the universities that offered summer language courses for foreigners. As we drove through the towns we visited the universities. Some of the towns we visited were: Santender, Segovia, El Escorial, Madrid, Toledo, Burgos, Valencia, Cullera, Salamanca, Valencia, Cordoba, Granada, & Seville.

When we reached Malaga, in the south, we decided to stay there. We camped on the bay and I studied at the University for a month, receiving a diploma at the end of my course.

In 1975 Franco, a dictator, was in power and there were many restrictions: meeting in groups wasn't allowed and there was a high tax on all foreign goods. Therefore when it came time to leave it was hard to sell our French bicycles and car. Finally, we placed a sign on our car in the campground and a gentleman from Madrid agreed to buy it. He

was a mechanic and said he wanted the car for parts and didn't intend to drive it.

After he paid us for the car, we agreed to give it to him at the airport before we boarded the plane for the States. The day of our departure he said he'd follow us to the airport in a truck and tow our car back. But when he arrived at the campground, he came without a truck, only with a paper bag!

We all rode together to the airport in our car. After we gave him the keys, we watched what he did. He drove the car to the corner of the parking lot where he opened the bag, took out a screw driver and replaced our French license plates with Spanish ones. Then he drove off. A simple solution to avoid the government tax!

Divorce

After we flew home from Spain I went through another difficult part of my life. I filed for divorce in 1976. Our marriage was always difficult, and even though we went to many marriage counselors none helped. Our main problems were his unreasonable jealously and his violent temper which sometimes resulted in physical abuse, and my determined personality.

To help survive this period of my life, I made a list of all the things I wanted to accomplish, in case something happened to me and it was my last year. As a result, I was not afraid to do anything: I learned to skate board, surf and backpack. I also walked the beach at night, went to Hawaii with Kelvin, sent Claudio to visit friends in France, and bought anything I wanted. As a result, it was the most productive year of my life and I had a wonderful time. The next year, however, I was exhausted and deeply in debt.

After the divorce was final, I felt and looked like a 'new woman' and every summer afterwards, I took a trip during my vacation. Sometimes I traveled with my sons and sometimes alone. Since I inherited my house, without a mortgage, I was able to save enough money for these trips. See Section Two for the itinerary and journals.

SECTION TWO

BACKPACKING TRIPS
1977-1983 & 1999 & 2000

Hiking on the top on a sand dune in Nambia, Africa in 1999

My Life

In 1977, after I was single again, I continued my travels. I took a backpacking trip every summer either with my sons when they were young or by myself when they were teenagers and a friend looked after them during my absence. The places I visited were: Alaska ,Canada, Western United States, Mexico, Central & South America, Australia, New Zealand, Tahiti, the Caribbean, Greece, Viet Nam, South Korea, Taiwan, Hong Kong, Tunisia, Canada, Middle East and Africa. In this section are excerpts from my Middle East and Africa trips.

AN ITINERARY OF MY AFRICAN TRIP IN 1999

SOUTH AFRICA
Part 1. Cape Town and vicinity
Part 2. Cape Town
Part 3. Garden Route & Wilderness
Part 4. Garden Route:
Natures Valley & Plattenberg
Part 5. Port Elizabeth & Cintsa
Part 6. Coffee Bay
Part 7. Drakenberg Mountains
LESOTHO
Part 7. Lesotho Mountains
SOUTH AFRICA
Part 8. Durban & Eschowe
Part 9. St. Lucia
Umfolozi and
Hluhluwe Game Reserves
SWAZILAND
Part 10. Miliwane Game Sanctuary
MOZAMBIQUE
Part 10. Maputo
SOUTH AFRICA
Part 11. Nelspruit & Kruger National Park
Part 12. Pretoria
ZIMBABWE
Part 12. Victoria Falls
ZAMBIA
Part 12. Victoria Falls
Livingstone

BOTSWANA
NAMIBIA
SOUTH AFRICA

COUNTRIES I VISITED

JOURNAL EXCERPS

SOUTH AFRICA
Part 1

Cape Town & Vicinity
July, First Week

As I stepped off the airport bus in Cape Town, Table Mountain loomed in the distance. I never imagined it would be such a spectacular backdrop for the entire city. After standing there for a few minutes, admiring its beauty, I began looking for a bus to my hostel. When it didn't come, I finally climbed upstairs to a tourist office and asked for help.

"I'll phone a 'rikki' for you," a friendly travel agent said.

"What's that?"

"It's a cheap taxi that you share." Noticing my heavy backpack, she assumed I wasn't in the market for an expensive taxi and she was right, of course!

I waited for the "rikki" in front of a noisy bus station. When it pulled up along side the curb--to my surprise--it wasn't a car at all. It was an open pickup truck that had seen better days. The driver was unusual, too: an elderly woman with gray, bobbed hair. I sat down on a long wooden bench in the back, and as she whipped around corners, she shouted, "We're going to pick up some more passengers."

"That's fine," I shouted back, not knowing in which direction I was really suppose to be going anyway. We darted in and out of Cape Town's narrow streets and at last pulled up in front of the Zebra Crossing Hostel.

"Here you are," she yelled over the traffic.

I rang the bell on the six-foot high wall. Shortly Marius, the director, a chubby young man, opened the gate and greeted me with a cordial smile. I had no idea if the hostel would be suitable for someone in her senior years, but his warm welcome put me at ease. The hostel turned out to be a charming place with two shady, brick patios, a comfortable sitting room, a community kitchen, and bulletin boards advertising budget African tours.

Marius showed me to a small, single room across from a cozy café in which I spent many hours, not only for meals but just trying to keep warm. July is wintertime in Cape Town and freezing cold!

The hostel guests came from all over the world and had fascinating adventures to relate: One middle-aged English couple had taken an overland truck tour for six months all the way down from North Africa. Some Americans, on vacation from Peace Corps, were teaching in Malawi and Lesotho and three youthful Norwegians boys had just cycled down from Ethiopia. Africa's wildness seems to attract the most adventurous souls.

After hearing everyone's exciting tales, I changed my entire itinerary. Instead of spending one month in Africa, I decided to spend three. Knowing that most things in life can be changed--that is, if you're willing to pay the price--I had Marius cancel all my flight and safari reservations. Literally, I wiped the board clean and started over again. In spite of the cost, this was a decision I never regretted.

My first day trip from Cape Town was to the Cape of Good Hope. On a rainy, gray morning Day Tripper's touring van picked me up at the hostel. We drove south along a winding road that hugged steep cliffs jetting into the ocean. The dramatic coastline, with its deep indented bays, reminded me of the gorgeous scenery along California's Highway One. When the narrow road straightened out, Craig, our guide and driver--so handsome he could melt any woman's heart, including mine--unloaded our bikes from the trailer behind our van. Then off we cycled to the cape, listening to the roaring waves of the Atlantic Ocean and occasionally braking for raucous baboons crossing the road. What a great experience!

At Cape Point steep steps led to the top of the cliff where we could see a lighthouse sitting on the very tip of a protruding rock. Nearby two different oceans meet. On one side is the Indian Ocean and on the other

the Atlantic. Most people think that Cape Point is the southern most tip of the African continent, but recent satellite pictures have revealed it's not true. The nearby Point Agulhas (needle in Portuguese) on the Indian Ocean side extends farther south.

After visiting Cape Point, we hopped on our bikes again and pedaled to the entrance of the Cape of Good Hope, a large nature reserve. In 1487 a Portuguese explorer, Bartholomew Dias, sailed around it for the first time. Because of its treacherous currents, and being a realist, he named it the Cape of Disaster. However, the Portuguese king, not wanting to discourage other daring explorers, renamed it. He called it the Cape of Good Hope. Like Columbus, Diaz was on his way to India for spices.

My second trip with Day Trippers was a tour to a black township outside of Cape Town.

Officially called an informal settlement, it was actually a shantytown filled with squatter shacks built of wood, corrugated sheets or cardboard. Though depressing, I felt it necessary to see it in order to understand South Africa's history of segregation. Until 1995, the blacks were forced to live here. In fact, they weren't even allowed to be in Cape Town after six P.M. otherwise they would be arrested.

We sat inside a "shabeen", an old, dilapidated shed used as a bar or meeting place. Here men in shabby clothes told us grim stories about their lives during apartheid. They were shipped here without their families from villages to work as laborers in mines and construction. Even if a man's wife wanted to visit him for a few days, she needed to obtain a special permit. What's worse, all the blacks and colored (people of mixed blood) were required to carry identification cards. With the new government these rules have all been changed. Thank goodness!

The second part of our tour was more pleasant. We drove out to the wineries in Stellenbosch; a valley nestled among high, imposing mountains, actually more beautiful than Napa Valley. Here we sipped wine to our heart's content.

Most of the wineries were started by the French Huguenots who came here in the 17th century to seek religious freedom, just like our pilgrims did. Because the Huguenots were Calvinists (Protestants), and not Catholics, they had been persecuted by the French.

The wine we sampled was excellent--as well as cheap. Imagine buying a good bottle of wine for only three dollars! Actually, everything in South Africa seemed like a bargain because the exchange rate for the American dollar was six rand.

Before leaving the wine district, we passed the prison where President Mandela spent the last three years of his 27 years in prison. When he was released in l990, no one thought his life term would ever be rescinded or that he would one day become President, one of history's surprises.

SOUTH AFRICA
Part 2

Cape Town

July, First Week

Today was another cold, rainy day in Cape Town—perfect weather for exploring museums. Bundled up in wool sweaters like on a ski slope, I strolled to the Cultural History Museum, a historical building, originally built in l679 as a <u>slave</u> <u>lodge </u>for the Dutch East Indian Company. Who'd think that they would need to IMPORT slaves INTO Africa! But the natives on the Cape refused to work for the Dutch. Being hunters, all they wanted to do was <u>steal</u> their cattle! Consequently, the colonists brought in slaves from Malaysia, Indonesia and Madagascar. Today, these brown skinned people make up part of South Africa's colored race.

The Museum exhibited relics from the Dutch and English colonial period. I found the "postal stones" from along the coast the most interesting. They had been engraved with the names of passing ships indicating caches of letters left by the crews. The senders hoped that their letters would be picked up by the next ship heading in the <u>right</u> direction. A system about as efficient as Africa's current postal service. Two months for a Cape Town postcard to reach France is a bit long, don't you think?

My next museum, called the South African Museum, showed displays of Africa's early history. Here I learned that the first inhabitants (after the stone-age tribes) were the San, known as Bushmen. They were short; brown skinned nomadic people who lived off the land by eating

plants and killing wild animals with bows and poison arrows. Not such a bad way to live, I bet, if the weather held out!

Related to the San were the Khoikhoi (Hottentots), semi-nomadic sheep and cattle herders. Together, these two groups are referred to as the Khoisan. Unfortunately, like our Indians, they were eventually driven from their lands and tragically killed by the white man's diseases or superior weapons. Today only a few still exist in Botswana and Nambia. Because of their primitive "lifestyle"—wearing NO CLOTHES, for example—they are a frequent stop on the tourist circuit!

The third racial group to arrive on the scene (about the eleventh century) was the Bantu speaking tribes. They settled in the northern and eastern part of the country and were black. More advanced than the Khoisan, they knew how to make iron tools, domesticate animals, plant farm crops and live in villages.

These different races, as well as the Dutch, English, French, German and Indians, compose South Africa's varied population. That's why the country is known as "the rainbow nation." Similar to Americans, most of the six million white South Africans have a mixture of European ancestors.

On my second rainy day, I rode a bus to the huge mall at the Victoria Alfred Waterfront. While shopping I realize that part of South Africa is as developed as the States. The mall had beautiful shops and restaurants, just like Costa Mesa's South Coast Plaza. The sales ladies were also very attractive women. They had bronze colored skin, big black eyes and lovely faces. Curious, to know where they came from, I asked one of them what her nationality was. Her answer surprised me. "I'm colored (mixed races)," she replied proudly.

After four days of bad weather, a few rays of sunshine pierced the gray clouds that hung over Table Mountain, known as the "table cloth" by the locals. Immediately I jumped in a "Rikki" (cheap taxi) and headed for the cableway that had been closed for a several days.

As I stood in a long line waiting to buy a ticket for the summit, I had my first conversation with a black South African, a middle aged man standing in front of me with his family. He told me he had graduated from a university in the States and now organized schools and teacher training for the black townships outside of Cape Town. "We're making lots of progress," he said proudly. I was glad to hear that he was optimistic

about South Africa's future. Most white South Africans don't feel that way. They think the country is deteriorating because of its new black South African government.

From the top of Table Mountain, 3000 feet high, the scenery was phenomenal. Bathed in the afternoon sunlight, the silent blue sea stretched along an enormous crescent shaped bay. Tall buildings stood beside its shores and red roofed cottages clung to the hillside below. A view so spectacular it was easy to understand why Cape Town is considered one of the world's most beautiful cities.

As I climbed over the craggy rocks and walked along the dirt paths, more exhilarating views assaulted me. On my left along the rugged shoreline, tiny, picturesque coves lay hidden below the steep cliffs. Then to the back of Table Mountain, steep dramatic gorges extended down to the green-carpeted valley below. Seeing this beauty, I felt grateful that my wish to see Cape Town had finally come true.

Though I hated leaving the Zebra Crossing Hostel, after five days I decided it was time to see more of the country. Marius, the friendly hostel director, arranged reservations for me on the Baz Bus, a fantastic service for backpackers. For only about a hundred dollars, the bus takes you all around South Africa: to the Garden Route, Durban, the Drankenberg Mountains and eventually to Johanesberg. Also the driver drops you off on the steps of any hostel on their list and picks you up when you were ready to leave. For convenience and price, you can't beat that!

SOUTH AFRICA
Part 3

Garden Route & Wilderness
July, Second Week

In the early morning mist the Baz bus picked me up at my hostel. The driver loaded my pack back into the trailer behind the bus and drove around Cape Town to other hostels for more passengers.

On the outskirts of town we eased onto the freeway, a beautiful four-lane highway with <u>no traffic</u>! A real surprise! When I lived in

Africa in the early sixties, all we had outside of Khartoum (Sudan) were narrow, bumpy, dirt tracks. Not even roads!

My seat companion, Patrick, was a friendly Irish lad with a great sense of humor. When he introduced me to his traveling buddy from London, he joked, "See, the English and Irish, <u>can</u> get along." For six months they had been sightseeing together in southern Africa. "Don't miss Namibia," he emphasized. "You'll love the pink sand dunes! They're spectacular!" With his recommendation, I added one more country to my long list.

Our first stop that morning was at a filling station for gas. While there, all of us piled out and hurried over to a nearby strip-mall which had everything for a weary traveler: a small grocery store, restaurant, souvenir shop and enormous white-tiled rest rooms with a full-time black attendant. After seeing these modern facilities and the luxurious, double-deckers Intercape buses parked nearby, I understood why South Africa's is often called the "United States of Africa".

Our next stop was at Mossel Bay, a horseshoe shaped bay, known for mussels and whale watching. Some of the passengers were staying in a hostel right along the beach made from converted train carriages. It was so unique that I wished I had planned to stay there, too.

My hostel, Fairy Knowe, was further down the road in Wilderness, a sleepy resort, perfectly situated near a river, beach and mountains. With a long veranda across the front, the main building of the hostel looked like a typical African lodge.

I stayed in an old wooden house at the end of a winding path through the bush. From my upstairs, corner room, I could gaze upon pine-covered mountains on one side and a slow, meandering river on the other. With these magnificent views, I felt I could stay here forever.

Shortly after my arrival, I had a very scary experience. As the afternoon light began to fade, I was strolling back to Fairy Knowe, after a long walk to the beach and village market. Since I feared I might be late for dinner, I turned off the main street to a deserted road that I thought might be a short cut. Shortly, though, when the sun dipped below the horizon, the sky suddenly became pitch black. With no twilight, no street lamps, no star-lit sky, I was completely engulfed in a blanket of darkness.

Many times I had been warned <u>not to be out alone at night.</u> And here I was all by myself.

Frightened that I might be mugged, I quickly concealed my expensive Nikon camera underneath my jacket and hid the 1200 rand (about 200$) that I had just drawn out at the ATM. The safest place I could think of was inside my bra!

Then I hurried down the road. Soon I encountered another misfortune: The road ended in a dead end. Now I was totally lost!

"Nothing to do but turn around," I said to myself, feeling angry that my adventurous spirit had betrayed me. Hurrying through the dark, I suddenly heard three African ladies singing. At first, I wanted to hide for fear of being robbed. But after a quick and anxious dialogue with myself, I decided to ask for help.

"Excuse me," I said cautiously, "Could you direct me to Fairy Knowe, please?"

They looked at one another, then one finally spoke. "Follow us," she said. Then they led me down a bumpy dirt path, through a spooky forest and along a deserted railroad track

One of the women spoke a little English. She told me that they worked as maids in a nearby hotel and came from a distant Xhosa village. Since their husbands couldn't find jobs, they had to leave their families and children to work here. Unfortunately, in South Africa unemployment is terribly high. Out of a population of 44 million about 50% are without work.

After a half-hour--which seemed much longer--we reached the hostel. Relieved that my nightmare was over, I thanked the women and gave them a few rand for delivering me safe and sound.

That night after dinner all of us guests sat around a big open bonfire and told stories. The owner, a lean, rugged looking Welshman, had the most interesting one. He told us how he happened to come to Africa.

"In my twenties, I traveled all the way down the African continent on my motorcycle," he said proudly. "But in South Africa I stayed too long and my visa expired so the government sent me back to Wales."

"Later, I applied for a job to come back and found one on a demolition squad. One day, while I was blowing up a building in Johanesburg, I noticed a beautiful lady in the crowd watching us." He paused for a moment, as if reflecting on that special occasion. "Then, by

chance, I met her again at a party. She was an Afrikaner (Dutch origin) and born here. After a year we got married and moved to Wilderness. I love it here," he said, poking the fire with a stick. "I never want to live anywhere else."

Three days later I left Fairy Knowe on an old steam train that ran in front of the hostel. To catch the train, I stood alone by the railroad tracks and waved to the engineer. When he saw me, he waved back and blew his whistle. Then--just for me--he stopped the whole train. I felt like a celebrity!

The train chugged along at a snail's pace with windows rattling, cars swaying, and engine hissing. All us passengers seemed pleased with our fantasy-like experience. We smiled at one another, as if to say, "Isn't this great fun?"

The train passed spectacular scenery of lakes, forests, rivers and beaches and stopped at the last station in Krysna, a town facing an immense lagoon with a river on the side. Except for a narrow opening into the ocean, the bay was completely surrounded by tall, red sandstone cliffs. It was gorgeous setting.

Here the Baz Bus met me and dropped me farther down the Garden Route to an even more scenic resorts.

SOUTH AFRICA
Part 4

Garden Route: Plettenberg Bay and Natures Valley
July, Second Week

My second stop on the Garden Route was at a trendy resort called Plettenberg Bay. Beautifully situated on a hill, it overlooked white sand beaches, a clear blue lagoon and hazy distant mountains. After seeing its elegant shops and hotels, I understood why it was a white man's playground.

In fact, with no black people on the streets, it was hard to believe I was in Africa. When I finally saw an African vendor, dressed in a long skirt and headscarf, I asked if I could take her picture. She willingly posed for me, probably wondering why I selected her to photograph.

One of my favorite past times in Plettenberg Bay was sitting in restaurants, eating fresh fish. The coziest pub in town, and with the best ocean view, was the Crown and Anchor. While munching at the bar on crunchy fried calamari (squid), I chatted with the local fishermen.

Bob, a big, rugged-looking man in his forties, told me all about fishing. "It's a hard life," he said as he slurped his rum and coke. "But I love the ocean and don't think I could ever do anything else."

Later he added, "We go out for about five days at a time. If we bring the frozen fish back in less than a week, we can sell it as fresh fish."

Hmmm…. In my innocent world, I thought fish had to wiggle to be fresh!

My other past time at Plettenberg Bay was strolling along its wide, empty beaches. I liked watching the young surfers ride the waves and the men get their loaded dinghies through the wild surf. Before they could start their engines and motor out to the fishing boats off shore, they had to push them beyond the breakers. Not an easy job from what I observed.

At Plettenberg Bay my hostel was in an ordinary house in a residential area, nothing special. To convert it into a hostel, the owners had filled most of the bedrooms with bunk beds. They lived next door in their fancy bed and breakfast, so we backpackers had the whole house to ourselves. Not bad!

I prefer staying in hostels, instead of hotels, for several reasons. First, the price fits my skimpy budget: a double room costs about $15, a dorm $7. Second, I can whip up something in the kitchen if I want. And third, there is always someone around to talk to. Even though I'm always the oldest backpacker--in the senior citizen category--it never bothers me. That is, as long as no one tries to make me the "house mother"!

After two days in Plettenberg Bay's warm sunshine, the Baz Bus picked me up and delivered me down the road to Natures Valley. I had planned to stay by the beach, but when I saw Kurland Backpacker's Farm I changed my mind.

It was absolutely beautiful! Just like in expensive hotels, tall, stately cypress trees lined the private road leading to the entrance. From the veranda of my room, I could gaze upon extensive lawns dotted with all kinds of trees and wild scrubs. It was a thrill to be able to stay in such attractive surroundings.

The owner, John, I liked a lot. He was a young, handsome man with a very kind heart. A graduate from a university in the States, he only recently converted his family farm into a backpacker's hostel. Before that, he ran a business with his brother in Johanesburg where they imported used clothing from the States and sold it to the Africans in open markets.

The Kurland Farm had a fascinating history. Originally it belonged to John's grandfather, a <u>Russian Baron</u> who grew up on a large estate surrounded by pine forests. It was located in Kurland province in one of Russia's Baltic States. When he emigrated to South Africa, probably for political reasons, he lived in Johanesburg. There he met and married a wealthy Afrikaner. In the early 1940's, they bought this farm in Natures Valley. To emulate his estate in Russia, he planted over <u>one million</u> pine trees on the surrounding hills. Presently, he runs a sawmill across the road.

One evening, Liz, the New Zealand hostel manager and cook, invited us to a brai (barbecue). We all piled into the back of a pick-up truck to Monkeyland, a new tourist attraction. The owner had recently sold his <u>private</u> game park up north--imagine being so rich--and invested in monkeys!

Yes, monkeys! <u>Eighty</u> of them to be exact.

These little creatures roamed freely around the surrounding forest. But amazingly most were <u>not</u> from Africa. They were imported monkeys! Out of the eight different species in Monkeyland, only TWO SPIECES were from Africa. Why? My guide had a fascinating answer: it changed a monkey's behavior to live in a small forest: If they weren't of different species, they would inner breed. In the wild, this phenomenon doesn't take place. It only happens in captivity. I guess that's what STRESS can do! It even affects the animal kingdom!

The guests at the brai were friendly people, all white South Africans who lived in Natures Valley. Most were teachers, B&B owners, lettuce growers, contractors and dairy farmers. It amazed me how much we had in common even though we were from two different continents.

The part of the brai I didn't like was all the heavy drinking. We arrived about six in the evening and weren't served dinner until ten. With no snacks, no chips, not even a sliver of butong (beef jerky), I became famished, woozy and weak. In desperation, I volunteered to

help cook the meat--hoping, of course, to secretly snatch a few succulent pieces. But no luck! Barbecuing was a man's domain.

After four hours of "boozing", you can imagine how much sense our conversations made. One portly gentleman introduced himself to me <u>three</u> times. I guess I wasn't too coherent either. I kept forgetting <u>his</u> name as well.

In retrospect, I wonder why these people liked to drink so much. It seemed to me they were living in paradise!

Part 5

Port Elizabeth & Cintsa,
July, Third Week

After two weeks on the Garden Route, I arrived in Port Elizabeth, a town rich with many old buildings of Edwardian and Victorian architecture. Today, however, it no longer reflects its former elegance. Neglected historical buildings, shabby streets and a run-down port make it an ugly city. Even the bustling downtown area with an exotic, African pulse is a place too dangerous to explore.

In Port Elizabeth I stayed for two nights. Not for sightseeing, though, but for shopping. The shutter on my Nikon broke, so I had to buy a new camera. I also wanted to replace my Adidas with a pair of sturdy leather boots for trekking.

The hostel I selected was in the "white" suburbs outside of town. Around the corner were many reminders of home: theaters with the latest American movies, a Kentucky Fried Chicken, a Wendy's and even an imitation Seven Eleven. Western culture, if you can call it that, was not what I preferred to see in Africa, but at least everyone said it was a safe neighborhood at night. It turned out they were right. I did survive an "evening out" at Speedy's Pizza Parlor.

The next morning I went shopping by bus. In the cool, brisk, invigorating air, I waited for one on a street corner. Before me passed a parade of mini-bus taxis, stopping, loading up and speeding off. Shortly, all the Africans around me had disappeared.

Since no bus was in sight, I asked a young man standing nearby if he thought it would be all right if I took one of the mini-bus-taxis.

"I wouldn't." he answered, seriously. "It's not safe."

"Why's that?"

"Too many accidents. They're always overcrowded and go too fast."

"Darn," I complained, disappointed that I couldn't participate in a local custom. It disturbed me, too, that I had to squelch my "go-native-desire".

Thinking that I had detected an American accent, I asked him if he was from the States.

"No, I'm from Canada," he replied, "but I've lived in L.A. I went to UCLA." Named Dustin, he worked as a zoologist for a game reserve.

When he realized that I "didn't have a clue" how to get to the mall, he offered to accompany me. "It's my day off," he said, keeping his eye out for the bus, "so I've got lots of time."

Without hesitation, I accepted his kind offer. And what a great help! Not only did he know his way around the huge, spread-out mall, but he was also an excellent bargainer.

I liked his wild animal stories, too. He told me his last job was transporting elephants to the nearby Addo Elephant Reserve. He brought them from Kruger Park to eliminate their surplus. Since elephants have no predators like other animals (except, of course, for illegal poachers), their population is hard to control.

"It was a difficult trip," he explained. "We had to keep turning the sedated elephants from side to side, because if they lie in one position too long, they break their ribs."

Imagine turning over an enormous sleeping elephant--in a truck, no less!

Dustin also shared with me his concern about the future. Since South Africa has affirmative action, the white people feel they are discriminated against. "I hope I'll be able to continue working here," he added. "I've been here for ten years and would hate to leave."

When we parted, I promised to send him a copy of my book, Asian Adventure, and he agreed to send me more animal stories. I hope he doesn't forget.

Cinsta (About 200 miles north of Port Elizabeth)

Everyone I met raved about Buccaneers Backpacker's Lodge in Cintsa. When I arrived, I immediately understood why. It was a fantastic place

with a breathtaking view! The main lodge sat on a hill and faced a wide, sweeping, blue lagoon and miles of unspoiled beaches.

The people who owned the lodge were special, too. Not only were they friendly and hospitable, but they even planned daily afternoon activities for us. My favorite one was the booze cruise down a scenic river with all the wine you could drink.

At Buccaneers, I stayed in a rustic beach cottage with an ocean view. Since it had two bedrooms, I shared it--not my bedroom--with other backpackers.

Here, I met the most unusual person of my whole trip. His name was Yasek and came from Poland. No matter what he said or did, he surprised me.

For instance, when I entered the cottage for the first time, he was in the kitchen heating a metal rod on the stove. After getting it red hot, he poked it inside of a four feet piece of bamboo.

"What are you doing that for?" I asked curiously.

Staring at me with his penetrating blue eyes, he explained that he was making an African musical instrument.

It didn't look like any instrument I've ever seen, so I continued watching him. Then came my next surprise: He told me that he hadn't come to South Africa for a safari or traveling, but to attend a three week Zen retreat. "While we were there, we couldn't talk the whole time," he said in his heavily accented English, "and we started meditating at three A.M." Personally, I could think of a better time to work on "spiritual repair", couldn't you?

The surprises continued. After the retreat he went to the Grahamstown Dance Festival. And what did he do there? He sold plastic, Japanese toy spiders to the spectators! "I made enough to pay for the whole trip," he said proudly. "They loved them!"

Wanting to know more about him, I asked him one day what he did in Poland. Another surprise! Besides being a musician and hawker, he also sold Rainbow vacuum cleaners and, believe it or not, Amway products.

Yasek's girl friend was traveling with him. She was a dentist from Germany whom he met at a Zen Conference in Warsaw. (A unique couple, wouldn't you agree?) Every night he cooked dinner for her and always invited me to join them. His potato pancakes and dumplings

made a sumptuous feast! I shall always remember Yasek. He was truly a free spirit.

Coffee Bay, South of Durban

July, Third Week Part 6

At an isolated filling station out in the middle of nowhere, the Baz bus dropped me off.

"This is the Wild Coast stop," the driver called back at me.

With only brown fields around, I hesitantly climbed down from the bus. Before I could panic about being stuck out here alone, a tired-looking pick-up truck pulled up beside me.

"Hi. Coffee Bay?" the young driver yelled.

"Yeah," I shouted, happy to be rescued from "no man's land."

I threw my backpack in the bed of his truck and climbed into the cab.

"My name is Patrick," he said, with an Australian accent. From his long hair and bare feet, I sensed he was a "laid-back" kind of guy.

For two hours, we drove on narrow paved roads through the rolling, barren hills of the Transkei, a predominately black African area where President Mandela was born. Turquoise painted rondavels (round huts) were scattered across the treeless landscape. For once, I felt I was really in Africa.

Finally, we pulled into the dusty village of Coffee Bay. Patrick parked his truck on the bank of what-looked-liked-a-river (actually an inlet from the ocean) and said nonchalantly, "The hostel is over there on the other bank. We'll have to wade across."

You gotta be kidding, I wanted to exclaim, but simply inquired politely, "Is this the usual procedure?"

"No, tomorrow, when the tide's low, I can drive across."

Cautiously, with boots off, pant legs rolled up and backpack slung across my shoulders I stepped into the deep water. While trying to avoid the slippery, sharp rocks, I wondered if anyone around here had ever heard of a BRIDGE!

The hostel stood among palm trees directly behind another house that faced the ocean. Since the double room had no electricity, Patrick

showed me to a dorm. Then he announced he had to open the bar. "Come over later, the first drink is on the house."

After unpacking a few things, I went over for a "free beer". Hardly bigger than a large closet, the bamboo-decorated bar was crowded with interesting people. Among the guests was the hostel owner, a wiry-looking fisherman; the elderly man from the front house who once had employed Africans for the mines in Johannesburg; a pretty veterinarian student from Slovenia (in love with the hostel owner); and an anthropology professor on a dig. His cute, young assistant accompanied him (probably also in love). Africa, it appears, attracts only romantic and adventurous souls.

I stayed one night at Coffee Bay Backpackers. The next morning Patrick,after rescuing his truck from the other side of the river, drove me out to another hostel called White Clay.

It sat on a hill overlooking a cozy cove encircled by jagged cliffs. Waves slapped against its pebbled beach, and African huts dotted the hills behind. Quiet, picturesque, isolated, it was just the place I had dreamed of finding.

One morning, about noon, I was sitting on a wooden bench in front of my room listening to the roaring waves and admiring the surrounding beauty. Suddenly, a small barefoot African boy appeared before me. "You buy lobster?" he asked, holding the wiggling creature in his hand.

"How much?"

"Ten rand." (About 2$)

"OK", I said, glad to have a bargain. Grabbing it by the tail, I headed for our community kitchen. Just as I was about to throw the lobster into a pot of boiling water, another hostel guest entered.

"What are you doing with MY lobster?" she exclaimed angrily.

"YOUR lobster?" I snapped back. "I just bought it for 10 rand.

"Well, it's mine. I paid 5 rand. I told a little boy to bring it up to the kitchen for me."

Not wanting to argue about the lobster's ownership, I relinquished my claim and ate my usual cheese sandwich for lunch.

But the lobster saga took an unusual turn.

Since it was a sunny day with teal blue skies and white floating clouds, I decided to walk to Hole in the Wall--an unusual rock about

three hours away. Other hostlers had been there. Not reporting any messy encounter with danger, I assumed it was safe to go there alone.

I climbed up a steep hill and followed the rugged coastline. After awhile, a narrow trail threaded through clusters of huts, where I met an African girl, balancing a bag of groceries on her head. She strolled leisurely along as stately and erect as a queen. Since I wasn't quite sure of the path, I asked her the way. She didn't speak English, but motioned for me to follow her.

We passed African women squatting in front of their mud huts, children with sparkling black eyes playing in the dirt and women climbing up from the beach holding baskets of mussels on top of their heads, gathered from the rocks below. Never have I walked so slowly in my life!

When the girl reached her rondavel, she motioned for me to continue straight ahead. I walked for another half an hour and came to a group of buildings. To my surprise, they turned out to be a first class hotel. Being curious, I peered into an open window and saw an elegant dining room. Even though it was after three o'clock, two elderly men were sitting at a table eating lunch. In front of them sat a bottle of white wine and a large platter of LOBSTERS.

"Hello," one of the men said, flashing me a warm smile.

"Hi," I answered, weary from my long hike.

"Would you like to join us?" he asked.

"I'd love to." And without hesitating, I walked inside and sat down. The waiter poured me a glass of wine and <u>filled my plate with a delicious lobster.</u> It was unbelievable! Fate must have been eavesdropping on my desires.

One of the men, Steve, was particularly charming. He had the air of someone who was used to living in the lap of luxury. Before retiring, he owned a cold storage business in Durban. Now he was on a fishing trip.

While dining together, the hotel manager joined us, a woman of cut diamond elegance, named Rose. The way Steve held her hand and looked amorously into her eyes, probably meant that they, too, were deeply in love.

Later, Rose asked a young boy to guide me to Hole in the Wall. Together we walked through forests, over boulders, along beaches and

finally came to an immense rock, sitting in the ocean. The pounding of the waves had eroded a huge hole in the middle. It was, indeed, an impressive sight.

When I returned to the hotel, Rose called a truck-taxi to drive me back to the White Clay Hostel. The driver was another fascinating man. Tall, thin, and about 45, he had worked all over Southern Africa, diving for diamonds in the rivers of the Central African Republic and off the coast of Angola. He told me great stories on the way! What a day of adventures!

SOUTH AFRICA AND LESOTHO
Part 7

Drakensberg Mountains
July, Fourth Week

Everyone I met insisted I see the popular Drakensberg (Dragon) Mountains. So, reluctantly I gave up my idyllic lifestyle at White Clay's beachside hostel and became a serious backpacker again.

My journey started on a crisp, sun drenched morning. Patrick, the manager of the Coffee Bay hostel, picked me up in his rickety, old truck and for two hours we jostled along to the "out-in-nowhere" filling station in Umtata. THERE I WAITED. When the Baz Bus arrived, it transported me down the road to Kokstad, about three hours away. THERE I WAITED AGAIN--this time for a shuttle taxi to Himeville, a small, predominately African town on the edge of the mountains.

My white South African driver was an attractive, refined woman in her forties—not the type you'd expect to be driving a taxi out in the bush. She ran a taxi business with her husband who insisted on living in Himeville so he could go fishing!

As we drove along on a two-lane country road, daylight gradually seeped from the sky, and evening shadows spread slowly across the vacant landscape.

"Aren't you afraid to be driving on these lonely roads?" I asked, noticing she showed no sense of fear.

"No, I have a cell phone," she replied nonchalantly, as if that would protect us from danger. Jane had grown up on a farm in the African bush and was probably accustomed to being the only car on the road.

After a long ride I landed in front of the Himeville hotel. HERE I WAITED ONCE AGAIN. In a half an hour a jeep arrived to take me up the mountains. The driver, a young, bearded man named Russell, was the hostel owner.

By the time I reached the Sani Pass lodge, I felt tired, famished and frozen. The hope of being revived by a hot meal at the lodge had kept my spirits up. But soon, I learned that dinner was over at eight. In my grumpy mood, I made a cheese sandwich, wishing I hadn't listened to the guy who told me the lodge served meals <u>at any</u> time.

The next morning, though, when I saw the magnificent, copper-colored mountains in the distance my mood changed.

Unlike the towering, gray, rocky peaks of the California Sierras, the Drakensbergs have low, flat summits or rounded ones like a camel's hump, and throughout the day they change color. When the sun shines, the mountains have a fiery orange glow, and as the evening shadows creep over their craggy faces, they become a reddish brown. Their changing faces fascinated me.

While at Sani Pass Lodge, I joined one of Russell's hiking tours to see the famous San (Bushman) rock drawings. First, we threaded our way through forests, hills, streams and valleys, passing breathtaking scenery. Then, we climbed up the side of a mountain to a shallow cave where San paintings decorated the inside walls of the overhang. They were simple stick-figure drawings of people and animals, painted in red and depicting hunting scenes. It's amazing that this rock art, according to research, has existed here for over 250 years.

The San people used to come to the Drakensbergs only in the summer time. Astute hunters, they used arrows with poisoned tips that came off and lodged inside the animal's skin. When it died later, they knew exactly how to track it down. Too bad these awesome hunters are now extinct in South Africa. Either they were killed in battle or intermarried with other African tribes.

My second tour from the Sani Pass lodge was to Lesotho, a tiny, mountainous country of two million inhabitants surrounded by South Africa.

A clever warrior, named Moshoeshoe, was responsible for its formation. Originally, he was the headman of a Sotho village. In the 19th century, during the many gruesome Boer and Zulu wars, he accepted the destitute refugees into his tribe, thus increasing its size. Later, he brought his people to these mountains and named his kingdom Basutoland.

Since his warring neighbors kept attacking his country, he asked the British for assistance. They agreed to help by annexing his land, and eventually it became a British protectorate. In 1966, when the country gained its independence, the king renamed it Lesotho. Today many Peace Corps volunteers are working there. The ones I met love it.

It was a cloudy, rainy day when I left on the Lesotho tour. Our driver-guide, named Sandy, was a-John-Wayne-type of man, tall and sturdy with a zest for adventure. I called him "the mountain man".

I admired him a lot, but he drove like a maniac. He swished us up through the steep Sani Pass on a terrible pot-holed dirt road like a racecar driver trying to finish first. We were all frozen with fear.

The closer our "mountain man" drove to the cliff's edge, the happier he seemed to be. Fortunately, a thick fog robed the mountain, so we couldn't see how far we'd fall, if he missed a hairpin curve.

At the Lesotho border, we stopped at the customs office to have our passports stamped. Then we climbed to an elevation of 9000 feet. At the summit sat a rustic, isolated lodge, known for the highest licensed pub in southern Africa.

We rushed inside the lodge to escape the bitter cold. Snuggling besides a crackling fire, we guzzled steaming hot coffee to try to get warm. Through the windows we could see a barren, treeless landscape of alien starkness, a perfect place for someone to stay who wanted to "get away from it all" and pretend they were on the moon.

Our "mountain man" unfortunately would not let us be warm and comfortable for long. He insisted upon returning to the cold to continue our tour.

First, he drove us to the top of a hill, where we could gaze upon the distant mountain peaks dusted with snow. Next we investigated the interior of a deserted rondavel, a round hut made of stones (instead of mud) and covered with a thatched roof. Sheepherders use this as a refuge in summer.

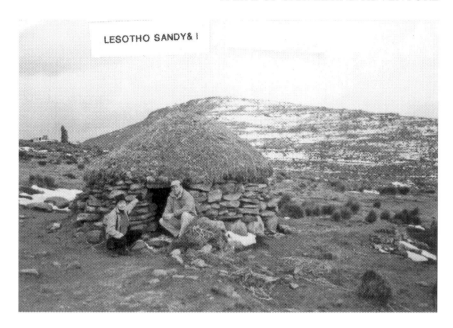

A rock hut where people live

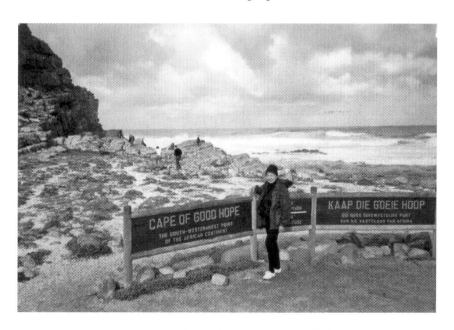

Me at Cape of Good Hope, the tip of Africa

Later, when Sandy drove past a rondavel with a white flag on top he stopped again. It meant that freshly brewed beer was for sale. In order to give us a real native experience, Sandy invited us inside. The other customers, wrapped in blankets, were sitting on the dirt floor around an open fire of cow dung. We never tasted the beer, though. We didn't have time. The smoke inside was thicker than L.A. smog. Our eyes began to water, and our throats choked up. In order to stop coughing and breathe again we had to escape. How these people can survive in such austere conditions is amazing.

On our way home, Sandy explained that sometimes the summit has heavy, unpredictable snowstorms. Once, he said, a professor was up there doing research and got caught unprepared in one of the unusual storms. A helicopter had to rescue him. Later, when the snow melted, the professor returned to get the jeep he had left. And guess what? He couldn't find it. The inhabitants had completely dismantled it and stolen everything except the windshield.

SOUTH AFRICA
Part 8

Durban & Eschowe (Zululand)
August, Fifth Week

Arriving in Durban from the Drakensberg Mountains was like landing in the middle of New York City from the Ozarks. I felt overwhelmed by the imposing skyscrapers, the bumper-to-bumper traffic, the crowds of people. When I got used to the change, though, the city's beauty and vitality captivated me.

Durban seemed to have everything: ornate Victorian buildings, a bustling port, elegant malls and a Miami-like ocean front promenade flanked with luxury hotels. It even had a surfer's beach right in the middle of town and plenty of street markets and sidewalk vendors with African flavor.

Sundays were my favorite time. Flea markets popped up everywhere in Durban, and an air of festivity permeated the city. The market I liked best was sandwiched between the Holiday Inn and the ocean promenade. From rows and rows of stalls, vendors sold everything from:

African woodcarvings, Zulu beaded bracelets, used books, clothes, kitchen utensils to whatever you could imagine. One man, I remember, displayed mainly safety pins. I felt sorry for him and even bought some.

When I became weary of souvenir shopping, I wandered over to the food stalls. Enticed by the tangy scent of spices, I bought some curry and rice and somosas.

Then in the warm sunshine (It's summer all year round in Durban) I sat down at an empty table facing a band blasting out jivy tunes.

Shortly, a pretty teenager joined me. Because of her bronze colored skin and curly hair, she didn't resemble an Indian or an African. Unable to squelch by curiosity, I tactfully asked where she was from.

She paused a minute, swallowing a mouth full of French fries. "I'm from Durban," she said with a half smile, not bothered by my question. Later she told me that she was colored (mixed races) and appeared to be proud of it. Over 3 ½ million colored people live in South Africa.

Before long, her father joined us. He had the same golden brown complexion but looked more African than his daughter.

While he waited for his wife to get off work from the Holiday Inn, we chatted about his family and job as a house painter. I sensed he was pleased with his life. President Mandela would certainly like to hear this. During Apartheid, which officially ended about five years ago, the colored race was greatly discriminated against.

In Durban, I stayed at the Traveler's Rest hostel, a pleasant two-story wooden house with a veranda and patio. Like one million other city residents, the owners were Indian. In fact, Mahatma Gandhi once lived in Durban.

One day when I stepped into the living room, I found, Patrick, my first Bas Bus seat companion from Ireland, looking at television.

"What are you doing here?" I exclaimed embracing him like a long lost friend. "I thought you'd still be traveling?"

"I'm waiting for my plane back to Ireland, I got tired of traveling," he admitted, returning my hug. Many tourists, like Patrick, prefer waiting in Durban for their international flights from Johannesburg. It's considered a much safer city--less muggings, except at night--and has frequent connecting flights to "Joburg".

In Durban, I switched from the Baz Bus to the Grasshopper Bus to see Eshowe, a colonial town in Zulu territory--once the center of the 1879 Anglo-Zulu war.

From here, I took several tours: The first one was to Zululand, a kraal of beehive shaped, grass huts encircled in a stockade. It was originally constructed for the film Shaka Zulu and now a tourist attraction. Here the Zulus introduced us visitors to their ancient tribal life: we met the chief, drank sorghum beer, (it tasted awful) and watched people make, shields, spears, beaded skirts and pottery.

After dinner they provided a lively dance program for us. Bare-chested men in knee length, leather aprons kicked and stomped to the rhythm of drums beating while women chanted. The performance appeared more like aerobics than dancing!

Zulu history I find fascinating: Their fearless king, Shaka made them famous. With his 50,000 ruthlessly trained warriors, he terrorized all of southern Africa in the 1800's. Like Napoleon, he devised ingenious battle strategies and, with his numerous conquests, carved out an empire, bigger than the size of France.

Part of Shaka's success was attributed to his new "close combat" spear, an invention similar to a bigger and better mousetrap. Instead of a long, skinny spear, his warriors fought with a shorter one that had a sturdy shaft and a long broad blade. No longer did he have his men line up and hurl their spears "willy-nilly" at the enemy--then lose them. Now, in a curved, bullhorn shaped formation, they encircled their adversaries and gorged their eyes out!

From winning many battles, Shaka became extremely wealthy. Besides amassing a harem of beautiful, bcad-bcdcckcd maidcns, he collected over 500,000 head of <u>snow</u>-<u>white</u> cattle, a true sign of African wealth. But in 1827, an unexpected event occurred which quickly ended his success: His beloved mother, Nandi, died causing him to suddenly "lose his marbles". In a bloody rampage he massacred 5000 mourners, and enforced ridiculous laws: for one year, no one was allowed to plant crops, milk cows or even give birth.

To end the mayhem, Shaka's half brother courageously murdered him. For more gory details, read James Mitchner's book, The Covenant, 1200 pages, or see the video, Shaka Zulu.

On my second tour from Eshowe, I rode in a jeep on bumpy, dirt roads out into the surrounding brown, rolling hills. I wanted to visit a Zulu family.

When I arrived, Duke, the oldest son, greeted me with a traditional triple handshake (three clasps in different positions). Then he invited me into his parent's living room, where his mother served tea. The house was simply furnished, but did have a black and white television sitting on the shelf. There was electricity, but no running water. His mother--a woman's job--had to carry it from a stream fifteen minutes away.

Behind their small house stood a special rondavel (hut), used strictly for ancestor worship. Duke explained that in their ceremonies they sit around a fire, burn incense and make offerings to the souls of the dead. No matter what they want, or don't want, they consult their ancestors' spirits about it.

When Duke and I strolled through the garden, which seemed to have more marijuana plants growing than vegetables, we talked about his life and Zulu customs. I learned that he was a night watchman and studying to be an electrician. His wife stayed at home with two of their three children. One child preferred to live with his brother. In African families this is perfectly acceptable: cousins are often treated as brothers and sisters and uncles and aunts are another set of parents.

Later, Duke revealed that his father, a farmer, had a second wife, living in a different house.

"I want another wife, too," he confessed. "But I need eleven cows for lobola (dowry)--the going price for a bride--and now I only have three. Our chief has already promised me land for another house."

When the jeep came back to pick me up that afternoon, I said goodbye to Duke. I really appreciated him giving me a chance to learn about Zulu life.

SOUTH AFRICA
Part 9

St. Lucia; Umfolozi & Hluhluwe Game Reserves
August, Sixth Week

After visiting Zululand, I hopped back on the Grasshopper Bus and headed up north to safari country.

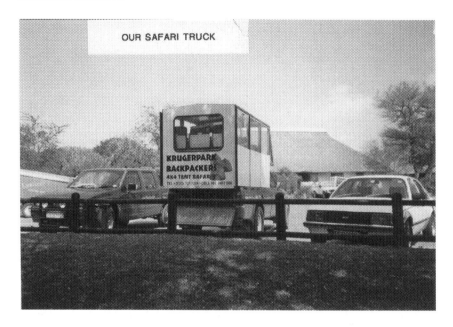

The truck we rode in on Safari in Kruger Game Park

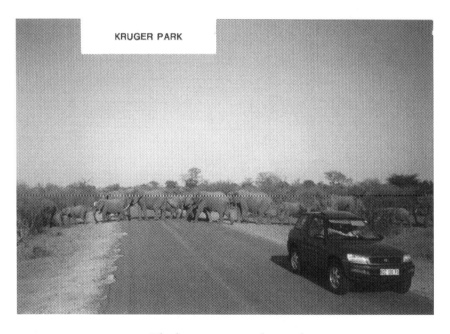

Elephants crossing the road

On the way I had an interesting experience:

As we were rolling along on a smooth, paved highway, the driver, for no obvious reason, suddenly turned off onto a dirt road. With only empty grasslands around, I wondered if he knew where he was going. We bounced along for a while, eventually passing some old, deserted trailers. Then farther down the road, we stopped beside a few rustic cabins sitting in a grove of trees. Beside them, in the shade, stood a beautiful young girl dressed in neatly pressed khaki shorts. With her long, golden hair and slender legs, she could have been a Vogue model. Why is such a beautiful girl, running a hostel way out here, I wondered? But Africa is full of surprises!

The girl asked our driver if he had any backpackers for her, then waved goodbye to one of her guests as he climbed on the bus with his shabby, leather backpack.

He was a thin man, about fifty, with rimmed glasses, unruly brown hair and wrinkled clothes. His narrow face wore an astute expression. For some reason, his appearance intrigued me. Wanting to know more about him, I turned around in my seat and began asking him questions. "Wasn't it lonely out here?" I asked, thinking it would be hard to stay in such a desolate place.

"No, I liked it," he replied, looking intently into my eyes.

Feeling a strong attraction to him, I continued my questions. "What did you do out here?" "I went to a game reserve." Later, he told me about the animals he had seen, mentioning that he was an ecology professor in Australia but born in South Africa. "I'm writing pamphlets for game parks," he added.

As we continued our conversation, I felt as if we were kindred souls. Besides enjoying backpacking, we shared the same love for Africa, its nature, its silence, its mysteries. We both agreed that Africa had a spiritual quality, and being here felt like being in the center of the earth.

"You can never tame Africa," he emphasized. Then he told me a story to illustrate his point: "Once," he said, "the government cleared some land for the Africans so they could plant crops and build huts. But the project failed. After a while, nature took over again and the wild animals returned, so the people had to leave. Africa will always be wild," he concluded.

After an hour on the road, our driver stopped at a filling station for gas, and my new friend got off to hitch a ride to the Umlalazi game park. I was sad to see him leave. I was hoping he'd ask me to join him on his safari. But he didn't. All he said was, "You should visit Umlalazi some time."

It's too bad I didn't have more courage and reply, "What about now?" and grab my backpack off the bus......Oh well, I suppose I can always write for some of his pamphlets! I have his address.

St. Lucia: a resort on an estuary--home of happy hippos and lazy crocodiles.

From my headquarters at St. Lucia, I joined a day safari to the Umfolozi and Hluhluwe Game Reserves. Our tour guide, named Mike, picked us up from the hostel, and in the early morning mist, drove us forty miles to Hluhluwe Game Reserve. After paying our entrance fee at the gate, we eased slowly along a network of well-paved roads through tree-studded plains with mountains rising in the background.

Surrounded by such classical African vistas, it was hard to keep my eyes focused on finding animals, so I depended on Mike and the other passengers. They told me where to look. When I did spot one of the creatures going about its daily routine in these natural surroundings, I shouted with joy. It was a thrill equal to winning a ski race.

The first animals we saw that morning were dainty tan-colored impalas with black and white markings. They ran and jumped through the thicket, like a troop of graceful dancers. Nearby stood two stoic-looking Zebras calmly nibbling on plants and undisturbed by their frolicking neighbors. Next, my seat companion pointed out a giraffe. It was standing behind an acacia tree. All we could see was its head peering over the top of the branches--what a strange sight to see a head above a tree! Because the giraffe had dark horns, Mike told us it was a female; the males have the lighter ones.

Farther on, we noticed a small herd of waterbuck standing motionless in the shade. Their dark gray skin had white markings on their buttocks in the shape of a "toilet seat". By distinguishing them this way, I didn't confuse them with the gray wildebeest.

About noon we stopped for lunch in a designated area where we were allowed to get out of our van. While eating our sandwiches, we watched baboons playing in the bushes and a herd of buffalo crossing to

the other shore of the river below. For the Africans, the buffalo is one of their most feared animals. Even though buffaloes eat only plants, they attack humans without provocation.

Later that afternoon, Mike took us to a special area in the Umfolozi Reserve where rhinos often "hang out". We walked through a long, narrow, wooden corridor with viewing slits on both sides. At the end of it was a small opening with benches below. We sat there, waiting silently. Sometimes the rhinos don't appear at all. This time, though, we were lucky. Shortly, two enormous ones strolled stiff legged into our view. They wallowed in the mud for awhile and then on nearby stumps and rocks began rubbing their genitals over and over again. All of us began to giggle and whisper funny remarks. Mike became annoyed.

"It has nothing to do with sex," he said sternly, attempting to get us quiet. "They're just scratching their sores and insect bites!" We weren't convinced.

Later that afternoon, as we were about to leave the Reserve, we spotted two cars ahead of us parked along the shoulder. When we got closer, we figured out why. Right in front of them stood three, big elephants, weighing about 12,000 pounds each. Immediately, Mike pulled over. Excitedly, we leaned our heads out the windows and quickly snapped pictures as they lumbered toward us. Holding our breath, we watched to see what they would do. Were we in danger? Would they damage our van? We waited in suspense. Then luckily, just before they reached us, the elephants nonchalantly veered off into the bush.

"That was close!" We exclaimed, breathing a sigh of relief.

On our way back to St. Lucia, I realized that this safari would be one of the highlights of my entire trip.

SWAZILAND & MOZAMBIQUE
Part 10

Mililwane Wildlife Sanctuary
Maputo
August, Seventh Week

When I heard about a hostel in Swaziland where zebras grazed on the front lawn, I knew I had to stay there. The hostel, called the

Sondzela Lodge, was located in the middle of the Mlilwane Wildlife Sanctuary.

The trip to Swaziland was easy. At St. Lucia I simply jumped back on the Grasshopper Bus again and in four hours we arrived at the border. Here the officials stamped our passports and welcomed us into the country.

Swaziland, like Lesotho, is a tiny kingdom of about 836,000 inhabitants and bordered by Mozambique and South Africa. For 66 years it was ruled by the British and in 1968 became independent. Their former king--Sobhuya II who died in 1982-- was known as the world's longest reigning monarch. He probably had the most wives of any known royalty, too. ONE HUNDRED in all! Today one of his 200 sons rules. His name is King Mswati III.

From the border, we traveled for another hour to the wildlife sanctuary. After registering at the entrance, we headed for the lodge. Dusk was falling and in the fields kudus, impalas and wart hogs were grazing on the grass. A wonderful sight!

The Sondzela Lodge sat among trees on the edge of a mountain range. It was a charming place with an immense overhanging straw roof and a dark wooden interior. As I had hoped every morning, zebras magically appeared in front of the veranda.

To my surprise, the lodge was run by three, young Swazi women, not by Europeans or white South Africans as in other hostels. The reason? Swaziland never had segregation. Consequently, only a few Europeans have been allowed to live in the country.

One day, in the bright afternoon sun, I took a two-hour hike to the main camp where most visitors stay. It was unusual to be allowed to walk inside a game reserve. But since it had no dangerous lions, it was considered safe. Our only restriction was to be off the path by 6:00 PM when the animals come out to graze.

The scenery along the way was spectacular: mountains on one side and slopping hills on the other. I walked in grass fields, through forests and over rocks, protruding out of the red soil. It was wonderful being alone and spotting animals as I strolled along. I saw impalas, ostriches, baboons and vervet monkeys.

About half way on the trail, I found a serene-looking lake, and on a tiny island I spotted a crocodile lying by a tree. Deciding to get closer

for a photo, I left the path and walked on the road. Shortly, I noticed a "bigger and better 'croc'" basking in the sunshine at the water's edge.

I had heard that crocodiles were dangerous because they can run fast in spite of their short, stubby legs. Nevertheless, the temptation to get nearer overwhelmed me.

Ignoring the risk, I slowly tiptoed up behind the "croc" hoping it wouldn't notice me. It was one of those times when I knew I was doing something wrong but kept doing it anyway. When I was within 15 feet of the crocodile, I snapped a picture and ran back to the road as fast as I could. Luckily the lazy creature didn't even twitch an eyelid.

Later I realized how foolish I had been. In hurrying back to the trail, I noticed a sign that I'd missed. It stated, "Passengers are not allowed out of their cars!" No wonder all the drivers stared at me as they drove by!

The main camp was full of tents and cabins. I sat in an open-air restaurant that faced a pond. Here I watched hippos bobbing up and down in the water. They are amazing creatures. Even though they spend half of their life in the water, they can't even swim. They simply walk on the bottom of the lake or river, feeding on the vegetation. Statistically, they are Africa's most dangerous animals. Either they tip over boats or attack people without warning when they feed along the shore at night.

MOZAMBIQUE
Part 10

August: Seventh Week

While staying at the Sondzela Lodge, most of the guests I met were scooting off to Mozambique--once the vacation spot for white southern Africans. Since it was only about five hours away, I couldn't resist not going.

I bought my visa in Mbabane, the capital, and took the Grasshopper Bus back to Manzini. From here, I rode in an uncomfortable, crowded minibuses, actually the most convenient way to go from Swaziland.

As we rode along, we saw African women selling their fruits and vegetables from roadside stands, exactly like I had seen 40 years ago

when I lived in the Sudan. It was comforting to know a part of Africa hadn't changed.

When we arrived in Maputo, the capital, the minibus driver drove me right to the gate of Fatima's hostel--the only backpacking one in the city. It was a shabby, dirty, noisy place but did have an attractive patio with tropical plants. At least here, I met fellow travelers who advised me what to visit.

Maputo had a Latin flavor: people spoke Portuguese and espresso stands and sidewalk cafes were everywhere. In spite of its relaxed ambiance, though, the city looked like it was hobbling on one leg. It had dusty streets, rundown buildings and sidewalks filled with holes. It certainly didn't resemble South Africa's capital.

To understand why the city appeared so poor, it helps to know about Mozambique's long history of war:

First, the people had to fight for their independence from the Portuguese. In 1962, Mondlane--who had an American wife-- organized the Frelimos, a guerrilla army that was supported partly by the Russians and the Chinese. This army overthrew the Portuguese government and in 1975 won independence. Samora Machel of the Frelimo party then became president. Hooked on Marxist ideology, he abolished private ownership and nationalized everything, even putting the farmers in communes.

Other countries like Portugal, South Africa, and Zimbabwe were unhappy about this communist government, so they supported a rebel group, called the Renamos. As a result, the new Mozambique government had to fight another guerrilla war. IT LASTED 17 YEARS. When the Frelimos (the good guys) built schools, the Renamos would blow them up. Because of all this destruction and the fact that communism wasn't working, the country's economy was soon in shambles.

Unfortunately, in 1986 President Samora Rachel was killed in an airplane crash (President Mandela recently married his widow). Consequently Chissano became the leader. Quickly, he dumped communism and changed the country to a market economy. Not until 1992, did the civil war finally end. With help from the UN, the government held elections in 1994. The Frelimos won and Chissano is again the president.

After all these years of war, it's amazing that Maputo still survives.

When I complained about the lack of buses, the broken sidewalks and having to change money on the black market at the local tobacco store, people would say, "You should have seen this town before!" Their descriptions of the past were grim.

In spite of all this, I enjoyed sightseeing in Maputo. In the daytime, I walked to the elaborate, refurbished Polano hotel that faced the Indian Ocean--a monument to colonialism; I investigated the run-down railroad station designed by Eiffel which had one train a day; I visited the revolutionary museum, where I was their only visitor and spent hours at the fabulous art museum. The Mozambicans are noted for their skill in carving wooden sculptures and painting modern art with vibrant colors and bold designs.

The evenings I spent sitting in sidewalk cafés. Here I ate sumptuous plates of seafood while bargaining with table-hopping vendors for souvenirs as well as for cashew nuts, which are grown here.

My trip to Mozambique was a short trip, but I was glad I had the chance to see another African country.

SOUTH AFRICA
Part 11

South Africa: Nelspruit, Hazyview and Kruger National Park
August: Seventh Week

To be have been in South Africa and not seen Kruger Park--the largest game reserve in Africa--seemed like visiting Paris without a trip to the Eiffel Tower. So, instead of traveling up the coast of Mozambique to join some young Australian surfers I had met, I headed back across the border and arranged a safari.

I landed at a hostel in Nelspruit, where the manager booked me on the 4 by 4 Tent Safari Tour out of Hazyview, about an hour away. The tour left from the Kruger Park Backpacker's Hostel, a rustic place with real African ambiance.

After one night there, I left early the next morning at 5:30 AM on the safari. My companions were two young, good-looking Frenchmen from Paris (lucky again).

Lloyd, our driver and guide, was a young white South African with a special love for wildlife. For two days he drove the three of us around in a RED AND WHITE, home-made-looking Safari truck. It was so unusual that when people weren't taking pictures of the animals, they were taking pictures of us.

I still smile when I think about it. It was a converted pick-up truck, built with imagination. Completely enclosed by windows, the square shell sat high on top of a truck-bed and extended over the cab. We loved towering over everything on the road--except the giraffes. It fact, we could stand up inside and wave to people from the front windows much like the Pope does in parades. Even our seats were unique. They were discarded airline seats.

When we reached Kruger Park at 6:00 AM, we entered by the Numbi gate, one of seven entrances. The entire 200 mile-long reserve is surrounded by a fence to keep the poachers out and the animals in.

As we cruised along that morning in the soft, pale light, Lloyd suddenly shouted from below, "Be on the look out for rhinoceros."

"Are we in rhino territory already?" We yelled back, impressed with our guide's expertise.

"Maybe," Lloyd answered. "The piles of dung on the road mean one is nearby." Then laughing, he added, "Rhinos mark their territory with their droppings."

We kept our eyes pealed on the landscape. Shortly, an enormous rhino--as big and solid as a tank--appeared by the road. We were thrilled. Rhino's are one of "the big five" that everyone wants to see and already we'd seen one of them. The others are elephants, lions, buffaloes and leopards. Personally, I like the lofty giraffes the best.

Our next exciting encounter involved baboons. While inching along on the road (speed limit is 30km) we noticed an OPEN safari-van coming toward us. All of a sudden a baboon jumped on a woman's lap and snatched her handbag! At once the van driver stopped and dashed out after it. From our top window, we could see a troop of treacherous looking baboons standing by a tree ready to attack. The van driver, being a fearless soul, completely ignored them and relentlessly chased

the thief, at last grabbing back the stolen handbag. We were impressed with the driver's bravery. I guess the other baboons were, too. They didn't even budge.

Imagine how happy the woman must have felt to see her belongings again. She was probably spared an embarrassing trip to the embassy, where she might have had to admit, "A baboon stole my passport!"

By ten o'clock that morning, we arrived at the gated Szukuza rest camp, one of eighteen in the park. It was a miniature town with huts, cottages, a bank, souvenir shop, grocery store, cafeteria, post office, museum and tourist center that listed the latest lion sightings.

In a shaded picnic area, Lloyd whipped up some breakfast. He cooked some tasty fried potatoes and a spicy omelet on a gas barbecue, provided by an attendant. There were also large urns of boiling water for everyone's use. I was impressed with the modern facilities.

In the Szukuza camping area we set up our tents and spent the rest of the day driving around sighting animals. We saw elephants, hippos and crocodiles at a river; a cheetah--the swiftest animal on earth--walking down a path; some ugly hyenas devouring bones and hundreds of impalas darting around. The roads were well marked, but we had to be careful to be off of them by 6:00 PM, otherwise we would be fined.

The second day of our safari was even more thrilling than the first. As we were driving along, we came across rows and rows of cars lined up on the road, indicating something special was happening. We parked our safari truck, and to our delight, spotted a pride of lions (one male and four females) lying by a bush near us. Then, gradually on the other side of the road, herds of wildebeest, impalas and zebras wandered onto the open field to graze on the grass.

With so many animals in one place, it looked like a Hollywood production.

The lions, seeing the possibility for an easy meal, slowly got up and wove their way across the road, hiding behind the cars. As the other animals sensed their approach, they became nervous, especially the giraffes with the best view.

Once the lions reached the other side, a real drama exploded. Suddenly, in unison, at least two hundred animals thundered across the road to our side. The mass exodus was an awesome sight. But the

herds didn't stay long. The lions returned to their bush beside our truck, so the other animals stormed back to their original grazing area.

After a short pause the lions tried again, this time sneaking more discretely across the road and concealing themselves in the bushes. We watched in suspense. Suddenly, a lion, running as fast as it could, darted out after one of the Zebras. Immediately, the herds rushed to our side of the road a second time. When the lion realized it didn't have a chance to catch the zebra, it immediately stopped the chase and casually turned around. You'd think that with so many animals to choose from, it could have at least caught one. Being a predator obviously is not an easy life.

We wanted to stay for the finale but after an hour of this spectacle, left to find a rest camp where we could cook our breakfast. Lloyd told us this was the most exciting hunt he'd ever encountered. We felt fortunate to have seen it.

That afternoon we returned to Szukuza camp to fold up our tents. Then, before leaving Kruger Park, we followed isolated gravel roads in order to look for leopards lying up in the trees. Unfortunately, we didn't find any, but in the two days we saw four of the "big five" and a total of 41 different kinds of animals and birds.

Truly, it was a great safari.

SOUTH AFRICA, ZIMBABWE AND ZAMBIA
Part 12

Pretoria, Victoria Falls & Livingstone
August: Eighth & Ninth Week

After visiting Kruger Park, I jumped back on the Grasshopper bus and rode to Pretoria, a city steeped in history. Having been the capital for three different governments: the Dutch (called Boers or Afrikaners), the British and now the Africans, it overflowed with historical sites.

To understand Pretoria it helps to examine South Africa's past. Basically, it's a history about the conflict between the Dutch (Boers) and the British. Since the time of colonizing (between 1648 and 1820), the two of them have argued about land and laws. To escape the dissention, the Boers (Dutch farmers) left the Cape (southern area) in 1830 and began their Great Trek north in search of land and freedom. Like

our westward bound pioneers, they traveled in ox-drawn wagons--but instead of fighting Indians--they fought the Africans, mainly the Zulus and the Besothos.

These "religious, cattle-farming" Boers settled in the north in the region near Pretoria, called the Transvaal. They didn't have peace for long, though. In 1881, the Boer Republic fought their first war against the British. The Boers won and founded the South African Republic, called ZAR. Pretoria became their capital and Paul Kruger their president. Much like President Lincoln, he had only a few years of formal education and was a strong leader.

In 1899 another war broke out. Diamonds and gold were discovered in the Boer's area, (1869 and 1871 respectively) so now the British wanted control of the Transvaal. This time the British won the battles and governed for the next 50 years.

Later every thing changed again but without a war. In 1948 a national election was held and the Afrikaner's (Boer's) National Party won. As a result, the government switched back to the Boers, and for the next 46 years they ruled, making the national language Afrikaans, a hybrid of Dutch and apartheid (racial segregation) the law of the land.

Only recently did the Africans get their chance to run their own country. In 1994, for the first time, they were allowed to vote. Since they make up 76% of the country's population, their party, the ANC (African National Congress), won the election. Now, South Africa has a black government and a black African president.

From this short view of the past, you can see why Pretoria has been the center stage of the country's history and why interesting monuments are everywhere.

From Pretoria I took a two hour flight to Victoria Falls, one of the great natural wonders of the world.

At the airport I caught a local bus into the town of Victoria Falls, where I walked to the Town Council Rest camp, recommended by The Lonely Planet Guide on Africa. Not only did it have a campground but rented modestly priced chalets for about $17 a night.

After plopping down my heavy backpack (too many souvenirs) in the camp's office, I stepped up to the reservation desk. "I'd like a chalet for one," I announced, feeling weary from the oppressive heat.

Without looking up from her desk, the receptionist barked, "We're all booked up."

I felt crushed. It was one of those frustrating moments in traveling when I didn't have a clue what to do next. I had a "plan B", but I didn't like either of my choices: go to a hostel outside of town with only dorms, no singles, or to an expensive hotel.

Feeling too hungry and exhausted to move, I hung around the office for a while wishing my indecisive mood would vanish. Finally, an idea popped into my head. In my kindest voice, I walked up to the receptionist and asked when she thought a chalet would be available.

Her response stunned me. "You can have chalet 31 NOW."

I'll never know what changed her mind. Maybe she felt my desperation. Anyway, it was the best news I could have had. I loved my chalet. It was a small, one-room house surrounded by beautiful lawns and trees. Though the showers and toilet were in another building, I didn't mind.

That afternoon, I walked to Victoria Falls, originally discovered in 1855 by Dr. Livingstone, a Scottish missionary. Their immense size was overwhelming. (two times higher than Niagara Falls). Tons of rushing water crashed down into a deep gorge, causing a deafening roar, and a rainbow hung in the surrounding mist. Nature seemed truly at her best. Seeing such magnificence was unforgettable. The Africans call the Falls "the smoke that thunders".

For several hours, I strolled along the mile-long path facing the Falls, snapping pictures. Every view was breathtaking.

A few days later on a rented bicycle I pedaled to Zambia for another view of the Falls. It was a short trip, just over the bridge on the Zambezi River with a couple of custom stops. Here I found the Falls equally impressive: enormous torrents of water rushing over the craggy cliffs, falling into the deep, narrow chasm.

From here I was looking forward to cycling in Zambia to the next town, called Livingstone, only 12 miles away. But all the park rangers--as well as the souvenir vendors—- didn't think it was a good idea. "There may be robbers along the way," they warned me.

Not wanting to encounter possible danger, I reluctantly parked my bike and headed for a taxi. Just as I got near, it filled up with people and left. Then I waited for a bus. As soon as I climbed on, it had a flat tire.

With no bike, no taxi, no bus and no luck, I decided to stand along the road and wave down one of the few passing cars. Finally, an open safari jeep screeched to a halt, and the African driver and his European lady passenger offered me a ride. Grateful to escape the sizzling heat, I climbed in.

Farther down the road, we picked up another passenger--this time, a tall, young Zambian man in his twenties, named Oliver. As we got acquainted, he told me his job was traveling back and forth to South Africa in order to bring back manufactured goods. He was a pleasant fellow. When I got off at the Livingstone museum, he volunteered to accompany me. I was glad he did. From his explanations, I learned a lot about Zambia: it has nine million inhabitants, got its independence from the British as early as 1964 and because there is no longer a market for its copper, has a poor economy.

Later Oliver and I walked into the center of Livingstone--a dusty, drowsy looking town with shabby merchandise in the shops. I felt a sense of poverty hanging in the air.

In a small café we stopped for a lunch of chicken pies and rice, and later Oliver accompanied me to the bus station. By four o'clock, I was back at the border--safe and sound--and pleased with my day's adventure.

There was so much to see and do in Victoria Fall, I stayed a whole week: It had elegant dining at first class hotels, an evening tribal dance program, a craft village showing huts from different tribes, a sunset cruise on the Zambezi River, a crocodile farm, a game reserve, and attractive souvenir shops with many wood carving and more. Of all these activities, though, I liked my cycling along the Zambezi River best.

One morning, under a teal blue sky, I pedaled along on a shaded path at the river's edge, stopping frequently under palm trees to soak up the lush beauty. Quiet and calm, the Zambezi River reminded me of the Nile, by whose banks I once lived.

At the end of the scenic three-mile trail, something happened that scared me to death. Suddenly I heard branches crackling. I looked up at the trees and saw two huge elephants standing next to my path, about 25 feet away. I froze. My knees began to shake. Would they feel threatened by an innocent biker and attack? Or were they used to

seeing a cyclist in their territory and ignore me. I waited breathlessly. I could hear my heart pounding loudly in my chest. Then, to my relief, one slowly turned and sauntered down the path--fortunately not in my direction. The other elephant continued munching on leaves. After snapping a few pictures, I turned around and quickly disappeared. Needless to say, this encounter made my day!

ZIMBABWE AND BOTSWANA
Part 13

Okavango Delta.
September: Tenth Week

Since the Okavango Delta in Botswana is the largest inland delta in the world, I didn't want to miss seeing it. However, from Victoria Falls I couldn't figure out how to get there.

One travel agent recommended that I join a super expensive $400-a-day-tour, which I couldn't afford, of course. Other backpackers I met suggested I hitchhike or ride in an overland truck for three days, unappealing options to say the least. Even the reliable Lonely Planet Guide, my bible, never mentioned transportation between the two places. Still, I knew, there must be a way.

One day, while standing in line at the "Vic" Falls post office, I heard a customer mention that Botswana Airlines had a new flight to Maun, the town nearest the delta. Elated by the good news, I darted off to the airline office and quickly purchased a ticket. What a bargain! Only seventy-five dollars!

Next I needed to find a reasonable mokoro (African canoe) trip into the Delta. While I was waiting in the airport lounge for the plane to Botswana, I began asking the passengers about their delta plans from Maun. Luckily, through my inquires, I met Hans and Mark, two middle-aged Germans. They had made their Okavango reservations six months ago and knew just where to go. God bless German efficiency!

When we arrived in Maun, my new friends introduced me to their travel agent. I told her I wanted to be on the same trip as they were on. By short wave radio, she contacted the Oddball Lodge in the delta and

in a few hours everything was arranged, proof that no matter what, there's usually room for one more!

The next morning the three of us boarded a tiny bush plane with six other passengers. Our pilot, a pretty, young Australian woman, flew us low over the Okavango River (third longest in Africa). From a crystal clear, blue sky we had a panoramic view of meandering waterways crisscrossing the dry, flat plains--a fantastic sight, especially with animals roaming the shores. The herds of buffaloes looked like swarms of ants.

The Okavango River begins in Angola. It forms the delta by spreading its long fingers through miles and miles of grasslands, eventually disappearing into the greedy sands of the Kalahari Desert. The Africans call the Okavango "a river that never finds the sea."

After forty minutes in the air, we skidded to a spine-jolting stop on an airstrip (term used loosely—more like a bumpy field). The "well-heeled" passengers walked only a few yards to the posh Delta Lodge at the river's edge while we backpackers, with heavy loads, hiked with a guide for twenty minutes under the scorching mid-day sun.

The Oddball lodge sat high up on stilts, facing the calm Okavango River, a perfect location. From its large wooden veranda we could sit for hours and watch a variety of wildlife: elephants crossing the river, hippos bobbing up and down, impalas jumping and sprinting along the river's banks.

The owner, Peter was a tall, slender, forty-ish man with unusual, piercing green eyes. His friendly manner made us feel instantly at ease. First, he lectured to us about being careful of the wild animals roaming around the camp and next assigned us to individual tents scattered among the trees. Each one sat on a wooden platform and was equipped with mattresses and sleeping bags.

Later, I understood Peter's warning. While in the washroom taking a shower, I heard a strange noise, as if someone were shaking trees. When I went out to investigate, I could hardly believe my eyes. Just a few feet away stood an enormous elephant munching on palm nuts he had knocked on the ground.

Joining the other spectators, I followed the elephant around the camp which shook every palm tree it could fine. When it had exhausted the supply of nuts, it performed a most amazing feat. Placing its long trunk vertically along the trunk of a towering tree, it gave one big push.

With a loud crash, the tree came tumbling down, fortunately missing a nearby tent. Now, without having to reach up so high, the elephant could easily tear off the leaves of the branches lying on the ground. "It's a frequent visitor to our camp," Peter commented, apparently unconcerned about his uprooted tree.

The following morning Hans, Mark and I began our delta trip. I had one mokoro, a narrow, dugout canoe, and they had another. Maiketso (I called him Mike) was my poler and guide. While he loaded our tents, sleeping bags and cooking equipment into our boat, I bought our canned food and bottled water from Oddball's store.

For three hours Mike poled me along in the Delta's shallow water. Standing up in the back, he lifted his ten-foot pole back and forth with the slow, graceful motion of a gondolier. We eased along through streams, lakes, canals, lagoons and ponds of water lilies. It was a marvelous trip. I felt like Cleopatra being chauffeured down the Nile.

Our polers, when possible, stayed close to shore, just in case hippos or crocodiles were lurking underneath the water, scheming to capsize our mokoros.

One time, while threading our way through a field of tall reeds, a loud splash suddenly ripped the stillness. In a clearing just ahead, we saw two buffaloes' mean, suspicious eyes staring at us. Our polers stopped instantly, and quietly backed up our makoros. They appeared to be as scared as I was. No one uttered a sound. Would the animals attack us? We waited to see. At last, after tense moments, they realized we were not a threat and slowly disappeared among the reeds.

Flirting with danger is one of Africa's attractions! It makes good photos, too!

After we found a suitable island, we docked along side it and set up our tents underneath a large, shady tree. It was a wonderful campsite, right in the heart of Africa's raw wilderness--savage and untamed. Across from our camp, on the other side of a marsh, we could see herds of impala gathering from time to time to graze. As soon as we moved or talked, though, they'd disappear.

I loved the nighttime in the bush. In the darkness and under a ceiling of sparkling stars, Africa spoke to me in another voice. Nocturnal sounds pierced the deep, immense silence, and the air filled with a symphony of exotic sounds. I was both excited and frightened at the same time. Did

the roars, grunts and screeches mean that the animals were far or near? And was I safe inside a canvas tent? Mike assured me that our all-night-fire would scare wildlife away. I prayed he was right!!!!!

Twice a day, in the early morning dawn and before dusk fell, Mike (unarmed) would take me on a two-to-three hour walking safari into the vast open plains dotted with trees. It was an immense thrill spotting the animals as we strolled along. But, unlike in a vehicle, we could never get close to them. Our scent, movement and noise scared them away.

From Mike, I learned many things about the bush. He taught me how to scan the tawny grasslands for the camouflaged creatures and how to recognize their footprints and droppings. One time, pointing at footprints the size of a large pancake, he observed, "Those from angry elephant."

"How do you know he's angry?" I asked curiously.

"It has baby."

Another time, after seeing a family of giraffes, I mentioned that they were my favorite animals. "What are yours?" I inquired.

His response astounded me. "I hate wild animals. They just for tourists," he complained bitterly. "Government spends too much on game parks. I want cows. I can support family with cows."

Being a tourist, I was sorry to hear this.

After three days in these peaceful surroundings, Mike poled me back to the Oddball Lodge. I stayed a while longer in the camp, wishing I never had to leave

NAMBIA AND SOUTH AFRICA
Part 14

Windhoek, Swakopmund, & sand dunes
Johannesburg, Soweto
September: Eleventh Week

All the tourists and backpackers I met raved about Namibia. After discovering it sat on Botswana's doorstep, I squeezed it in to my itinerary.

From Maun, I flew directly to Windhoek, Namibia's capital of 161,000 inhabitants. Sitting on a flat, arid plain, its tall buildings extended like fingers into the sky.

Lining its main street stood half-timbered storefronts, a clock tower, Wiener schnitzel and bratwurst restaurants and shops where only German was spoken. It was hard to believe I was still in Africa.

This German influence seeped into the country when the European nations began their untamed colonizing of the world. In the late 1800's Germany grabbed Namibia, then called South West Africa. But it didn't rule the country for long. After World War 1 the League of Nations gave it to South Africa. Not until 1984 did Namibia's one and a half million inhabitants win their independence. Even today, you can feel touches of South Africa's presence. They still use its rand as currency.

While in Namibia, I wanted to see Sossusvlei's ever shifting sand dunes, known to be the highest in the world. Since no public transport was available, I joined a tour from Swakopmund, a town on the foggy Atlantic Ocean below the wild skeleton coast. From Windhoek (windy corner) I took a four-hour bus trip across a dry, barren desert to reach the coast.

In Swakopmund I stayed at municipal rest camp. My small bungalow had a kitchen and bath. It wasn't anything fancy but a real bargain for $17 a night and only four blocks from the ocean.

The town was definitely a tourist's resort with all its attractions: palm lined beaches, decorated buildings with colorful, ornate facades and turrets, a new aquarium, a historical museum, a fishing pier, seaside promenades, outside cafes and elegant hotels. Even Michael Jackson and other American celebrities have stayed in them.

The next morning I joined a tour to the dunes. My fellow travelers were young couples from Italy, England, Holland and Austria, and our young driver and guide, Ursala, was from Namibia. I admired her a lot. Not only was she a good organizer and cook but also knew how to repair our van when it broke down. Her efficient, Germanic manner kept us all in line. No one dared be late!

Our first stop that morning was at Walvis Bay to see a bird sanctuary. Here thousands of beautiful pink Flamingos stood motionless in a large blue lagoon--an unforgettable sight. Afterwards we turned inland and for the next five hours jostled along on a rutted, gravel road. All

the passengers, being from crowded Europe, were enthralled with the endless space and the harsh desert landscape. As for me, I felt I had never left California.

That night we pitched our sturdy canvas tents in the Namib Desert campground. Then the following morning at 5:00 A.M.--still half asleep--we piled into the van for a two-hour drive to Sossusvlei. Then, from the parking area we walked in the clear, fresh air to the bottom of the dunes, a three-mile hike.

Climbing up the dunes was much more difficult than I had anticipated. To reach the top of the first one, we had to crawl in the deep, fine sand on our hands and knees. Once on a ridge, it was slightly easier to trudge along as long as we followed in someone's footprints and didn't fall off the narrow edge; otherwise, we had the unpleasant task of crawling back up again.

We stopped frequently to catch our breath and admire the magnificent views. A sea of pinkish, brown dunes extended before us as far as we could see. Then as the sun climbed higher in the sky, the landscape turned a gorgeous apricot shade.

For two hours we labored with every step until we reached the summit of the highest dune, about 1000 feet high. From here, exhausted but exhilarated, we gazed at even more extensive, spectacular views.

I feared that our descent would be another struggle, but it turned out to be a "blast". Barefooted, we ran down the steep mountain of sand, feeling free like a bird. It didn't matter if we fell into the deep sand; it was as soft as feathers.

At the bottom sat a dried-up lakebed, called a pan. Its white, cracked crust dotted with dead, black tree trunks, gave it an eerie, surrealistic look. Walking on its lifeless, moon-like surface made me feel I was on the edge of another reality. On the other side of the pan, we ascended more dunes, now a rich orange tint from the bright sunshine. This spectacular panorama took my breath away and so did climbing up more steep dunes.

Even though the entire hike was long and strenuous, the dramatic views we saw made it all worthwhile.

<div align="center">Johannesburg</div>

September Twelfth week

From Namibia I flew back to South Africa. I wanted to see Johannesburg even though I knew that it was the most dangerous city in the world and might be similar to stepping into a <u>minefield.</u> Nevertheless, I was willing to take a chance.

While at the airport, I phoned the highly recommended Ritz Backpacker's Hostel and, at no charge, they sent a driver to pick me up.

Fortunately, I landed in a safe, affluent suburb. All the neighbors on the street had mansions with private pools and tennis courts. Our hostel was equally impressive with stone towers, a large swimming pool and lush gardens encircled by tall trees. The estate had once belonged to a general who used it as a fortress during the Anglo-Boer war in 1899.

I wanted to see Johannesburg's downtown area. But when I asked the desk clerk how to get there, she exclaimed, "Do you want to be <u>killed!</u> There is nothing to see there anyway. All the hotels and shops have been closed."

Not wanting any messy encounter with death at this stage of my trip, I changed my plans and joined a tour to Soweto, a town on the other side of the city where 5 million blacks live.

Soweto, I learned, has many sections. Our guide led us first through the poorest area, a shantytown with dilapidated shacks, crowded closely together along narrow, smelly, dirt paths. Here the Africans live in abominable conditions with only public pit toilets, no inside electricity and no running water except for a few outside water facets. It was depressing to see "life" in the grips of such hopeless poverty.

Later, we passed through other Soweto neighborhoods. Some had small, individual houses, but surrounded by only dirt--no lawns, trees or flowers--they looked poor, too.

At the end of our tour, we passed by larger houses, like the ones of former President Mandela, now a museum, and the present home of Winnie Mandela.

My intentions were to stay five days in Johannesburg but having "traveler's burnout", I left a few days early for London. While waiting for my plane to the States, I spent a few days with my Canadian and English friends, Teresa and Tony. In retrospect, this was a poor decision.

London turned out to be <u>even</u> <u>more</u> <u>dangerous</u> than Africa. While there, I was hit on the head with a FLOWERPOT.

Was I walking under the wrong window? Not at all.

All I was doing was sitting in my friends' apartment in the WRONG chair. It happened to be next to a six feet tall bookcase where a flowerpot was holding up some books on the top shelf. While putting an atlas back on the top shelf, Teresa accidentally knocked over the books and down came the flowerpot on top of my head. It's Only suppose to happen in movies, right?

SECTION TWO: BACKPACKING

ITINERARY OF MY MIDDLE EAST TRIP: 2000

TURKEY

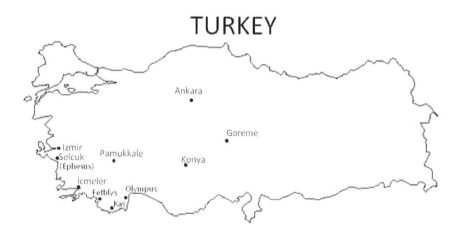

Places I visited

TURKEY: Ankara, Goreme & Konya, Olympos, Kas, Fethiye,
Marmaris, Icmeler, Selcuk,
Pamukkale
ISRAEL: Tel Aviv, Jaffa, & Jerusalem , PALESTINE: Giza , EGYPT:
Cairo & TUNISIA.

JOURNAL EXCERPTS

Part 1

Ankara

My Middle East trip began in Turkey. Since I'd already seen Istanbul several times I flew directly to Ankara, the capital.

My first adventure began at the airport. I piled into a bus headed for the city and soon discovered that none of the passengers spoke English or any of the other languages I knew. What was worse, no one had every heard of the Engen Hotel where I planned to stay. Without a clue of where to get off, I just kept circling the city and Ataturk's statue until I was the only one left on the bus.

Finally, the driver stopped and pointed to the door. I got the hint. Grabbing my heavy backpack, I climbed down with no idea where I was. All I could see were the surrounding brown fields and a nearby three story, concrete building. Only later I learned that the central bus station was on the ground floor.

Weary from my 16 hour flight, I reminded myself that the first day of a trip is the toughest. "It's bound to get better," I mumbled.

Wishing a taxi -- or anyone for that matter-- would rescue me, I waited by the curb. After a while an old sedan drove up; luckily, it was a taxi. I showed the driver the name of the Engen Hotel. Nodding, he indicated that he knew EXACTLY where it was.

"How much will it cost?" I inquired cautiously. Without one word, he simply pointed to the meter. Assuming that everything was under control, I opened the door and sat down.

As we cruised through the city, with the meter ticking away, familiar monuments popped up, like the equestrian statue of Ataturk sitting high on his bronze horse directly in the middle of a roundabout.

Was I on another city tour? I wondered anxiously.

Soon we turned onto the busy, six-lane-Ataturk *Bulvari* (Boulevard). Suddenly, the driver, ignoring the cars behind, stopped in the middle of the lane and pointed to the door. Not again. I thought. I could see no hotel in sight--only fancy shops and streams of pedestrians walking on the sidewalk.

While horns blasted and motorists shouted angry words--that luckily I couldn't understand--a lengthy sign-language session ensued between the driver and me. I got the idea that somewhere in the vicinity sat my hotel. Since it was situated on a one-way street, he motioned I'd have to walk. I only prayed this didn't mean I would end up at the bus station again.

The taximeter indicated that I owed thousands of Turkish lira (there were 500.000 to one dollar). I handed over a stack of bills with so many zeros on them that it looked like I was paying the national debt. But instead of being pleased, the driver shook his head and shoved them back into my hand.

What's up? I wondered, thoroughly confused. Hadn't the driver already driven me all over town--instead of taking a direct route? And now he wanted extra money? What nerve!

As horns honked louder and the traffic jam behind us grew in size, all I wanted to do was escape. Finally, like in a game of cards, I spread out all the money I had exchanged—a hundred dollar's worth---and said sarcastically, "O.K, it's your turn, you choose!" Watching millions of lire disappear from my hand made my heart sink. "Weren't things supposed to get better?" I grumbled, watching the taxi disappeared.

Only later did I understand what actually happened. Since taximeters don't show all the zeros (because there are too many), it was quite possible that the driver hadn't over charged me at all. Who knows? Nonetheless, it was an expensive taxi ride--about 26$.

For a while, I wandered around looking for my hotel. The taxi driver was right. It was on a narrow, one way street and difficult to find.

The Engen Hotel was a friendly place with a large, curbside terrace. Every morning I sat there for a Turkish type breakfast of tea, crinkly black, bitter olives, salty goat cheese, crisp toast and sometimes a hard-boiled egg and tomato slices. Ugh! I would have preferred Turkish coffee, but it's usually drunk after a main meal and not for breakfast.

The following day I planned to rest and recuperate from jet lag. But since I couldn't sleep, I got up and rode a bus to one of Ankara's famous sights: the Museum of Antolian Civilizations. Here I learned about Turkey's long, historical past. The displays began with the Hittites--who had a few "run-ins" with the Egyptians around 2000 BC--and were followed by relics from a string of other civilizations like the Persians, the Greeks, the Romans, the Byzantines, the Seljuk's and the Ottomans. Turkey, having been the main stage for so many civilizations, has ancient ruins everywhere.

From the museum, I hiked up the hill. Behind a tall, thick stonewall stood the *hizar* (fortress) built by the Byzantines in about 600 AD. While strolling through the cobblestone streets, I discovered an elegant, terrace restaurant, overlooking red-roofed houses and the surrounding hills. Usually, I don't eat in expensive restaurants, but feeling travel weary, I decided to treat myself.

"I'll just have an eggplant salad (*Patlikan*)," I said to the waiter, wanting something Turkish to eat.

When it came, though, it didn't resemble a salad at all.

"What's that?" I asked, pointing to a glob of beige-colored puree on my plate.

"*Patlikan.*" Then he motioned for the headwaiter to come and explain in English, that, without a lettuce leaf, it really was a "salad".

It had a strong garlic flavor and with the help of plenty of toast and mineral water, I finish most of it. Since *Patlikan* is on every Turkish menu, I was glad I tried it at least once.

The next tourist sight I visited was Ataturk's mausoleum, a huge rectangular monument with square columns, guarded by high stepping soldiers dressed in blue and white uniforms. It was extremely impressive and gave me the feeling of the greatness of Ataturk, known as the father of the nation.

After WW1 and the demise of the Ottoman Empire, Ataturk saved the country from being carved up by the Western nations. He fought courageously against the allies and renegotiated the treaties. Then, in 1923, he established the Turkish Republic.

While President for about fifteen years, Ataturk accomplished many important things: he separated the government from religion, removing Islam as the State religion; replaced the Arabic alphabet with a modified

Latin one so people could read more easily; adopted a constitution which gave women the right to vote and lastly required everyone to take a last name.

Some problems, though, still exist between the orthodox Muslims and the government. In *The Turkish Daily News,* an English language newspaper, I read that one afternoon some strict, orthodox Islamic women harassed and threw things at women employees as they were leaving the ministry of education after work. Why? "Because their arms were uncovered!"

I stayed in Ankara for three days. Then--by direct route, this time— returned to the bus station to catch a bus to Gorme an area with unusual formations in Cappadocia.

TURKEY
Part 2

Goreme & Konya in Cappadocia

On the way endless stretches of golden brown wheat fields flashed by my window as the bus rolled along a deserted, two lane highway. It was a pleasant four-hour trip with superb service: all the way a smiling, young boy poured perfumed water into my hands and brought me free drinks and snacks.

When the bus reached Nevsehir, a van was waiting to take a Japanese man in his 50's, and me to Goreme, a village of weird-shaped columns of tufa (soft porous stone) caused by the eruptions thousands of years ago of three distant volcanoes.

I had hoped that the Japanese passenger would know of a good pension in Goreme, but all he had was the same list as I from the *Lonely Planet Guide.* Our driver, a kind soul who understood our dilemma, volunteered to drive us around and look for one. I wanted to stay in a pension with "cave rooms" hacked out of tufa. However, when I tried one and saw how musty they smelled, I changed my mind.

Finally, we settled for rooms at the SOS Pension. It proved to be a good choice. Nestled against a hill at the end of the village, it had a wonderful, whitewashed terrace that overlooked a valley of exotic shaped pinnacles, formed by hardened ash that had been eroded by

wind, rain and rocks. If boulders were sitting on top of them, they were called "fairy chimneys".

I liked my small, roof top room. It was covered with deep crimson, oriental carpets on the walls, floor and bed--so comfortable it was like being in a lover's arms. And from my window I had a million dollar view. I gazed upon a dramatic lunar landscape of strange tufa formations, all for fifteen dollars a night!

My days in Goreme were leisurely and quiet. After the blazing sunrays seeped from the sky, I would stroll in the late afternoon through green valleys hidden among the mushroom-like columns where peasant women were digging in vegetables plots or picking grape leaves for an evening meal--their donkeys tied nearby.

Later, in the evening's balmy air, I'd saunter to the small village with other pension guests. From an open-air restaurant we'd watch farmers returning in their donkey-drawn carts from their fields and listen to the prayer calls from loud speakers of nearby mosques.

After a couple of beers, we ordered dinner. It always began with an appetizer (*meze*) that we selected from a glass case near the kitchen. My favorite one was stuffed eggplant; called *iman beijiter* and translated "the monk fainted" because it tasted so sumptuous. For our second course we usually had fish or shish kebab. Turkish cuisine I found delicious.

Goreme, though only a farming community, was invaded daily by busloads of tourists. They came to see its famous Open Air Museum, an area of hundreds of concealed churches and monasteries carved out of tufa cliffs. To avoid being slaughtered by the Romans and later the Muslims, the early Christians hid inside them. Some of the churches from the 7th, 8th and 9th centuries had interiors covered with Byzantine frescos that depicted Christ's life and miracles. The newly restored one were exquisite.

The area around Goreme also had many interesting sites. The main ones I visited on an organized tour. First, we stopped at the underground city of Derinkuju where people lived off and on for over 2000 years, hiding from invaders or religious persecutors. Because the volcanic soil was soft, they were able to dig down as far as 80 feet or eight layers. Inside a labyrinth of small rooms were airshafts, wells, tunnels and even

a winery. "Boozng it up" may be the secret of their survival in such dark, austere conditions.

At another stop on our tour, we saw a restored *Caravanerai*, sort of an 800-year-old Motel Six where camel herders could pull in for a safe night. Behind its high, thick walls and majestic carved portal were all the comforts a camel herder could dream of, except maybe swirling belly dancers. It had barns, dormitories, canteens and even a two-storied, square-shaped mosque for prayers. Along the old Turkish trade routes, other *caravanserais* ruins can still be seen. They were usually about 40 kilometers apart, a day's camel ride, if all went well.

It was hard to leave the sleepy, little village of Goreme and its extraordinary tufa scenery. But after five days, I hopped on a bus again to visit Konya. I wanted to see the capital of the powerful Seljuk civilization, of the 12th & 13th centuries, and the burial place of Rumi, a revered mystical poet who began the whirling dervishes.

I learned about Rumi (called Mevlana in Turkey) from my Afghanistan and Iranian friends that I met at Divers Cove in Laguna Beach. While lying in the warm sand, they used to read to me Rumi's poems; so ethereal they'd send me spinning on the edge of reality for hours.

Upon my arrival in Konya, I headed directly for Rumi's mausoleum. By wearing a borrowed smock and removing my shoes, I was allowed to enter. The interior was gorgeous. Every inch, from floor to ceiling, was decorated with rich red and gold arabesques symbols and the top of Rumi's coffin was covered by a thick velvet shroud of gold embroidery and a symbolic turban. Like the other visitors on their pilgrimage, I kneeled in front of the great sage's tomb. Then, while praying, something magical happened: a deep sense of peace descended over me which made me feel that I was in a truly holy place.

Konya, in addition to its religious importance, was filled with many ancient Seljuk ruins and mosques. In spite of this, few foreign visitors were around. In fact, I seemed to be the only one. I wasn't lonely, though. The ubiquitous carpet vendors kept me company.

They were easy to meet, always standing in front of their open-faced shops luring me inside with offers of hot apple tea. Sometimes they were pushy fellows, but usually entertaining: One played his guitar while his friend danced a Turkish jig; another explained to me Konya's history

and the third told me about his trip through Bulgaria on the way to his shop in Milan. "I used to drive through Yugoslavia," he explained, "but now with the trouble in Kosovo, it's too dangerous."

Of all the shopkeepers I met, Kamil was my favorite. A stocky, middle-aged man, whose deep black eyes pleaded for romance. He enticed me "among his carpets" with a dinner invitation. While serving me pizza (*etli ekmek*a) and a yogurt drink (*ayran)*, his assistant laid out carpet after carpet at my feet. They were beautiful, but I admirably resisted handing over my visa card. Instead, I steered our conversation to stories about Kamil's life. He told his mother was a strict Muslim who always wore a long coat and scarf in public, his uncle taught him the carpet business and he had an arranged marriage.

"Why was that?" I inquired curiously, thinking he had the stamp of a modern European man.

"It was the easiest way to find a bride," he answered. "Besides, I thought my Mother's judgment was the best."

How I wish my sons felt that way!

TURKEY
Part 3

Olympus

When I flew into Turkey, I never intended to go to Olympus, but all the tourists I met raved about it. "You'll love the beach there," they exclaimed. "And you can stay in a tree house at the Orange Pension. It's only four dollars a night, including breakfast and dinner."

The more I heard about this bargain, the more intrigued I became.

"How do I get there?" I finally asked.

"Just take a bus from Antalya and ask the driver to drop you off along the road near Olympus. You'll *probably* find a van waiting to take you to the Pension."

The word "probably" bothered me. "What about an address or phone number?"

"Oh, you won't need that. Everyone knows where the Orange Pension is."

The beautiful beach in Oympus where I stayed

The famous Celsus library built in the 2 nd Century AD in Ephesus.

These vague directions worried me, of course, but I couldn't resist a resort that sounded like paradise. Besides, I was use to sacrificing security for adventure. So, instead of heading for the Aegean Sea as I had planned, I hopped on a bus for the Mediterranean.

The six-hour ride from Konya took me past serene, sapphire-blue lakes and pine-covered mountains. None of the passengers, however, knew a word of English. I managed, though, because I discovered a few Turks spoke German. They had gone to German schools when their parents worked in Germany as *gastarbeiters* (guest workers) after the Second World War. In fact, I used to have some Turkish students in my classes when I taught in Germany. What an interesting surprise!

After we pulled into Antalya, I transferred to a small bus that supposedly passed by the road to Olympos, or at least that's what I understood from a ticket vendor who only spoke Turkish.

Sitting on the bus were two other tourists: a young Chinese girl from Singapore named Joyce and her English boyfriend, David, a cyclist who had just ridden his bike all the way from India to Turkey. Imagine! They were also camping on the beach at Olympos and confirmed its spectacular beauty.

"What's the Orange Pension like?" I asked, thinking they'd know where it was.

"The what?" They responded with surprise. "We've never heard of it."

A pang of disappointment shot through me like an arrow. How was that possible?

Didn't everyone know about the Orange Pension?

"We get off near Cirali," David added. "Maybe your stop is further down the road."

With dusk seeping from the sky and fearing I might become stranded, I wasn't about to find out. So when Joyce and David got off the bus, I joined them. (I didn't know the name of the place I was suppose to get off anyway.) "I'll look for the Orange Pension once I arrive," I said, consoling myself.

According to David, A taxi was supposed to be waiting on the road at Cirali to take us 13 km to the beach. But none was in sight. Without a choice we began hitchhiking.

Night crept around us as we waved at passing cars. At last, a driver in a Mercedes picked us up. In broken English, he explained that his motel was only part way down the road, which meant we'd have to walk the rest of the way to the beach.

Under an ink black sky, we trudged along the remaining kilometers, stopping occasionally to ask if anyone had heard of the Orange Pension. "No" was always the answer.

Resigned to my fate and ignoring my surge of disillusion, I checked in at the Yavuz Pension, a comfortable place that served a copious Turkish breakfast.

The next morning I hurried to the beach. After one glance, I understood why my friends had raved about Olympus. It was a breathtaking beach. The blue Mediterranean sparkled in the fresh morning sunlight and a quiet serene feeling hung in the air. Green carpeted mountains rose majestically in the background and at the end of the crescent shaped bay rocky cliffs jetted into the water.

For a while, I strolled happily along the pebbled beach (also a reserve for sea turtles) and-believe it or not- I finally met another tourist who actually knew where the Orange Pension was. "Go to the end of the beach," he explained, "and follow a path inland for about a mile. You can't miss it."

Excited about the news, I rushed to the trail. It led me through the Olympus National Park, an area filled with ancient tombs and aqueducts from a Lycian city (2 BC) and a Roman settlement (1AD). Then the path edged along the banks of a stream through a narrow, rocky gorge lined with thick verdure, leading to a shady open café under a clump of trees. The Orange Pension, at last!

Sitting at tables were hippy type people chatting with friends or writing letters while others lounged in hammocks nearby. A feeling of "anything goes" permeated the air. After I located an empty table I sat down and ordered a cup of apple tea.

Shortly, a young, chubby Japanese girl joined me. "I love this place," she bubbled excitedly. "It's my second time here." Her name was Kamara, and she worked in L.A, making commercials for TV stations in Japan. "The Japanese like to see beautiful, blond girls on California beaches," she explained.

Later Kamara showed me her tree house, a primitive, one room, wooden shack, built on stilts snuggled among orange trees. A ladder lead to her front veranda. It would have been a novel place to stay, but I liked the Yavuz Pension near the sea and didn't want the trouble of moving.

For five days, I lounged around the tranquil beach at Olympus, swimming in the salty Mediterranean, reading books under thatch-roof umbrellas and dining in the beachside cafes with my new-made friends.

Everyday I postponed my departure. I couldn't imagine ever finding such an idyllic place again. Besides, I dreaded hitchhiking back to the main highway and waiting for a bus that had no schedule.

To my surprise, though, my departure day turned out to be terrific.

It began at the local store café. Here I sat waving at all the passing cars on the narrow, dirt road. Finally, a motel owner offered to take me to the main highway. After a long wait in the boiling midday sun, a shinny, green sedan screeched to a stop beside me.

"Where are you going?" a young man with black bushy hair, shouted.

"To Kas"

"Hop in! We're going there, too."

Without hesitating, I slung my backpack into the back seat and sat down in his luxurious, air-conditioned car with Turkish folk music oozing out of the stereo. "My name is Junet," he announced, "and this is my wife, Eepak. We're on our honeymoon from Ankara."

Junet, a journalist, was a super- kind of guy--fun and free-spirited. He stopped and investigated all the tourist sites along the way and picked up anyone who needed a ride.

Our first stop was at Myra where we saw a large, impressive Roman amphitheater and some Lycian rock tombs which resembled small houses, carved into the hillside..

Next, we visited the 3rd century church of St. Nicolas, built in honor of a Byzantine monk, named St. Nicolas, famous for giving presents to children and the needy. Who'd ever imagine that our Santa Claus legend originated in Turkey!

Later, we picked up a fisherman. Following his recommendation, we drove an extra 25 km to a quaint fishing village just for a fresh fish lunch. Then, afterwards, we hired a large private yacht (big enough for 30 people) for a delightful cruise around Kekova Island to see the Lycian's sunken city and have a refreshing swim in the clear blue water.

As twilight faded, we arrived in Kas where Junet stopped at a cliff-side hotel to look for rooms and to bargain for a good price. I had already watched him bargain for the biggest fish in the restaurant and the largest yacht in the harbor. Now, he began haggling with the desk clerk, next with the manager and lastly with the owner. Watching everyone stand around, you'd think Junet was trying to buy the hotel.

But thanks to his expertise, I had a great room with a beautiful view of the surrounding hills and islands of the Mediterranean--all for twelve dollars a night including two sumptuous meals a day. Kas was another idyllic place.

TURKEY
Part 4

Kas, Fethiye, Marmaris, Icmeler, Selcuk & Pamukkale

Kas, a village steeped in quiet beauty, was known as the pearl of the Mediterranean. Green hills framed its island-filled bay and chalky white cliffs lined the water's edge.

Staying in Kas was so wonderful I felt that life's worries were put on hold. Daily in the warm sunshine, I'd lounge on one of the cliff-side terraces. Then I'd swim in the cool, refreshing water, enjoy snacks and drinks served by an attentive waiter and chat with friendly lounge-chair neighbors: an elderly couple from Germany and a pretty flight attendant from Istanbul.

After dinner, my ideal life continued. In the evening's warm, velvety air, I'd take a stroll to the main square and browse in its artistic shops. My favorite one sold handicrafts and peasant jewelry from Turkmenistan, a country across the Caspian Sea and formally a part of the Soviet Union. Once, while I was trying on a heavy peasant, silver necklace, the supply merchant arrived from this country. He was a short, dark skinned man

with a round face and slanting eyes. I would have liked to talk to him about life in Turkmenistan, but no one could translate for me. I had heard from two Peace Corps Volunteers stationed there that the country had not wanted its independence. But since it was so poor, the Soviet Union wouldn't allow it to remain in their union. I wondered if that were true.

My next bus stop along the Mediterranean was Fethiye, a small port about three hours away. It was an easy trip. Most of the time the driver and I were the only ones on the bus. The difficult part was finding a place to stay once I arrived. First, I took a taxi to the Ideal Pension. However, it turned out to be anything but *ideal.* With its tiny, funky rooms, its dusty outdoor, rooftop lounge and creepy manager, it was the last word in discomfort and I knew I couldn't stay there, so I walked toward the harbor and found a suitable two star hotel, called the Otel Dedeoglu. Here I had an air-conditioned room with breakfast, a TV and a view of the boats coming and going--all for only seven dollars a night. A real bargain!

The shortage of tourists in Turkey had brought down the prices. Because of the political situation, many Europeans had cancelled their trips. Ocalen, the "top dog" of the Kurds, had landed in prison. Defiantly, he announced that if he were condemned to death--which happened after my arrival--he'd have his terrorists bomb the "hell" out of the tourist resorts. A reasonable threat to scare cautious tourists away, right? Being courageous or stupid, I ignored the travel warnings. This was something I had done once before…and survived. In l987, right after the Chernobyl nuclear disaster, I traveled to the Soviet Union. I took the Trans Siberian Express from Beijing, China and had a fabulous trip! With only a few passengers on board, I practically had the entire first-class car--and the attendants—all to myself!

This time, by ignoring Ocalen's bully tactics, I was enjoying a bargain-priced vacation. Anyway, flirting with a little danger always adds excitement to the adventure.

While in Fethiye, I took the famous twelve-island boat trip. We cruised the entire day among small islands, stopping in picturesque, sandy coves for relaxing swims. Usually we moored next to luxurious, chartered yachts that tourists leased to sail around the coast from Mamaris to Antalya. I would have liked to have taken one of these

weeklong cruises. Unfortunately, though, I was always headed in the opposite direction.

After Fethiye, I left the Mediterranean Sea to visit the scenic Aegean coast. I knew the famous resort of Mamaris would be expensive, so I planned to stay in a neighboring town.

"You'll love Icmeler!" my friends exclaimed. "It's a small resort and really beautiful."

In Mamaris, after visiting its immense covered bazaar and hilltop fortress, I jumped into a water-taxi for a twenty-minute ride across the picturesque bay.

As we pulled into the Icmeler's harbor nestled below the mountains, I couldn't believe my eyes. It wasn't a small resort at all. Its shores were lined with at least fifty super costly hotels and rows upon rows of yellow umbrellas and white plastic lounge chairs.

Dazed and disappointed, I stood motionless on the pier. A fellow passenger, noticing my state of shock, asked what hotel I was looking for.

"I don't have a cue," I replied. "I'm an 'unpackaged' tourist."

My answer probably surprised him. Most visitors in Turkey are on arranged tours.

I couldn't afford to stay in a large, high-priced hotel. Not knowing what to do, I wandered down to the beach. On the sand, I found some scarf-covered, peasant ladies renting beach chairs and selling fruit. Feeling hungry, I bought one of their succulent peaches and then using sign language, indicated that I would like to leave my heavy backpack with them for a while. With friendly smiles, they agreed.

Before hotel hunting, I stopped at a café for a quick snack—food always improves my unhappy moods. Afterwards, I walked through the side streets until I finally found a moderate-sized hotel. Using my new bargaining skills, the ones I learned from Junet in Kas, I haggled about the price. After a lengthy discussion with the manager and desk clerk, I got a front-balcony room for a reasonable price. I know Junet would have been proud of me.

I stayed in Icmeler for four days and eventually came to like the busy resort. While swimming, I made friends with two young English girls who were so madly in love with two Turkish men that I wished I were young again, too. One boyfriend was a cute waiter in a local cafe and

the other a handsome veterinarian who told me a lot about his life in Istanbul. He said his mother wanted him to have an arranged marriage, but he preferred English girls. "Turkish women are too restricted," he complained.

After Icmeler I left the coast and took a bus inland to Selcuk. I wanted to visit Ephesus, the world's best-preserved Roman city and the former capital of their Asia Minor province. It was only 3 km from Seljuk

In spite of the blazing sun, I spent hours wandering around its ancient Roman ruins. I saw the huge 25,000-seat theater where St. Paul lectured to the Ephesians to mend their errant ways, the marble street lined with pillars that led to the harbor and the magnificent Celsus library which was built in the 2nd century AD by the son of the Julius Celsus, the governor of Asia Minor.

Decorated with friezes and statues, the library also had two rows of Corinthian, marble columns which were so perfectly proportioned that just looking at them, gave me a sense of beauty and harmony. No wonder the library's picture is on the cover of most Turkish brochures.

In addition to these Roman ruins, Selcuk also had famous Christian sites. One was the remains of the Basilica of St John, built in honor of John the apostle who lived here while writing his Gospel. The other was the house where Virgin Mary died. St. John brought her to Turkey after the death of Jesus. From visiting these places, I realized, for the first time, the important role Turkey has played in history of Christianity.

TURKEY
Part 5

Pamukkale

Before leaving Turkey I wanted to see Pamukkale's dazzling white limestone pools advertised in every travel folder. Since they were near Selcuk, where I had been staying, I jumped in a tourist van, and in less than three hours I arrived.

By walking around Pamukkale, I found a small, <u>yellow</u> pension, called the Weisse Berg (<u>white</u> mountain) where I found a room. For a while I lounged around its shady pool until the sweltering heat subsided.

Then about five o'clock, I started my hike up to the white limestone hill outside the village that looked like a ski slope sitting in a green field.

When I reached the terraced pools, once formed by calcium deposits from volcanic springs, I felt as if I were looking at an imaginary landscape. The pale blue water in the snow-white basins glistened in the sunlight. It was breathtakingly beautiful.

Though I enjoyed my hike up to these scenic pools, it was difficult. Nobody was allowed to step inside them where the surface was smooth, or to wear shoes. We were required to stay only along their rough edges. When my feet began to scream with pain, I'd ignore the rules and put on my shoes or wade in the pool's warm, shallow water. If an inconspicuous guard saw me, he'd blow his shrill whistle, embarrassing to be singled out.

At the top of a 400-foot plateau was another special sight: the ruins of an ancient city called the Hieropolis, built about 1800 years ago. The Romans were excellent city planners: they had placed this temple right next to hot, bubbling mineral springs. I strolled past its huge, square stone pillars to the adjacent municipal spa, once called the Sacred Pond. Just like Cleopatra, who was rumored to have bathed here, I floated in my bathing suit in its knee-high thermal pools. Unlike in her times, the marble columns were no longer decorating the pool's edge. They were on the bottom in fragments, scratching my feet. Repeated earthquakes had tumbled them down.

After a few days of enjoying thermal swims and home cooked meals at the Weisse Berg, I rode the bus directly to Izmir to catch a plane to Isreal. I had been in Turkey a month and felt sad to leave. I knew I'd miss many things, especially its friendly people and beautiful beaches.

ISREAL
Part 6

Izmir, Tel Aviv, Jaffa & Jerusalem

My flight to Tel Aviv from Izmir was late. For hours I sat in a crowded waiting room, listening to Turkish announcements I couldn't understand. Finally, I got tired of not knowing what was going on, so

I walked over to a group of people and spoke to one of the large, gray haired women.

"Do you speak English?" I inquired politely. She smiled and shook her head.

Since I used to be a foreign language teacher, I tried again. "*Sprechen Sie Deutch*? I asked. Another shake of the head.

Next I questioned if she knew French. The same negative response.

Even though I was "batting zero", just for fun I continued. "*Habla espanol*? To my utter amazement, she replied, "*Si*". Was I shocked!

Even though her pronunciation was different from mine, we could converse together. I learned that she lived in Israel and came to Turkey to see her relatives and tour the Black Sea. When I asked how she knew Spanish (known as Ladino), she patiently gave me a history lesson:

"My ancestors came from Spain. Then during the inquisition in 1492 (that's when the all Jews were expelled) they immigrated to Izmir, Turkey I'm what you call a sephardic Jew,"

I found it amazing, that after so many years, her main language was still Spanish and not Turkish or Hebrew.

On the plane we sat next to one another, and when I was ready to give my snack tray back to the flight attendant, she did an amusing thing: She took my unused salt and pepper packages and handed them to me. "You may need these," she said in Spanish. I appreciated her motherly interest but wondered if her frugality was an inborn Jewish trait.

It was about eight o'clock when we arrived in Tel Aviv. After fighting my way through crowds and customs, I went to the reservations office to ask for help. Having heard that Isreal was more expensive than the States, I wanted to avoid landing in a high-priced, ocean front hotel.

A lady at the counter listened to my request and phoned many places, but at such a late hour everything was full.

"What should I do?" I asked, feeling I was about to sink in the murky waters of despair.

She thought a moment. "I guess you'll have to stay in Jaffa."

"Where's that?"

"On the outskirts of Tel Aviv." Then she phoned the Jaffa Hostel, and they had one room left for forty dollars "You're lucky," she said "You'll like it there. You might even have an ocean view."

Afterwards she showed me an ad in a booklet that said, "Our Jaffa Hostel offers you the most romantic, beautiful rooms in Tel Aviv." I hoped that was true!

After a long and complicated bus ride to Jaffa, I wasn't prepared for what I was about to experience: When I climbed into a taxi, it took me through the worst looking slums, I have ever seen: Narrow, dark streets were lined with dilapidated buildings, trash heaps were piled waist high and alley cats darted in and out of them. Without streetlights it looked like the perfect hangout for hooded gangsters Even though I thrive on adventure, this time I felt I had crossed over the line. I was flirting with danger and felt scared.

We stopped in front of an old, rundown three-story building. For fear of being mugged, I rang the bell as quickly as possible. The door creaked open. Inside, I discovered a dingy entrance where plaster was pealing off the unpainted walls and grimy, threadbare carpets covered the stairway. I tried <u>not</u> to 'freak-out', reminding myself that unpleasant situations sometimes turn out O.K--a "dime store" philosophy perhaps, but it usually works.

When I climbed up to the third floor, a pretty, young African receptionist greeted me. I felt better for a moment until I saw the room. It was so small it looked like a closet, and there was no outside window, only a small opening onto a stuffy hallway.

"I can't stay there," I complained in a disturbed voice.

She looked disappointed. "Well, you can always sleep outside on the roof."

From the expression on my face, she knew that was an unacceptable solution. Then she thought a moment. "If the people who reserved room 31 don't arrive by eleven, you can stay there."

I examined room 31. It looked shabby, but at least it had a fan, a window and a balcony. With a weary sigh, I threw my backpack in the corner and stepped into the hallway to wash my hands.

Just then a nice looking man in his 40's walked by. "How do you stand this place?" I asked, wanting to share my disappointment.

He smiled. "That's exactly what my wife said last night when we arrived. We made our reservations from Germany over the Internet, and by looking at their website we expected to find a romantic get-away."

We both laughed. I liked his sense of humor and we continued talking. I learned he came from Ireland and was teaching English near Frankfort.

When I mentioned that I would like to get something to eat, he suggested going out to a *falafel* stand. "Come and meet my wife. Maybe she'd like to go with us."

Betty, who was from Uganda, was lying on the balcony too tired and hot to move, but Paul, their teenaged son, agreed to go.

That night, after eating delicious *falafel* sandwiches (made of garbanzo beans) the three of us strolled along the beach, joking about our "romantic, ocean front rooms". By the time I returned to the hostel, my spirits had improved, especially after hearing that room 31 was mine!

ISREAL
Part 7

Jaffa, Tel Aviv, & Jerusalem

Since I arrived at the Jaffa Hostel after midnight, I was looking forward to a long, peaceful sleep. But it didn't happen. About 5:00 a.m. I heard motors roaring, brakes screeching, people shouting. "What's going on?" I barked, angrily. Half asleep, I staggered to the balcony to investigate. Below, from a jumble of trucks, vans and horse-drawn carts, I saw men busily unloading everything imaginable: shabby sofas, used refrigerators, old tires, whatever. Just my luck! I exclaimed, "A 'bloody' flea market underneath my window!"

Too upset to go back to sleep, I stomped down to the kitchen to cook my simple breakfast of cereal, toast and tea. Since the Jaffa Hostel was a run-down, scruffy place, I expected to see guests with long, matted hair and earrings in their nostrils. However, that wasn't the case. Those sharing the small, basic kitchen were all interesting travelers from every corner of the globe. I met an Austrian doctor working in Brazil, a young Australian on a Middle East tour and an Irish journalist doing odd jobs

in Tel Aviv. Listening to their stories and travels was so fascinating; that I hung around the dining room for the entire morning.

Around noon I decided to examine the bustling flea market. Weaving in and out of parked trucks and piles of junk, I found a narrow lane, choked with colorful carpet vendors and glistening brass dealers. Then, pushing my way through a covered, crowed musty smelling alleyway, I discovered an exotic bazaar. On one side sat clothes merchants snuggled under their garments that hung from the ceiling, and on the other side silversmiths squatted on platforms in front of their jewelry. After browsing a bit, I bargained for some silver looking, engraved bracelets. Pleased with the reduced price, I bought two.

Later, I wandered down to Jaffa's small harbor, supposedly founded by Noah's eldest son and one of the world's oldest. Having been in operation for more than 4000 years, it attracted many conquerors on its shores: Phoenicians, Persians, Egyptians, and even courageous Napoleon. In spite of it's top-of-the-line historical past, the port looked unimpressive. It did, however, have a good view of Tel Aviv. In the distance I could see its wide, crescent bay rimmed by tall, luxury hotels. Like Rio De Janeiro, it boasted of being a metropolis with a beach.

On my second day in Jaffa, I caught a bus into Tel Aviv to the Egyptian Embassy. We passed dingy shops, a few open markets and section's of modern buildings. It seemed to be a sprawling, unplanned city. Too bad the expensive hotels had grabbed up all the beachfront real estate. If the city had faced the lovely blue Mediterranean, it would have been a more attractive place.

I had to leave my passport at the Egyptian Embassy for three hours for a visa, so I wandered down to the beach. Acting like a well-to-do guest, (I combed my hair) I stepped into the Hilton's five-star, air-conditioned lounge, in order to avoid the oppressive heat. As I was enjoying the comfort of a plush sofa, some rich American tourists and their Israeli relatives sat down near me. I couldn't help overhearing their conversation.

"The first place I think you should visit is Jaffa," the Israeli lady said, planning her guests' sightseeing tour. "I'm sure you'll like its old world charm, especially the flea market."

Flea market! I chuckled to myself--never imagining my tacky hostel was overlooking a tourist attraction! In fact, the whole neighborhood

around the Jaffa Hostel was so dingy and dirty, I thought I was staying on the wrong side of town!

After four days at the Jaffa Hostel, I left on an easy 50-minute bus ride to Jerusalem where I stayed inside the walled city of Old Jerusalem.

I loved its atmosphere. Every day I'd thread my way by foot through narrow, cobblestone alleys to one of the five religious quarters: In the Christian area, I saw the Church of the Holly Sepulchre, where Jesus was crucified and buried; in the Armenian part, I attended an orthodox catholic mass; and in the Temple Mount, a Muslim area, I visited the Dome of the Rock, an Islamic monument built around the stone where Abraham was willing to sacrifice his son.

Then, in the Jewish section I prayed at the women's side of the Western Wall, the only remains of their temple that was destroyed by the Romans in 70 AD. Being a pragmatist, I couldn't understand why the Jews insisted on worshiping at a wall, instead of forgetting the past and building a new temple in their own quarter. It's the power of religious tradition, I suppose.

Frequently stories appeared in the newspaper revealing this rigidity. For example the orthodox Jews, the ones dressed in black, believe that no one should drive a car on the Sabbath. When the unorthodox Jews, who disagree with this religious view. insist on driving near there these traditionalists block the road and throw stones. Often the police have to interfere. In Jerusalem it appears that the different Jewish Sects outside the walls have more difficulty living together than the various religious groups inside the Old City.

To visit Israel's other important sites, I took a couple day excursions. I saw Nazareth, the Sea of Galilee, the Jordan River, the Masada and the Dead Sea. Seeing how dry and barren Israel's landscape was—not even a bush or a weed growing in the desert soil—made me wonder how this bleak area could have ever been called the <u>Promised Land</u>.

One tour I missed altogether. One morning I was planning to catch a 7:00 o'clock bus so I hurried down to the hostel lobby at 6:30 a.m. And guess what? The front door was locked, and no one was at the reception desk. In panic, I rang a buzzer on the counter, almost loud enough to wake up the dead. Yet no desk clerk appeared. Then I knocked on the doors of a few sleeping guests. Still no results. Realizing I was about to

miss my bus, I woke up Andrea, a young American graduate student, sleeping on a couch in the hallway. She found a set of keys, but none fit. From all the commotion I made, a whole crew of sleepy guests gradually assembled in the lounge. While they were giving me suggestions—like using a fire escape that didn't exist—a young boy came down the stairs wearing his backpack.

"Where are you going?" we asked, chuckling.

"I'm leaving this place," he complained. "It's too noisy."

We apologized and told him to try again later when the door was unlocked. In disgust, he returned to his room.

When I realized that my hostage status was not going to change for a while, I began to relax. One guest, a minister from Singapore, made me a cup of coffee in the kitchen, and another whipped me up some breakfast. "This is the most community I have ever seen in this place," Andrea commented. She stayed here often while doing research for her thesis on the Palestinian plight.

Finally, about eight o'clock the mysterious desk clerk appeared; who had been comfortably sleeping in a vacant room upstairs. Upon seeing our gathering, his only remark was: "You should have told me you were leaving so early!"

Having to change my plans, that afternoon I joined Andrea on her field trip to a Palestinian settlement at Hebron. Together with a translator-guide, we took a *sherut* (shared taxi) through bleak hills to a refugee camp. First, we visited a family living in a simple concrete house, then walked through the dirt streets, followed by a string of cute, wide-eyed, barefooted children.

Later in a bare community room, we joined a meeting of the elders. Dressed like Arafat, with head coverings and long white gowns, they sat in a circle on the floor. For over an hour Andrea and I asked them questions about the Palestinian problem. They told us about losing their homes and land in the war and expressed bitterness about their poor living conditions. "We want equal rights with the Israelis," they kept repeating. "Now we pay taxes and have no power." They also felt that Arafat was not doing enough for them.

Missing my bus that morning turned out better than I anticipated. It gave me the chance to visit a Palestinian settlement that I had always wanted to see.

The Church of the Holy Sepulchre in Jerusalem built on the site of Jesus'
crucifixion.

The hostel in Israel where I stayed which faces an open market

EGYPT
Part 8

Jerusalem to Cairo & Tunesia

After Israel, my next destination was Tunisia. Since no planes flew directly from Tel Aviv I had to first travel to Egypt. The most interesting and cheapest way to go, I thought would be by bus through the Sinai Desert. This assumption, though, was definitely wrong. The long bus journey was so unpleasant that riding a camel or footing is like Moses would have been better.

All along we had delays: The 7:00 o'clock Mazada bus from Jerusalem left an hour late. Next we stopped in Tel Aviv for twenty minutes just to collect the driver's eight-year-old daughter who came along for the ride.

This shy, little girl sat in the front seat next to me. Her father, a friendly man with two missing front teeth, told me she was one of his eight children.

"Why so many?" I inquired curiously.

"God gave them to me and he'll take care of them," he answered. Then he boasted that he would soon take an additional wife. As a Muslim, he is allowed four.

I wondered if he thought the more children he had the richer he was. I know the Bedouins feel that way.

Our stops continued. Later we picked up two stern-looking soldiers carrying machine guns, who stomped through like generals to inspect our documents. When they carried my passport off the bus, I prayed they wouldn't accuse me of being a sneaky spy. In my travels this has happened twice: once in Iraq and another time in Russia. Both were frightening experiences I didn't want to repeat.

As we drove along our passport stops became more numerous. I never knew if they were random road checks or border formalities on the Gaza Strip,

Eventually we passed by a strange, deserted area that had so many rows of barbed wire it looked like we were entering a war zone. I think

we were near a border, because later we arrived in Rafah were we changed busses and drivers and had longer passport checks.

When we crossed over to the Egyptian side our border examination was even more thorough. Just to get through customs, the Palestinian couple in front of me had to stand in lines for three hours. The video tape they were carrying appeared to give them the most trouble.

At the Egyptian border station we seemed to get stuck. For hours we waited outside in the sweltering heat without even a waiting room or café nearby. No one knew when we would leave. I tried to find out from our driver before he went to sleep in the shade of the bus. Speaking only Arabic, he answered me by stretching his arms up and looking at the sky. I think he meant, "God only knows!"

Finally, about 2:30 p.m. our bus pulled out behind a string of five vans and four other buses. At that moment, I realized the reason for our delay: We were crossing the Sinai desert in a convoy. Two siren-screeching police cars escorted us, supposedly to scare off would-be attackers.

The scenery through the Sinai was bleak, barren and boring. Only occasionally we passed a Bedouin mud hut and some goats. Few people live here because of no water. The Egyptian government is trying to change this, though. They are building a narrow channel from the Suez Canal in hopes of transporting water and are also offering free land to new settlers.

About six thirty, just as the sun's orange ball of fire was dipping below the horizon, we arrived at the Suez Canal. There was nothing special to see here, just a wide ribbon of water between two sandy shores. All the big ships had already passed by earlier. Nevertheless, to ferry across the canal in the evening's balmy air was exciting.

As we neared Cairo the traffic became horrendous. For a distance of twelve kilometers, it took us over an hour. It seemed that there were only two traffic rules for this crowded highway: pass the car in front of you any way you can and constantly honk your horn. I wondered if they all stopped pretending that they were race car drivers and stayed in one lane, would they run into one another?

About ten thirty that night, we arrived in the center of Cairo. Instead of pulling into a bus station, the bus driver let us off on the edge of a congested roundabout with cars whizzing by.

I needed to find a hotel, so shared a taxi with a young Bulgarian doctor and his wife. We told our driver the address of a budget hotel, but he couldn't understand our English. In frustration, he eventually gave up and dumped us off on a busy, one way boulevard.

Exhausted and famished, we searched for budget hotels that had empty rooms. After an hour we ended up at the dumpy, fifth floor Claridge Hotel. The building's rickety, cage-like elevator looked like a suicide trap, so not trusting our fate, we climbed up the five flights of stairs, lugging our heavy backpacks.

Just like my trip, my room was the ultimate in discomfort. Not only was it dirty, hot and infested with bussing mosquitoes, but it had only one small window that opened onto a courtyard below where a TV blasted away. In spite of all this, I was glad to have a place to stay and eventually drifted off to sleep.

My next day in Cairo made up for this. I loved the city's pulsing life and historical sites. Having just spent two months in the Middle East, I was used to its confusing ways and also found Cairo less chaotic than on my previous trips here.

My plane to Tunisia left the following day so I crammed all my sightseeing into 24 hours. First I roamed through the noisy, bustling streets, fascinated by all the shops and people. Then I sat down in a coffee house filled mostly with men. I wanted to watch them smoke their *shishas* (water pipes with long hoses). Besides serving coffee, the waiter brought his customers the requested amount of tobacco for their pipes. Seeing the smokers' contented expressions made me wish I were daring enough to smoke one too.

Later, I taxied to Saludin Square in old Islamic Cairo. Here I gazed upon a group of beautiful, medieval mosques that made me feel I had stepped back in time. I entered two of them, built by Saludin in 1176. Then, before I began climbing up to the hilltop citadel, which once fortified the city against the crusaders, I stopped at a sidewalk café for a cup of mint tea. A man sitting in an adjacent table informed me that I had been walking in the wrong direction. Being a kind soul, he offered to drive me up the hill in his new Chinese-made truck used for delivering meat.

From this fortress, where Egypt's rulers lived for 700 years, a hazy panorama of Cairo stretched below: tall, slender minarets rose above

the houses and the slow moving Nile snaked slowly through the city. It was a spectacular view.

Inside the Citadel's sturdy wall stood many ancient mosques and monuments. The most impressive ones were a huge alabaster mosque and mausoleum built by Mohammed Ali in 1848. He was a famous warrior and the ruler who expelled the British from Egypt after Napoleon's occupation.

At closing time, I returned to the entrance to look for a taxi. A flock of drivers dove at me like seagulls fighting for a piece of bread. I selected the driver who spoke the best English and offered the best price.

As I sat down in his taxi, a poorly dressed vendor dumped a stack of colorful, Egyptian papyrus scrolls onto my lap. Thinking they wouldn't fit into my backpack, I told him I wasn't interested. Still he kept insisting and lowering his price. Unable to resist a good bargain, I finally bought three for only a dollar a piece.

Suddenly, out of nowhere, a plain-dressed man appeared on the scene. He grabbed the hawker by the neck and took him away. "What's going on?" I asked the driver.

"He's being arrested for harassing a tourist."

I felt sad. Maybe I was responsible.

After this incident, the driver took me to Giza for a quick glance of the pyramids and then to an ancient mosque to see an evening program of Sufi dancing. Men in long colorful skirts spun and whirled to the melodies of high-pitched flutes. It was a perfect way to end my stay in Cairo since the next day I flew to Tunisia and then home.

SECTION THREE

THAILAND & CHINA
1984-1989

A Thai village near Pattani

My Life

My backpacking summer trips stopped when I resigned from the Anaheim School District in 1984. Since my sons were in college and I was single, I joined Peace Corps and was sent to Pattani in Thailand. There, snug among the palm trees and buzzing mosquitoes, I taught English for one year at a university situated on a peninsula near the Malaysian border. My experiences were so unique, that I wrote about them. Below are excerpts from my book.

.

THAILAND
(Excerpts from: *Asian Adventure*)

POVERTY

No one could tell me how much my salary would be when I joined the Peace Corps. They simply said, "You'll earn the same as a Thai professor." Little did I know what that meant in a developing country.

It meant that: I had no telephone (it probably wouldn't have worked anyway); I rode on a rickety bike instead of in a nice car; I listened to the radio instead of looking at television; I found a bottle of beer a luxury; and even though the mosquitoes were gnawing at my legs, I could barely afford a can of mosquito repellant. In addition, any traveling was out of the question....well, unless I chose to go to one of those "inspirational" educational conferences, where everything was paid for. One weekend I found myself broke again and out of food. To tide me over until Monday (pay day), I needed the equivalent of seventy-five cents, enough for three eggs and some bananas—the cheapest food around, besides rice. I thought for awhile about my resources, consisting of a visa card which was only valid in Bangkok, and a good friend, Teresa, who had left for the weekend. Feeling trapped by my poverty, I groaned, "Just my lousy luck." Then it suddenly occurred to me that I had a handful of recently-bought postage stamps in my desk drawer. "I know, I'll go over to the campus post office and ask for a refund. My sons don't need to hear from me this week anyway." The postal clerk, being a friendly fellow, wouldn't mind helping me out, I thought. Pleased with my idea, I grabbed the stamps and headed for the door. Just as I was leaving the building, I met Howard, the white-haired Fulbright scholar whose big

salary and comfortable furniture were the envy of everyone, especially me.

"Hi, Martha," he said with a courtly smile, "What are you doing tonight?"

"Nothing, as usual."

"Well, what about dinner?" I knew Howard must be lonely to ask me out. Although he lived close by, we seldom saw one another. He probably thought I was too frivolous, and I considered him too serious. At that moment, though, my attitude got an instant overhaul.

"I'd love it," I answered, grinning happily. A large dinner was a much better solution than selling postage stamps, believe me.

"Ok, I'll pick you up at six." That evening we took a taxi into town and ate a delicious dinner at a Chinese restaurant. You should have seen ALL the food I ordered! Howard didn't say much....not until the waiter covered our entire table with a wide assortment of dishes. "I didn't know you could eat that much!" He observed tactfully. "I'm just breaking a FAST," I answered, exaggerating the truth. Later on our way home, my stomach began to ache, and the pain caused me to reflect on my life in the Peace Corps. "Why do we volunteers have to have the same standard of living as the local Thai people?" I wondered. "Wasn't POVERTY the cause of many of the world's problems? It certainly was the cause of mine!"

A FAST FOOD MECCA

In Thailand, delicious food is always within arms' reach. In fact, fast food is to Thailand what Greek architecture is to Athens.

Once in Bangkok, I consumed an entire meal while riding around on a bus. Here's how it happened. At my first bus stop, I munched on some mouth-watering squid roasted on a sidewalk charcoal brazier. Later, when I transferred buses, I slurped down, from a curbside stand, a bowl of steaming hot noodles sprinkled with chopped peanuts. And before I reached my destination, the fabulous temple, Wat Phra Keo, I relished two luscious desserts: a creamy coconut pudding with sweet mangos slices on top and crispy fried bananas sprinkled with sugar. "Food is cheaper and better from the food stalls," some of my friends told me, "so we seldom cook." And it seemed to be true. Succulent odors

of barbecued meat assault you from every corner. You simply step out of your house, and a vendor is there waiting to stir up your favorite dish, often noodles or rice mixed with vegetables, roasted meat and spices. If you take your stir-fried delicacy home, the vendor hands it to you in a clear plastic bag (the kind we carry gold fish in) and tightly seals it with a rubber band. Could a hot meal be easier to enjoy? No shopping. No cooking. No dish washing. And inexpensive, too!

No matter where you are in Thailand, eating appears to be the national pastime. And just like Americans talk about sports, the Thais chat about food. For example, one afternoon our English Department Faculty arranged an outing for us to a Buddhist Monastery. Before the bus departed, our leader happily announced that we'd have *two snack* stops. "We can't miss the specialties along the way," she said. This news threw everyone into ecstasy except me. Consequently, by the time we arrived at the monastery, the sun was about to set and the doors were about to close. From our quick fifteen-minute-visit I had time to snap only one colored slide!

Another unique Thai custom is the way villages and towns convert their busy, morning market places into night restaurants. In the balmy evening air, food vendors wheel in decorated stalls, converting the square into a pleasant place to meet friends and share an inexpensive meal. Upon arriving, the first thing you do is stroll around and look at all your choices. Roasted meat, fish and corn are always available as well as delicious seasonal specialties. After deciding on your menu, you return to the stalls and place your order. Then, while sitting at a plastic-covered table in the middle of the square, pretty young girls deliver your food--all freshly cooked to your specifications.

Usually it's a gourmet's delight, unless, of course, you find it too spicy. You see, the Thai's love to cook with chilies. I must admit, it took me a lengthy period of suffering, before I discovered, how to handle them. By accident, I found that the "little rascals" were color coded. In green bean dishes, they sneaked in green chilies; in tomato dishes, they hid red chilies and in the succulent yellow-looking curries, they were completely camouflaged. With these rules in mind, I usually had no trouble avoiding them.

However, if I ate a chili by mistake, I simply put out the "fire" with a gulp of beer or Thai whiskey, called Mekong which came in

The beach I discovered near Pattani that was within biking distance, where I used to go swimming.

The fishing village next to Pattani.

several varieties. Usually, I bought the cheap kind. If mixed with something else, it tasted just like the expensive brand. Even the quality of headache was the same! Bang or sky water (made from sugar cane) was another variety of cheap alcohol. Being illegal, though, it was hard to find. Only the peasants in the countryside had a good supply, and to avoid the police, they were very careful--and clever--how they sold it. My friend, Charon, bought his bang in a large, red metal can with the words "gasoline" written on the outside. In my opinion, it tasted about the same! Regardless of my skimpy salary, I avoided drinking it-- its putrid odor made me sick. Charon told me, "If you're drunk enough, the smell won't bother you!" In closing, I might mention, that Thailand's ubiquitous food vendors, though much loved, are a serious problem for the government. Just like weeds in a well-cared-for garden, they continually pop up everywhere, often avoiding regulations and license fees. In the *Bangkok Post*, I frequently saw amusing warnings. One read: "No more food stalls allowed around gas stations. The fire department had too many calls." Another one told the vendors to stay out of Bangkok traffic jams. "Your trays of roasted chicken are making them worse." But the funniest one of all announced, "Food vendors on the Bangkok Freeway to be eliminated--too many serious accidents in the fast lane!"

Well, what do you think? Is it possible to change a beloved national custom with a simple regulation? I hope not!

I CAN'T HEAR THE TONES

I really should have learned Thai while suffering through Peace Corps' language training, but I couldn't remember the vocabulary. Imagine, the first sentences they taught us were, "The blue block is next to the red block and the yellow block is under the green block." (Or was it vice versa?) Anyway, we weren't allowed to use books; we had only *Lego Blocks*. Yes, that's correct, *Lego Blocks*.

This method was called the "The Silent Way". And, as far as I'm concerned, all it did was to keep me "silent". Without being allowed to write anything down, I couldn't remember the words.

What made matters worse was that our teacher spoke to us only in Thai. "It's complete immersion," he explained. He was right. I felt as if I were drowning!

After several weeks of such medieval language lessons, you won't believe what happened next.

Someone drove me in a rickety bus out to a one-shop village and left me with a large Thai family for two long weeks. What was the reason? So I could try out my *new* language skills! You'd think, for this on-the-spot-experience, some thoughtful soul might have handed me a dictionary. Hardly. I was given a mosquito net, instead. Though extremely useful, it didn't benefit my language-learning one bit. Village living, I must confess, taught me many things that I'm sure I'll long remember. It taught me, for instance, how a monk is ordained (we partied for two days), how a body is cremated at a funeral (we listened to beating drums for two days) and, most important, how to get a good night's sleep with a buffalo under the house banging against the pillars. It was simple: I just dreamed I was experiencing a California earthquake. Oh, and I almost forgot, it taught me one more thing: how it feels to be deaf and dumb--an experience I wouldn't wish on my closest enemy. Not being able to communicate in strange surroundings was extremely painful. In the Thai family, only the eighty year old grandmother befriended me. She was partially deaf and had no front teeth, so we had the same problem, both of us had trouble talking. When I finished my three months language course, I attempted to learn Thai by a more modern method. I bought a BOOK. Again, though, I had a vocabulary problem. In the first chapter the sentences they gave me to memorize were, "The buffalo is bigger than the cow, (Or was it the cow is smaller than the buffalo? I've forgotten) and, "How many grains of sand do you see?" The answer, surprisingly enough was six. For me, though, it was none if I didn't have my contact lenses on. Imagine trying to converse with such sentences!

My second book caused me a vocabulary problem, too. It was given to me by a pretty Mormon missionary before she returned to the States. You'll never guess what my first sentence was this time, "Do you want to be saved?" I suspect, even if I had found a proper book somewhere in Thailand, I still might not have mastered the language. The five different tones were too difficult for me to distinguish. Every time I memorized

a word, I had to remember which tone belonged to which syllable. For instance, *mai mai* means, "New silk doesn't burn." or, "Does new wood burn?" depending on the tone you give each word.

At least, by using the wrong tones, I now have some amusing stories to tell: During Peace Corps training, I stayed in a hotel in Nakon Nayok. My room was number nine. Every time I asked for my key the desk clerk either handed me the wrong one or burst out laughing. You'd think, being a foreign language teacher for fifteen years and having learned many languages in my round-the-world travels, I might have mastered one simple word. But I couldn't. I finally ended up just showing nine fingers when I wanted my key. Luckily, I wasn't in room twelve! The word "University" was another one I couldn't pronounce properly. This inconvenienced me even more. If I were down town in Pattani and told a taxi driver, "Take me to the University, please," he'd just look confused and wouldn't budge. Unless I found someone on the street to translate for me, I was stranded. In the end, I gave up and wore my University pin if I left the campus. Just when I thought I was making progress with the tones, something usually happened to discourage me again.

One time I stepped into a general store to buy coffee. I didn't come out with coffee, though. I came out with envelopes! This is how it happened. Before I could say, "I'd like some coffee, please," the attentive saleslady asked me a question. I thought she inquired: "What do you do in Pattani?" So I answered: "I teach English at Songkhla University." With that reply, she handed me a package of envelopes. Feeling confused, I bought them and quickly left. Later, I discussed this episode with Nikul, my colleague, and he explained that the word "to teach" and "to send" is only a tone apart. Another embarrassing incident occurred in a restaurant while I was eating dinner. I ordered a bottle of soda water, and what do you think the waitress brought me? A bottle of smelly fish sauce. The funniest conversation I ever heard of, though, happened to my friend, Joan. She was talking to a Thai friend and mentioned that her male colleague had two children. The words she used were not only in the wrong order but in the wrong tones. What Joan really said was: "My colleague has two balls." When her Thai friend looked surprised and inquired how she knew, she answered seriously, "Because he showed them to me in his living room."

Thank goodness, Thai isn't the language they use in the Security Council!

BRING ON THE VEGETABLES

Two or three times a week, I bought my fresh vegetables from a plump Chinese lady named Ma Da Yen. She displayed her produce on top of a long, shady table beside the University co-op. Usually, I bought just lettuce, tomatoes and onions because that's all I recognized. One day I decided to make some fish soup that required a variety of vegetables. Since none of them were available at Ma Da Yen's stand, I asked for substitutes. Her first suggestion was: "Would you like *f---k tom*?"

"What?" I asked in surprise, not sure I had heard correctly.

"Do you want *f--k tom*?" she repeated seriously. I paused for a moment, reflecting on my boring social life in Pattani and trying to imagine what it would be like."O.K., I'll go for it," I announced, anxious to see what she would produce. Handing me a long, pale green squash.

"Six *baht*, please."

Well, that figures. I wondered what she'll ask me next? Sure enough she topped my expectations.

"Do you want a *pr--k*?" she inquired

"A *pr—k!*" I exclaimed. Wow, was buying vegetables fun! I wondered what the Thais thought that was?

"Sure, I'll take one...or maybe two, if it is what I think it is," I answered, grinning hopefully. This time Ma Da Yen grabbed a couple of long chilies and threw them into my bag."Chilies! Well, that does it!" Before I could snatch my bag, she caught my arm and began insisting I buy some of her *boo doo*.

I shall *never* forget the first time I smelled *boo doo*. It was on a sunny morning near a small fishing village. I was cycling down a dirt road towards the beach where I sometimes swam. There, among the palm trees, four women, clad in colorful batik skirts, were dipping out a murky, rancid-smelling liquid from cement tubs and pouring it into large plastic bags. While holding my breath, I stopped to inquire what the pungent odor was.

"*Boo doo*," they replied.

"*Boo doo*?" That meant nothing to me. I asked more questions but couldn't understand their explanation. Later, after returning from my bike ride, I stopped by Charon's apartment below to ask him what *boo doo* was.

"It smells like fish fertilizer," I commented. He laughed.

"It's a sauce we eat with rice."

"You've got to be kidding!" I exclaimed. "How can anyone eat such smelly stuff?"

"You ought to try it," he smiled. "It's delicious."

That day the more I refused Ma Da Yen's *boo doo* sauce, the more she insisted. "It's special," she kept saying, "You'll like it."

Not wanting to seem rude, I quickly paid and left. After I got home and spread out all the strange looking vegetables on my sink, I realized that I didn't know what to do with them. Should I chop them, slice them, grate them, or just peel them? And how much should I use? I wanted to skip back and ask Ma Da Yen. But I lacked the courage. I was afraid she might make me buy some of her stinky *boo doo* sauce.

CULTURE SHOCK

Here's a letter I wrote to my sons but *never* mailed. I feared they might think I was hallucinating and not telling the truth. Dear Sons, I don't want you to think I'm unhappy and not adjusting, but things have gotten worse here in Pattani. Listen to this! The brown rat with the long tail, the one that has been running wildly around the bathroom, gnawed a hole in my kitchen screen last night and ate up a whole package of "instant noddles". He left the wrapper. The lizards are multiplying like rabbits and climbing all over my walls. The ants just ate a hole in the crotch of my new purple pants which I left lying on the floor. Purple was the only color they had in "extra large" for ten Baht (50 cents).Our electricity keeps going off. It's O.K. when "Radio Moscow" is cut off. All they talk about is increased production or the awful imperialists. I guess that's us. But I do get annoyed, though, when the electricity stops my cassette player right in the middle of Linda Ronstadt's tune: "Sometimes You Just Can't Win." Also the water from the tap is now a horrible brown color. I'm wondering if it will do any good to wash the

dishes. I could mention, too, that sometimes I feel so hot that I can't breathe. This happens after a rain storm. Don't suppose I've got a heart problem, do you? Well, that's all the "good news" for now. Hope you're both fine. Thinking of you,

Love, Mom

P.S. In my next letter I'll tell you about the birds in my bathroom and the snails in the garden which are so big, they'd make dinner for two.

.

This might've been their response.

Dear Mom,

We hate to tell you this, but your last letter sounded a bit out of touch with reality. We think our medical insurance would pay for a "shrink". You'd better forget Peace Corps and come home immediately. See you soon.

Love,

Your sons, Claudio and Kelvin

NEVER MIND THE TRUTH

In Thailand, people often avoid confronting the truth as if it were a snake ready to strike. I never understood why, but for an outspoken American to accept such a custom was as difficult as a senior citizen learning to roller blade. In fact, I could have used a complete personality overhaul.

Here's an incident that illustrates my point.

One day my neighbor, Mouse, (nicknamed because she was tiny and sort of looked like one) asked me if I would share a subscription with her for the *Bangkok Post*, an expensive English newspaper.

I liked the idea. My skimpy Peace Corps salary never allowed me the luxury of a newspaper subscription. Not unless, of course, I skipped my refrigerator payments and got used to spoiled vegetables again.

Mouse and I discussed the arrangements and mailed our money in together. We agreed that she'd receive the newspaper first. Then after reading it each day, she'd drop it off at my apartment below.

You'd think such a simple plan couldn't go wrong. But it failed immediately.

Within three weeks only five newspapers landed in front of my door--all about four days late. And more disappointing, never with an apology.

You can't imagine how annoyed I became! I wanted to shout, "Darn it (or something more descriptive), where are MY newspapers, Mouse?"

I had learned, though, that the Thais dislike any kind of direct confrontation. It's best to avoid it at all costs. For instance, during my Peace Corps training, I once expressed my displeasure about our daily routine. As a result, the "Higher Powers" of our group told me: "You'll be sent home, if you don't change your critical behavior." A rather forceful threat, I thought, for a little constructive criticism.

From that experience, I knew it was unwise to say anything directly to Mouse about her sloppy behavior. Besides, if I accidentally embarrassed her, which seemed easy enough to do, I could easily cause her to "lose face"--an act in Thailand as bad as burning down someone's house.

Anyway, as fate would have it, the plot thickened. Why? Because unfortunately Mouse was not only my neighbor but also my supervisor.

That's right! She held the prestigious title of English Department Chairman.

I could just imagine nasty evaluations clogging up my file. Or after a year's worth of hard work receiving a letter of recommendation that would blow my rosy future right out of the Orient.

All this made me feel as vulnerable as a boxer cornered in a ring.

For awhile no solution popped into my mind. Then one day I thought of something that might work.

With my flash of inspiration, I jumped on my bike and headed for the English office. There I found Mouse working at her desk.

Feeling as nervous as an employee asking for a raise, I approached her slowly. Clearing my throat, in a firm voice, I said, "Dr. Boonraksasatya" ("Mouse" seemed too flippant for addressing such a serious matter), "I.... really appreciate your wanting to share your newspaper with me (a big fat lie). But... I think I should have my own subscription. I need to use the articles for my English classes."

Upon hearing my excuse, Mouse smiled pleasantly and didn't say very much; at least, nothing that I can remember.

However, in uttering my gross exaggeration, I, at last, understood one important thing: why the Peace Corps required a <u>two</u> week debriefing course before sending us back to the States.

Our director knew, I'm sure, that it would take lots of practice before we'd be comfortable AGAIN shaking hands with the truth.

IT WON' T STOP

While I was sitting in the English office, my Thai colleague, Nikul, handed me a neatly typed letter and said, "Sign this, please."

"What does it say?" I questioned, not being able to read Thai.

"It's a request to repair your sink. You said it was stopped up." Nikul was a handsome young man who sat next to me in the office and often helped me.

"What's wrong with phoning?"

"We can't; we need a letter."

I heard that Thai bureaucracy could shove you around like a bully. Now I realized it was true. Efficiency was its opponent.

A week passed and no repairmen appeared. I began to wonder if the well-typed letter I signed had been my resignation from the University instead of a repair request.

Finally, on a sultry afternoon, two short, dark men knocked at my apartment door.

"*Nam*" (water), they shouted curtly.

Thinking they were plumbers, I led them into my kitchen. But they didn't go near my stopped-up sink. They simply checked the half empty water bottle sitting on the floor.

"Twelve *baht*," one said, stretching out his hand. It was the amount I owed for last week's delivery. In Pattani, tap water was unsafe to drink.

My plumbing problem grew steadily worse. The water in my sink turned a nasty black color and looked like a perfect breeding ground for sneaky Asian microbes. Though it was boring living in a small fishing village, I had no desire to try cholera as a remedy.

One warm, balmy evening, while I was sitting on my balcony, I reflected about my sink. After my third lemonade and *Mekong* (cheap alcohol), this drink with western imagination, tasted something like a whiskey sour, an idea popped into my head. What about yelling "fire" in Thai? Maybe someone in the fire brigade is a plumber. I played with this thought for awhile until I realized that patience was a virtue I had never acquired. This might be a good time to a "make a stab" at it, I concluded, somewhat amused. For a few more days I waited, but nothing improved. Soon a putrid stink permeated everywhere, giving my apartment the smell of a garbage dump.

"Forget the patience," I shouted, stalking angrily into the kitchen. "I'll get rid of the smelly water myself." With great determination, I shoved open the screen, grabbed a pan, scooped up the water and boldly threw it out the kitchen window--Asian style. If I had a bad throw, or encountered a gust of wind, the odious water would hit the neighbor's apartment below. At that moment, I didn't care. Later, when my conscience returned, I did wonder how hard it was for Charon's mother to clean left-over fish soup from her windows below.

At last, I received a message in the English office that the plumbers were on their way. I was thrilled. Even ecstatic!

Jumping on my bike, I pedaled along the campus *klongs* (canals) and across a wooden bridge, whistling happily all the way. When I reached my apartment, I expected to see a truck loaded with rotor rooter equipment. Instead, two skinny men were leaning up against a palm tree, one with a plunger in his hand.

Disappointed, but still hopeful, I led them into my kitchen and pointed to the clogged-up sink. For about ten minutes, the men took turns plunging. Then I heard the thrilling sound of water gurgling down the drain.

Impressed with their plumbing skills, I led them into my bathroom to introduce them to another problem: only my *RIGHT bathtub faucet was safe to use because I could turn it off.* It didn't bother me having only one faucet; I had no hot water anyway and never took a bath. How did I bathe? I simply squatted down and threw cold water over myself with a bowl. I learned to bathe this way when I lived in a Thai village during my Peace Corps training. In a climate too hot for a warm bath, it's a simple, refreshing way to keep clean and cool. Nevertheless, I wanted my

Me in front of a Buddhist Temple in Thailand

Young monks at our University on a special occasion to collect food

broken left faucet repaired. I feared I might turn it on by mistake and be unable to turn it off. Since the plumbers thought they could repair it, I bravely turned on the left knob. Sure enough, the water gushed out like Niagara Falls. Worse yet, neither of them could stop it.

Desperately, without success, the plumbers worked with all their strength. After about twenty minutes, leaving the water running full blast, they disappeared. At this point I was grateful I wasn't paying the water bill and that the bathtub had no drainage problem like the kitchen sink.

In a half an hour, the plumbers returned--this time with new tools and new parts. Once more hammering and pounding ensued until at last the roaring water stopped.

To have silence again in my apartment made me feel as happy as a newly enlightened Buddhist. Quickly, I dashed into the bathroom to congratulate them and check their work.

First, I opened the LEFT faucet that they'd just repaired. It worked as efficiently as my smoke detector at home. Then I turned on the RIGHT faucet; the one I had always used before. To my surprise, this innocent gesture brought sudden misfortune. The Niagara syndrome started all over again, and water came gushing out that couldn't be shut off.

The plumbers were amazed. For another fifteen minutes they banged monotonously. Having profited from their previous experience, they eventually stopped the angry rush of water.

As they gathered up their tools and were ready to leave, I had no desire to check their work a second time, especially after their last-minute warning: "Remember," they emphasized, "only the *LEFT faucet is safe to use.*"

From this experience, I wonder, "In Thailand are plumbing problems always contagious?"

CLIMATE

Have you ever wondered what it would be like to live in the tropics?

Well, try to imagine this. In Pattani, it was so hot that as soon as you put on your nail polish, it hardened. When you dropped ice cubes into your evening drink, they melted instantly. If you washed your clothes,

in a matter of minutes they dried and in the morning, when you took the butter out of the refrigerator, it softened so quickly that you could spread it on your toast by the time you made your coffee.

As far as I was concerned, the heat was unbearable. I felt lifeless and feverish most of the time and always wondered if I was suffering from a tropical disease or having "hot flashes". In fact, once I ran a high fever for three days without realizing it. I simply thought the weather had turned extra sultry.

It amazed me that the Thais seldom complained about the climate, nor did they perspire very much.

I seemed to be always dripping wet. In the classroom, this was particularly embarrassing. Even though I carried a fan in my hand, the slight breeze it created didn't help much. By the end of the class a small puddle always decorated the floor where I had been standing. And I knew I didn't have a kidney problem!

Well, that's LIFE in the tropics!

DO IT AGAIN, PLEASE

One morning in Pattani, I decided to reform my sloppy, "do-nothing" Saturday routine. To accomplish this lofty goal, I found my list of neglected errands and chose the easiest one: go get my bike brakes fixed.

In the cool, fresh morning air, I bumped along a gravel road, past groves of stately coconut palms. Soon I arrived at Abdulla's Bike Shop, really only a garage with some bike wheels hanging on the walls.

A dreamy eyed, young man with a mop of thick black hair, named Abdulla, greeted me. "*Sa-waht! dee kahp!* (Hello)," he said, smiling.

"*Sa-waht! dee Ka.*" I replied. "I need my brakes repaired." He nodded his head, indicating that he understood my Berlitz-book sentence that I had been rehearsing all the way.

Next he motioned for me to sit down on a small, three legged wooden stool, while he lifted my bike onto a metal stand attached to the ground.

As I watched the wheels come off, I felt pleased with myself.... for once I was actually doing what I thought I should be doing. It was

dangerous riding around with bad brakes, especially with so many animals and people cluttering the streets. Sitting there, I also thought about my last repair job. Here is what happened. A few weeks before, after much complaining, the University maintenance department sent over two workmen to repair my apartment window screens. I was tired of stuffing newspaper in the holes to keep out the blood-thirsty mosquitoes which attacked me regularly at sundown.

When the men saw my tacky screens, they decided *to do me a favor.* Instead of repairing them, they would install new ones. All afternoon, they pounded, sawed, cut and sewed. Since I was busy grading papers, I paid little attention to their work; however, I did notice it took them a long time. Not until their departure, did I understand why.

As unbelievable as it may sound, they hadn't measured ONE screen correctly. No, not one. Every screen was adorned with patches of various sizes. In fact, my *NEW* screens had as many patches on them as my old ones, only NOW in different places! Seeing the poor job, I realized that probably they weren't repairmen at all! Probably, they were gardeners "faking it" to avoid the scorching hot sun. After all, with a temperature of over 100 degrees in the shade, wouldn't you?

It didn't take long before Abdulla had finished installing my new brakes, and I was leisurely on my way again, cycling past a large, grassy meadow. Cows were grazing contentedly along the road's edge.

For a moment, for some reason, I turned and glanced to the other side of the road. Just then, without any warning--not even a "moo moo"--a free-spirited cow stepped onto the road--directly in front of me!

As quickly as possible, I slammed on my NEW brakes. To my astonishment, though, I kept right on going toward the cow. I yelled and how I avoided hitting it, I'll never know. Perhaps, it was the grace of "Buddha" that saved me.

"These brakes are worse than my old ones!" I said angrily, tossing out obscenities that rang loudly through the quiet countryside.

When I had recovered from my fright, I quickly turned around and headed straight back to Abdulla's shop.

"He'd better not charge me for repairing 'his repair job'," I growled to myself.

As I rode along, wishing I had never changed my old Saturday schedule, I began reflecting about what it meant to live in a *Third World*

Country. Maybe it meant that every job has to be done a *third* time to get it right

A CHUCKLE

In Pattani, one of my daily pleasures (and there weren't many) was reading the *Bangkok Post*, an English newspaper. The articles either told me interesting things about Thai culture or gave me a CHUCKLE.

This evening's paper gave me a CHUCKLE. An article entitled: "Thailand's Coming Vasectomy Festival" turned out to be as funny as its title. Or maybe funnier. In the first paragraph, the article mentioned the success of Bangkok's last grand "Vasectomy Rendez-Vous". At that special event, they inflated hundreds of colorful condoms and let them float like balloons over the city. "Quite a sight," they reported, "with the blue sky in the background."

"Even some drifted over the American Embassy!"

The grand occasion was made even more memorable by the number of volunteers. Over a hundred men enjoyed the privilege of being vasectomized.

Since the Thais act extremely prudish about anything relating to sex, I was really surprised by the frankness of the article. Not only do they seldom use the word "sex", but dating isn't a part of Thai culture. When young college students go out, they do so in groups, not couples.

I'll never forget my own experience with Thai prudishness. One afternoon, I went riding on a motor scooter with Nikul, my Thai language teacher and colleague. We rode to the peninsula near Pattani so I could look for a swimming beach that I could reach by bike. We found the beach, all right, a really gorgeous one, but this innocent excursion ended our friendship. From then on, Nikul refused to give me another Thai lesson. I suppose the campus gossip--about our being seen together when we weren't married--was too embarrassing for him.

The article also went on to describe in detail the next extravaganza, which planned to be even more spectacular than last year's. Besides live entertainment with popular singers, beauty queens would be on hand to pass out condoms to anyone who attended! Naturally, free vasectomies

The entrance gate at a temple in Pattani

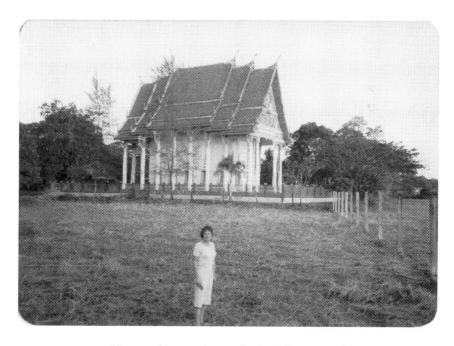

Me standing in front of a Buddhist temple

were on the agenda again. This time they hoped to surpass last year's record!

Well, what do you think? Worth a chuckle, huh? A few days later, after reading the vasectomy article, I found another one in the *Bangkok Post* equally as humorous. This time it pertained to women. The government announced it would give a FREE baby pig to any village woman avoiding pregnancy during one year.

For their campaign I thought of a snappy slogan. What about, "A pig in the pen is *better* than a baby in the crib?"

A COMPLAINT

One day, while I was in the English office correcting my students' compositions, Dr. Bangsomboon, the department supervisor, a tiny woman with fierce-looking eyes, suddenly shouted to me from across the room.

"Martha, I have a complaint about you!"

Feeling intimidated by the severity of her remark, I still kidded back, "Just one?"

Dr. Bangsomboon, a Ph.D. from the States, was a no-nonsense woman who spoke to everyone as if she were lecturing to her students.

Before listening to her complaint, I tried to guess which one of Thailand's rigid, Victorian rules I had violated. Let's see... wearing a two-piece bathing suit in the University swimming pool? (The rule clearly states that *only one* piece suits are allowed.) Or flirting with Charon, the cute ecology professor who lived downstairs? (It's true, I lured him into my apartment under false pretenses. I pretended I needed advice about my termites!)

Or worst yet, could I be too insensitive to the Thais' ban on exposing the flesh? Recently, while wearing a skimpy bikini, I answered the doorbell (after all, it was 102 degrees). Expecting to see the laundry lady, not the water man, I neglected to throw on a sarong. When the young man carrying the water bottle saw my tiny bra--the one with a smiling tiger across the right breast--he dropped the bottle right on my front steps. Not only did I have to clean up his mess, but he charged me for the dumb water bottle! Definitely, not my day!

Shortly, Dr. Bangsomboon voiced her complaint.

"You ride your bike on the wrong side of the street!" She stated in her firm, authoritarian voice.

Relieved that my offense wasn't more damning, I quickly agreed. "You're right. I'm not used to riding on the LEFT hand side of the street."

"You need to be more careful," she continued.

I quickly nodded, confessing that I had trouble with RIGHT hand turns from INSIDE lanes.

"Why's that?" she asked sternly.

I could feel I was about to be criticized for my cultural indiscretions. My voice echoed momentary pain. "I...I get confused. I can't remember what lane I'm suppose to end up in after making the turn."

Without showing any sympathy, she knitted her brows. "The other day, by the administration office, you almost hit one of my students."

Remembering the incident made me wince. I had just finished a right hand turn when I saw a cyclist heading straight at me. Barely missing him, I made a wild turn, realizing afterwards that I should have been on the other side of the road.

"I'm very sorry," I apologized. "I thought he was riding on the wrong side.....Anyway," I added with a smile, "my last-minute swerves ALWAYS save me from nasty collisions."

Dr. Bangsomboon didn't find my remark at all humorous. Still frowning, she continued her complaint. "Martha, you're FRIGHTENING my students."

From the tone of her voice, I realized how upset she was. "I...I'll try to be more careful," I promised, wondering if my cycling habits would ever improve.

We continued our strained conversation. A little later, I tried to end on a lighter note.

"Dr. Bangsomboon," I added, "just tell your students not to worry I still have a perfect no injury record."

THE KING AND I

In Thailand, almost everyone I met had an "I saw the king" story, and I have one, too. King Bhumibol gave a party for five thousand persons near Pattani, and I attended it..

Surprisingly enough, an invitation to this event was about as hard to obtain as a winning lottery ticket. Our University received only twelve, and just by chance, I got one. Well, almost!

One Saturday morning under a fiery, hot sun, I was strolling along the mud flats in front of the campus when, unexpectedly, Ajaan Silapan (my Peace Corps liaison person) drove by in his blue VW.

"Hello," he shouted, leaning out of his window. "How are you doing?"

"Fine," I lied, not wanting to tell him how lonely I really felt and that I was looking for something to do.

Thin and short, Ajaan Silapan was a pleasant, middle aged man who frequently forgot important things, like neglecting to tell me, when I arrived, that my tap water *wasn't* potable. (Luckily, I'm still alive.)

After chatting for awhile, he casually mentioned that he was attending the King's party that afternoon. "Sorry, I forgot to get you an invitation," he apologized. "But you can always go next year." I knew there would be no next year in Pattani. I mean, never! Though I liked my University teaching, the isolation of living in a fishing village with strict Muslim and Thai customs was too difficult for a free-spirited Californian like myself.

"I may not be here next year," I confessed. "Can't you find me another invitation? I REALLY want to see the King."

After hearing my whiney plea, Ajaan Silapan promised to look for one and let me know.

To my surprise, at 1:30 pm a young boy knocked at my apartment door with a note. It read: "Be in front of the Humanities Building by two. I'll meet you later at the palace."

I was thrilled. Now I would get to see the King!

Faster than you can say P a t t a n i, I got ready, arriving just in time. The ten other professors were already sitting in back of the van. As soon as the driver squeezed me in, we took off.

For two hours we jostled along through chartreuse-green rice paddies, passing mosques, temples and towns all vividly decorated for the King. Colored lights outlined the buildings, red, white and blue flags waved gently and large posters of the King and Queen stood everywhere. I loved the feeling of festivity. Even soldiers lined the roads awaiting his Majesty's arrival.

As we approached the King's palace, one of the teachers said to me in a conspiratorial voice, "Martha, you need to hide. We don't have an invitation for you."

"Oh?", I answered, surprised that no one had mentioned that earlier. Quickly I squatted down, wondering what would happen if I were caught. Deportation, maybe?

While at the palace gate, a stern-looking guard collected all our invitations. Through the dusty window, I could see him counting the invitations carefully. Then his eyes glanced back at our tightly packed bodies in the van. It was a tense moment with everyone breathlessly silent. After a pause, he handed the invitations back and without a word to our driver waved us on. What a relief! He didn't even bother counting us, probably assuming teachers were honest!

After parking the van, we walked towards another gate and another guard. Without an invitation, I wondered what would happen to me this time? Would I have to secretly climb the fence? Surely, Ajaan Silapan must be nearby.

Just as despair began clouding my thoughts, I spotted him, standing a few yards away with a big smile brightening his face. "I see you made it," he said, laughing good naturedly.

"Yeah, but I was REALLY scared. I'm not used to sneaking into palaces."

Handing me a blue invitation, he explained that there were three colors: yellow for dinner only, red for dinner and a center seat at the performance and blue for dinner and a seat on the side.

Clutching my precious invitation, I headed towards a large grassy area near the beach where a large crowd had gathered. The smell of burning charcoal wafted through the air. From immense woks on top of charcoal or gas braziers, people were cooking food from all the different Southern provinces. I felt as if I were visiting a country fair.

Fascinated by all the culinary activity, I walked around, surveying the different dishes. At last, I stood in line for a bowl of thin, yellow noodles with slivers of meat and vegetables on top. HMMM....NOT BAD, I thought, slurping them down. From another stall, I gobbled up a bowl of chicken curry with rice. WOW.....EVEN BETTER! Then, I spotted some mussels being roasted over hot coals. When the shells opened wide, the cook, with the ease of a gourmet chef, picked them

up with a pair of tongs and piled them high on my plate. THESE ARE JUST RIGHT!

While listening to the lapping waves caress the shore, I ate my tasty mussels with the noodles and curry while watching the people chat with their friends. I wished I wasn't alone. But there was no other foreigner to talk to.

About six o'clock, as the soft gray dusk began to cover the sky, two of my Thai colleagues spotted me. "It's time to go inside now," they announced. "Otherwise, we won't find good seats."

Weaving our way through a massive crowd, we entered a huge canvas tent. Inside, in front of the stage sat rows and rows of *hard wooden* chairs, as close together as seats on an economy flight.

I sat down next to Ajaan Rujiwong, a plump woman with large black eyes, who spoke good English. "When does the performance begin?" I asked curiously.

"It begins when the King arrives," she replied abruptly.

"When's that?"

"About 7:30."

"Not until then!" I exclaimed, concerned about what I'd do for an hour and a half.

To occupy my time, I watched the people enter the tent. Most of the women were dressed in their national Thai costume, a tight, ankle length skirt and a fitted long-sleeve blouse with a Chinese collar--figure revealing but impractical in a tropical climate. As for the men, they wore slacks and Nehru-type shirts of bright hand-woven fabrics—except for, those who they were civil servants or Army men. They strutted around in beige uniforms decorated with gold shoulder bars and colorful chest ribbons.

When I grew weary of people-watching, I turned to Ajaan Rujiwong. "Do you think the King will be here soon?" I asked hopefully.

"Maybe," she answered nonchalantly, "but he'll probably arrive late."

I was well acquainted with the Thai custom of never being punctual. It seemed to bother no one else but me.

A little later, a group of TV men rushed by carrying heavy video cameras on their shoulders. Excitedly, Ajaan Rujiwong whispered, "The King is coming."

Suddenly, we all stood up. Then, as if produced by magic, the King and Queen entered. Awe and respect charged the air. After prancing majestically down the center aisle, they sat down at a small table facing the stage. The King appeared just like in his pictures: solemn, serious and without a smile; the queen, though, smiled graciously and looked regally beautiful in her navy blue evening gown.

Next, a rather surprising event took place: (I might add that it was terribly boring, too--my apologies to the King!) For the next hour, officials collected donations from the audience. Yes, that's right! People GAVE money to the King. An announcer broadcasted the donor's name and the amount he dropped into two golden bowls sitting on the King's table.

To be truthful, I found it hard to believe that a King needed money. I always thought Kings were rich. This wasn't the only thing I found strange, though. During the entire evening, the King never spoke one word to the audience--not even after he received 5,000,000 baht ($250,000)! Imagine!

When the donations were over (earmarked for medical and agricultural projects in our area), His Majesty and the Queen moved to the back of the tent. They sat at a long, elevated table where during the evening friends joined them, and waiters served everyone food and drinks. I must confess, I looked on with envy.

About nine o'clock, the dancing FINALLY began. Dressed in elaborate costumes, the graceful dancers swayed, turned, hopped and twisted to the rhythm of ear-piercing, minor-keyed music, occasionally wiggling only their fingers and wrists--a style suitable for the hot, sultry climate.

Though I enjoyed the dancing, I regularly left my *hard wooden* seat to go outside for exercise, remembering each time to follow special exit protocol. At the end of my row, I faced the King, put my hands together, touched my face and bowed. Then, when I passed nearer to the King, I would lower my head in respect. I don't know why, but I enjoyed performing this ritual.

The audience's favorite number was the *Ram Bon*, the Thai national dance, which the Princess and her husband performed with four other couples. Facing their partners, they danced in a circle, making beautiful hand movements while their feet kept rhythm to the music. The *Ram*

Bon is often performed at Thai festivals. I've danced it often, even at a religious ceremony.

Since each province in Southern Thailand had to "show off" its special dancers, the program--unbelievable as it sounds--lasted until almost TWO in the morning.

You can't imagine how happy I felt when I saw the King and Queen preparing to leave!

This time, they exited directly in front of us. As we rushed towards them, the King looked straight ahead, but Queen Sirikit turned and talked to us, truly possessing the radiance of a Queen.

In retrospect, I'm glad I attended King Bhumibol's party. I doubt, however, if I would ever want another invitation. Five-hours of watching Thai dancing from a *hard wooden* seat will last me for a long, long time--maybe for eternity!

LEAVING THAILAND FOR CHINA

My Life
After one year, in 1985, *hoping to escape my boring isolation, I leaped over to China. I got a job teaching English in an Institute for Petroleum Engineers. I knew moving from Thailand to China would be an adventure but never expected the avalanche of difficulties ahead of me and also never expected to land in another isolated area right in the middle of rice fields.*

ON MY WAY
Excerpt from: *Asian Adventure*

Resigning from the Peace Corps was as tedious as getting into the CIA. It took a week of circling around Bangkok's crowded streets in a *pedicab* to collect all the required forms--some from doctors and nurses, others from government officials When I signed out at the Peace Corps headquarters, I asked the director why I was never taken off of probation after they sent an official from Bangkok to Pattani to see how I was doing. I couldn't believe his answer. "I never knew you were on probation." He replied. If I'd only known that, I would have worked less and traveled more.

Then I spent another week searching for my misplaced plane ticket to China. The Beijing government was supposed to have sent it to the China Airline's office, but no one there had ever seen it.

To complicate matters, when I knocked at the Chinese Embassy for help, all I found were locked doors. A sign read: open Tuesday and Thursday afternoons only. After returning several times, I finally *did* locate my ticket. Without telling anyone, a diplomat had tucked it away in his desk drawer.

My final obstacle to leaving Thailand was boarding the plane to Canton, more complicated than you'd imagine. At the Bangkok airport, my flight kept being delayed. After hours of waiting, I was told to return the following day, not an easy request with eight pieces of luggage at my feet and most hotels over an hour away from the airport.

Eventually, I did land in China. My luck, however, hadn't changed. In fact, it seemed to get worse. The people who met me at the Canton airport, and registered me in a local hotel, promised to accompany me to my Chengdu plane two days later but they never appeared so at the last minute I decided to reach the airport by myself--an experience as frustrating as rearing a rebellious teenager.

In the hotel no one understood English. Not a soul. Unable to request a porter, I hurriedly loaded my heavy luggage into a small elevator and without understanding a word anyone said to me, quickly checked out of the hotel.

My next challenge was flagging down one of Canton's scarce taxis. Then guess what happened? Misunderstanding my sign language, the driver delivered me to the WRONG airport!

When I realized I was at the international airport instead of the local one, my taxi had already faded away into the distance with no others in sight.

Time was rapidly running out, and I couldn't afford to miss my plane. First of all, someone was meeting me at the Chengdu airport and secondly, the next plane to Chengdu didn't leave for another three days.

Pacing up and down the DESERTED parking lot like a caged lion trying to escape, I hadn't a clue what to do.

Luckily, after waiting impatiently for a few minutes it seemed more like an hour--a shiny black government car pulled up. Once the passengers got out, I dashed over to the driver. Using improved sign language, as well as a few dollar bills, I asked him to take me to the other airport. Fortunately, he agreed.

Since I arrived late at the check-in counter, I assumed no one would be waiting there. Wrong again. With only two clerks handling all the airport passengers, the line extended out the front door, over a block long. In desperation, I thought of a scheme.

Dragging my heavy bags to the front of the line, I plopped them down on the scale pretending it was the normal thing for a foreign woman to do. Surprisingly enough, not one person objected. Just minutes before take off, I jumped on board -- happy but totally exhausted.

At the Chengdu airport, when I saw a big sign saying, "Welcome Martha Marino!" I felt my last hurdle had been cleared. And I was right. From then on, my experiences in China surpassed all of my expectations. Chinese hospitality was wonderful. We stayed three days in Chengdu so I could see all the famous sights and eat at the well known restaurants Every morning the chaffeur and translator picked me up at my hotel and chauffeured me around the city. One day we even went to the zoo to see the pandas. I was treated so royally that I couldn't believe that I was the same person who had such an austere life in Thailand.

NANCHONG, CHINA

Excerpts from: *Asian Adventure*

ARRIVING IN NANCHONG

As our chauffeur passed under the big, red arch of the Southwest Petroleum Institute, Lao Wang, my interpreter, a young man who spoke English well, announced cheerfully, "We've arrived." I felt relieved to have reached my destination. For nine long hours, in freezing, winter weather, we had bumped along dirt roads, passing through primitive villages and vast rice fields. Though scenic, the trip from Chengdu left me exhausted.

Weaving around tree lined streets, we now passed dingy, dusty dormitories and run-down looking buildings. Only one was new, a tall, pink research laboratory. Though the surroundings were unattractive, it was exciting to be here. For years, I had dreamed of living in China.

At last, we stopped in front of a four story, yellow apartment building.

"Here's where you live," Lao Wang said, smiling. "Great!" I exclaimed, anxious to see where I would spend the next year and a half of my life.

"We call it yellow palace. Yellow is the royal color, you know."
Shortly, a beady-eyed woman in her forties opened the sedan door and grabbed my bags from the front seat.

"She's Zo Wen, your maid," Lao Wang added.

"My maid!" I couldn't believe the good news. I had just resigned from the Peace Corps where I was supposed to have enjoyed poverty as a monk enjoys solitude. I never did, of course.

Zo Wen ushered us up three flights of stairs to my apartment. It was light and spacious and had a living room, bedroom, study, large shower room with a washing machine and a toilet in a separate room. The view from the front balcony was breathtaking. In the distance, I could see endless rolling green hills and below, a slow, winding river. "I can't believe we're in the middle of rice fields!" I exclaimed.

"That's right." Lao Wang added. "The University was built here by mistake."

"How'd that happen?"

"Some government official thought that oil was here, and later they discovered there was none."

I laughed.

Next, we stepped into the living room. Modestly furnished with beige linoleum floors, it had a radio and color television sitting on a desk. "They're luxuries," Lao Wang mentioned. "Not many people have them."

Then pointing to the two large thermos bottles standing like tin soldiers in the corner, he explained that Zo Wen would deliver them twice a day and that I must drink only boiled water.

We continued to look around. In the entrance, I noticed a large refrigerator but saw no kitchen.

"Where do I cook?" I asked Lao Wang, curiously.

"You don't. You have two cooks."

"Two cooks! You mean, besides a maid, chauffeur and an interpreter I have *two* cooks!"

This wasn't exactly my image of Communism. Nor anyone else's probably. I couldn't wait to write my Peace Corps colleagues and impress them with my good fortune. Two of them had already taught in China and had told me how to get this job. It was easy. I simply sent my resume to the Ministry of Education in Beijing and asked to teach English in a University. No interview. Nothing. Then, after six months a telegram arrived offering me this position in Nanchong (a rural town of 130,000 inhabitants in Southern China). Of course, I had no idea where Nanchong was or what to expect. But being an adventure-lover this hadn't bothered me.

Later, we skipped downstairs to inspect the dining room and kitchen and meet Liu Su, the main chef, a short man with crossed eyes and

thick black hair. A pretty young girl dressed in red was his assistant. She did his marketing and chopped vegetables. "He is best cook in the University," Lao Wang bragged. I soon understood why. Liu Su cooked delicious meals, mostly hot Sichuan food with chilies, garlic, ginger and shallots. Only occasionally did I tire of his stir-fried dishes and Peking duck and crave a hunk of cheese or a dish of chocolate ice cream.

That evening while unpacking, I heard a knock at my door. When I opened it, four somber-looking gentlemen in Mao jackets, stood on the steps staring at me.

"Good evening," they said politely.

"Good evening gentlemen," I answered rather surprised.

I didn't know who they were, but they looked distinguished enough to invite in.

"Come in," I said, ushering them directly into my bedroom! I could tell they were embarrassed sitting there, especially when I curled up on top of my bed (I was out of chairs). However, I had no intention of taking them into my icy living room when the only heater in my apartment sat in the bedroom window.

Having just stepped out of the steaming tropics, I felt as cold as a bald cat stranded on an floating iceberg.

"We've come to wish you a successful stay," the English department chairman cordially announced, while introducing the other three serious-looking men. None of them spoke English, and all had impressive titles and complicated names that I couldn't remember.

"We're happy that you arrived safely," he continued.

"Well, I almost didn't," I responded, then I recited my adventure of leaving Thailand.

Next, my official guests asked me how I liked the three day sightseeing tour they had arranged for me in Chengdu. I told them it was wonderful.

Imagine this! Before coming to Nanchong, I was chauffeured around in a shiny black Russian-made sedan--with lace curtains and bright blue velvet upholstery--to all the ancient temples and historical sights in the area. You can imagine how important I felt! Every time we stopped, the chauffeur, with his white gloves and black cap, opened my door as if I were a prominent diplomat, an experience I'll never forget!

One morning, we even cruised over to the zoo to see the famous, cuddly pandas. And everyday for lunch my chauffeur, translator and I ate at well known restaurants, always ordering more dishes than we could possibly finish. A custom that definitely appealed to me.

Chinese hospitality continued to impress me. My first week in Nanchong was filled with special events, all in my honor.

For instance, one afternoon I had an appointment with the University president, a handsome man who spoke fluent English. In his office, a photographer was on hand to snap my picture while signing my contract, one copy in English and one in Chinese.

I wish I had been more properly dressed for the occasion. In order to keep warm, I was wearing my down jacket and scruffy hiking boots that I had worn trekking around Nepal.

Another afternoon, I attended my first tea party, given for me by the English faculty--about twenty Chinese teachers of all ages.

It was a formal affair held in the faculty lounge. All the chairs were prearranged in a circle and between each one was a small table set with a plate of candy and cookies, an orange and a handle less mug with a lid.

After we sat down, a waiter walked around and poured boiling water from a large tea kettle over our green tea leaves; each of us steeped our own tea.

For some reason the leaves in my mug never completely sank to the bottom. Deciding to ignore them, I drank the tea anyway. And what happened? The leaves clung to my front teeth as tenaciously as a leech clings to its host. Embarrassed to talk, I brushed the fuzz off my teeth with my finger when I thought no one was looking.

The next time I saw Lao Wang, I asked him how I was supposed to handle "floating tea leaves".

"Easy," he explained, "just sweep them to the side with your lid before sipping the tea!" Simple enough, right?

Another evening, seven high-ranking university officials in dark suits arranged an elaborate banquet for me. Being the only woman and the center of so much attention made me wonder if I were the exact same person that left Peace Corps only two weeks before. The banquet began with drinks and plates of hors d'oeuvres. Some had strange tastes, but I

ate them anyway. True to Chinese custom, the men gave me numerous toasts and compliments, making me feel like a queen.

When it was time for our dinner, a waiter served us large platters or bowls of food as the chefs finished cooking them. Then with our chop sticks, we dipped into the dish, putting our small portions either on our saucers or directly into our mouths as you would do with fondue.

In all, we had about fifteen different dishes. Most were truly works of art and very delicious--except, of course, for the slimy eels and the slippery seaweed.

Unlike the usual Chinese meal, which has many vegetables, we ate mostly pork, fish and chicken. The rice was served last with the tea.

This sumptuous banquet ended my welcoming events and the best week of my life. Two thousand years of civilization certainly got the kinks out of Chinese hospital

LIFE ON CAMPUS

Living on campus exceeded all my expectations. I had comfort I never dreamed of and adventures I never expected.

Only a few things bothered me. One was the loud speaker that regulated the campus routine. Barking out commands as efficiently as a drill sergeant, it continually told us what to do. In the morning at six o'clock sharp a loud, peppy march woke everyone up. A few minutes later, the tempo shifted to a snappy one, two, three beat, reminding health enthusiasts to dash out to the athletic field for morning exercises. After that, the day's announcements blared out, usually so blurred nobody could understand them.

Then all was quiet for awhile. At 11:30 soft melodic songs floated through the air that reminded us to stop for lunch and take a nap.

Yes, we all took naps--including the guard who closed the campus gate during rest time. We slept until about 2:30 when cheerful tunes woke us up. However, if the disc jockey overslept, as he sometimes did, we had a longer siesta and straggled in late to our afternoon classes. At dinner time, another set of breezy tunes floated around the campus. With so many interruptions, it was hard to believe that silence prevailed

at bedtime. Sundays were a real treat; the chatty loudspeaker had a total rest and so did we.

Besides the early morning loud speaker announcements, peddlers shouted daily underneath my bedroom window like circus vendors selling peanuts. From their twin shoulder baskets, they sold tofu, eggs, vegetables and fruit. Whoever yelled the loudest, seemed to think he would sell the most.

Fortunately, I possessed a pair of rubber ear plugs which I valued as much as my gold jewelry. By stuffing them into my ears at night, I could sleep until about eight o'clock when my maid awakened me. (I told you, my life was comfortable.)

Every morning she delivered my breakfast. I always had coffee, toast, jam and butter--surprisingly enough, a special menu. No shop in Nanchong sold coffee or jam, so every few months my cook's assistant rode the bus to the city of Chongqing, ten hours away, to buy them just for me.

A Chinese breakfast, as you can imagine, is very different from ours. Usually, it's green tea, rice gruel and spicy condiments, a combination I only swallowed when I had no other choice.

About 2,500 students attended The Southwest Petroleum Institute, and all studied petroleum engineering with government scholarships. It was difficult to be admitted here, because the students had to pass a special exam at the end of high school. Actually, it was so demanding that farmers' children seldom passed it. They didn't have the opportunity to attend good schools nor did they have parents who could help them with their studies. Among my students, only one had parents who were farmers.

It is interesting to note that Deng Xiao Ping—one of China's most influential leaders—was born in the countryside. Actually, his home, which I visited, is near Nanchong. His father, a wealthy farmer and land owner, had sent him to Chongqing for his secondary education. It's probably Deng Xiao Ping's rural background that helped him instigate his successful policies for the farmers.

My classes at the Institute were a delight to teach; I had only conversation classes and my students were all Professors. (How lucky can you get?) Most were petroleum engineers who planned to study

abroad in the States, but a few were English translators who worked in the oil fields or taught other students English.

My only problem was the text book I was supposed to use. It was published so long ago in England that it was as out of date as polyester suits in Paris. Instead of following it, I made tapes from the Voice of America radio programs and played them in our modern, well equipped language lab, or else we read articles from *Time Magazine* which came from Hong Kong.

Thursday was my favorite teaching day because we had no afternoon classes. Everyone, including the Professors, was attending political meetings in his unit. These get-togethers sounded a bit like Sunday school, except they talked about Communism, not God. Being a staunch Capitalist, I was never invited. Instead, I would ride my bike into town to shop or to simply watch the people.

One day I asked Lao Wang, my interpreter and friend, about the meeting. "What did you do in your political unit this afternoon?"

"Our leader read a newspaper article about economy."

"What did it say?" I asked, hoping to get a peek into their political system.

"I don't know. I sat in back and read a magazine."

This was a typical attitude of many young people. In order to stay out of trouble with their leaders, they had to attend. Few, though, did so with any enthusiasm.

I liked the location of my apartment. It was right in the middle of campus, and besides being near the sports field, swimming pool and amphitheater, I could watch the students come and go. Three times a day, at meal time, they strolled to the canteen with their own white enameled bowls and wooden chop sticks in hand. Then, once a day they brought their large thermos bottles to the central boiler for drinking water. (Tap water was unsafe to drink.) Other times, carrying their towels, I saw them walking toward the bath house. The dormitories and apartments had only cold water, so everyone (including Professors and their families) took only one hot shower a week. I never heard anyone complain about this arrangement. Austerity is a part of Chinese life.

The only thing I didn't like on campus was having others know what I was doing at all times. With so many eyes following me around, any kind of romance was certainly out of the question. It would have

been hard to arrange anyway in a culture that seldom practices romantic love.

As a matter of fact, I never did understand their version of romance. Here's an example of what I mean. One spring afternoon, I was walking in the serene countryside with some students. Just in front of us was a teenage peasant couple strolling together about two feet apart. Morosely, with bowed heads, they stared at the ground. As we passed them, my students whispered to me, "They're in love!"

"In love," I exclaimed, "I thought their parents had just died, they looked so depressed!"

Student romances had strict rules on campus: they simply were not allowed. Officials claimed they interfered with their studies, and those who fell in love (and were discovered) were expelled or transferred. Imagine, if students wanted to hold hands, they had to hide behind the bushes at night.

The administrators kept their eyes on us teachers, too.

Once, while I was giving a dinner party in my apartment, one of my guests and best friend, Zhao Lin, got up to leave as soon as we had finished our dessert. "Where are you going?" I asked disappointedly.

"I have special meeting. I just received notice this afternoon."

"Why didn't you tell them you couldn't come?"

"I couldn't do that," she said emphatically.

I soon learned that obedience for the Chinese is as important as freedom for Americans.

In retrospect, life on campus was an unforgettable experience. Besides enjoying my teaching, I loved the hospitality. Where else could a teacher have a free apartment, a maid, chauffeur, interpreter, two cooks, plenty of leisure and be paid the highest salary in town?

WINTERTIME

According to an old Chinese belief "If you live south of the Yangtze River, you don't need heat in the winter." I don't know which enlightened Emperor coined this "ancient bit of wisdom," but as far as I'm concerned it's fortune cookie nonsense. China's winters below the Yangtze are colder than a polar bear's cave.

While living in Nanchong--supposedly in the warmer South, even though the Himalayas stood right next door--I never felt colder, not even in a whirling blizzard on a deserted ski slope.

Personally, I think China should roll up in a ball during winter and let everyone hibernate. Pandas do it, why not the Chinese? They could postpone their modernizations that everybody talks about until spring thawed them out.

Not much progress is made during the winter months, anyway. Many of my students were sick and couldn't come to class. Those who did attend shook from the cold and after twenty minutes in an unheated classroom, their thinking processes seemed to freeze up. From then on, the English they spoke sounded like an unknown foreign tongue.

Numbed by the cold, I, too, was affected; my memory became a slur. In December, I kept reciting the same Christmas story over and over again. The students didn't remember hearing it, and my mind barely recalled telling it.

The Chinese have two methods for surviving the below zero weather, neither of which took the chill out of MY bones. One is to continually drink hot tea. My maid, Zo Wen, made sure I had an ample supply of boiling water at all times. Twice a day she delivered it to my apartment in two large thermos bottles, Sundays were included. In addition, a thermos of hot tea always sat in my office. A lady custodian in baggy, blue cotton slacks kept it full, so between classes I could sip a cup of hot tea.

The other way they keep warm is to dress in layers. When I tried it, I had so many layers hugging my legs that I walked as stiff-legged as a duck. In this condition, I didn't dare climb on my bike; without any "knee flex" I could hardly turn the pedals.

Let me describe MY layer look. First, a lacy pair of panties, followed by some old, worn-out panty hose (irreplaceable in Nanchong); third, a discarded pair of tights an American teacher had left me; next, a pair of red long johns I used in our Christmas Video Special when playing the illustrious role of Mr. Claus; fifth--or is it sixth?--my green sweater pants.

In America sweaters only warm the upper body. Not so in China; they knit them to cover your legs, too. I bought my sweater pants for one dollar from a pushcart peddler near the hospital in town where I went

The apartment house on campus where I lived.

The farmer's market in Nanchong

for my weekly acupuncture treatment. (To be honest, a few needles in my tennis elbow each Wednesday was one of my diversions.)

But back to the bottom layers. I finished off the sequence with knee socks and a pair of loose fitting slacks to accommodate all this underwear. Dressed in so many clothes, I had to be careful about one important thing: not being in a hurry when I left the bathroom. If I forgot to pull up a layer or two, a large bulge appeared around my knees and caused me to walk with a strange shuffle.

As for the clothes above the waist, Chinese women wear several thick, padded cotton jackets. In fact, their shoulders are so wide you'd think they were getting ready to play football and chase quarterbacks. Even on Utah's ski slopes, I never permitted myself to look like a member of a North Pole expedition. Instead of bundling up in cotton jackets, I wore three wool sweaters, one on top of the other. Though I looked square and chubby, at least my gender was still in evidence.

The only problem with this method was that I owned only three sweaters. So, for variety I rotated them. I could always tell when Thursday came around. That's the day my beige sweater came out on top.

Along with my layers, I devised something else. In my handbag I carried a jump-rope. No matter where I was, if I felt a hypothermia attack creeping up, I graciously excused myself. Grabbing my rope, I headed for a deserted hallway. After a hundred or so jumps, my cheeks turned pink and my fingers began to move again.

Whatever my Chinese friends thought about my innovative "jump rope routine", they never said. I imagine they simply attributed it to another one of my American idiosyncrasies.

In spite of 30 degree weather, it never snowed in Nanchong. I wished it had, because the continual somber skies were terribly depressing. Actually, after four months, I even forgot that the sky could be blue. When I went on vacation in February to Kumming, in the sunny south, I found myself constantly staring overhead. The beauty of the white, puffy clouds floating in the teal-blue sky, thrilled me as much as looking at all the tourist attractions.

True to the Chinese's exceptional hospitality, the University gave us three American teachers the ONLY HEATERS on campus.

Unfortunately, they were designed mainly as air conditioners and operated as ineffectively as left-over Chinese coins in my home town

parking meters. (I know, I've tried.) The heater sat high in my large bedroom window and kept only the ceiling warm--great for drying dripping laundry in four days. In the apartment below, my neighbor's heater wasn't much better than mine. At night, when I tried to sleep, it roared like a jet plane ready for take off.

At Christmas time Lao Chu, our foreign affairs director, asked me, "What you want for Christmas?"

"I'd love a heater that works," I answered in a hoarse voice, fighting off my eighth cold in one year. The pleasant thought of being warm again made my head spin with ecstasy.

"I look for one," he assured me. Lao Chu, a thin, willowy man, was extremely conscientious. I knew he would do his best.

To locate a heater in Nanchong was harder than changing Communism into Capitalism. For weeks, I had poked my head into the local shops and only spotted charcoal braziers sitting on the shelves. To look elsewhere seemed out of the question, because the nearest city took ten hours to reach by dirt roads.

On Christmas morning, another dreary, gray-sky day, a loud knock interrupted my silence. Who could that be? I wondered, as I opened the door.

"Merry Christmas," Lao Chu cried out cheerfully, pushing a funny looking, portable heater into my arms.

"A heater. How wonderful! Thanks a lot," I shouted, hugging the ivory metal as if it were a soft, furry kitten.

The heater actually looked like an antique with its tiny metal legs and rusty grill across the front. I wanted to inquire where this homely appliance had come from, but feared embarrassing Lao Chu. Obviously the heater had a long, and probably interesting, history dating back to the Sixties. As a matter of fact, it might have been from the same vintage as the black Russian sedan that they chauffeured me around in.

Anxious to thaw out my icy hands and feet, I returned to the living room to plug it in. No luck, though. The outlet was the wrong size. Lugging it from room to room, I desperately searched for a three pronged outlet.

Finally, I located one in my shower room, a place I usually avoided, because the white tiled floor and loosely fitted windows made it bitterly cold. If I also forgot to close the blue printed curtains, the students on

the walkway could watch me shower and I could watch them stroll to class.

To heat my shower room with this heater didn't make much sense. To do so, I would have to unplug my water heater and suffer through a cold shower. Besides, I hated taking showers. I always feared being electrocuted. The wall heater hung right next to the shower and *only switched on* when I turned on the hot water faucet. Worse yet, the heater often spit out angry red flames, shorting the electricity.

When this happened, the campus electrician, a tall, thin-faced man, would come to my rescue, always assuring me that my water heater was safe. I never believed him, though, I knew that electricity and water didn't mix and was sure this must be true in China, too.

Feeling disappointed about my unusable Christmas present, I dumped it next to my potted Christmas tree and crawled back into bed to keep warm like the Chinese do. "Nice try, Lao Chu," I said to myself, wishing I were someplace where it was warm.

After three weeks of anticipation, some workmen dropped by one afternoon to install a three pronged outlet in my living room. From that moment, life brightened with a new glow. I even switched my evening classes from the freezing language lab to my warm living room.

This arrangement, I thought, would please my students as much as me, however, they complained constantly. "Your room too hot," they told me. Not until I saw them stripping down to their long underwear, did I agree to turn my precious heater off and put my coat back on.

"I'm used to California's winter sunshine," I tried to explain, "I can't handle the cold." No one sympathized with me, though. The Chinese stood the harsh climate as stoically as soldiers in combat. Perhaps they had no choice. None of the buildings were equipped with furnaces, and for them to have electric or gas heat cost too much.

If the cold winter had lasted much longer, it might have driven me to alcoholism. I'm serious.

Certainly, the conditions were just right: dirt-cheap liquor and gloomy skies that made me want to cry. Already, to keep my circulation flowing, I habitually poured vodka into my morning orange juice and brandy into my afternoon tea. The final step, I reasoned, was to become addicted to the local "fire water", a drink so powerful that when I accidentally spilled some on my hand my nail polish disappeared.

Thank goodness, my fingers didn't dissolve, too. At a corner stand, a friendly merchant sold this liquor from a huge jug sitting on a dirt floor. For a few coins, he carefully filled any size container I brought, from a shampoo bottle to a quart jar. After swallowing his powerful brew, I warmed up immediately and forgot I ever came to China.

Though I continued to suffer from China's harsh winters, I realized that they did make one dream come true. For once in my life, I could eat all the food I wanted and still stay pencil-thin.

THE CHINA NO ONE SEES

Hidden among the smooth green hills and hugging the banks of the slow, twisting Jialang River, lies the isolated town of Nanchong where 130,000 inhabitants still live today as their ancestors once did.

Every Thursday, while my students were attending their Communist meetings, I'd cycle into this rural town to immerse myself in its old style of Chinese life.

Upon leaving the campus, I always tried to remember one important thing: to hop off my bike at the tall, red arch at the entrance. Why? No one seemed to know.

"It's simply a custom," everyone told me. "You must walk underneath the arch."

If I forgot, as I frequently did, the vigilant gatekeeper barked angrily and shook his fist at me. Had there been a suggestion box around, I would have recommended a stop sign and a better job for the gateman.

On my way into town, I passed many unusual and wonderful sights.

The first one was right outside the arch. There by the road, hung rows of cream-colored noodles draped over bamboo poles like sheets on a clothes line. When bone dry from the pale sun, they were cut and packaged. Then old women sold them from push carts all over town. I know they were tasty; my cook served them every Thursday.

Next, sharp, bell-like sounds rang through the afternoon air. Sitting along side the road, stone cutters busily struck their chisels and hammers against hunks of granite, shaping them carefully into oblong stones. They worked hard. Even the tiny pebbles covering the road were smashed by their hammers, proof that they had rolled back time.

When I turned the corner, I always slowed down to gaze upon the open market. There, the butchers stood patiently behind tables, displaying large hunks of red meat--mostly pork. If a customer appeared, they hacked off a piece, selling it not by the cut, but by the pound. Usually, they motioned for me to buy some, but I only waved and gave them a friendly smile.

Nearby squatted the vegetable ladies, their baskets of produce at their sides. Sometimes I'd see pale green cabbages as big as pumpkins or yellow bean sprouts six inches long.

Next, I passed the eel man, always trying hard not to stare at him. But each time my eyes were drawn to his chopping board covered with fresh blood. Sitting on a small stool, he busily cleaned his wiggly, pencil-sized eels gathered from the rice fields. After grabbing them from a water bucket, he knocked them on the rim, and while partly unconscious, mercilessly jabbed a nail through their diamond shaped heads to keep them from sliding off his board. Then, to finish his preparation, he sliced them down the middle and removed their bloody stomachs. Cooked eels are a delicacy in China.

When not in a hurry, I liked to stop and chat with the orange vendor, a kind old man whose leathery, wrinkled face revealed that his life had been hard.

"How much a *gene* (pound)?" I shouted.

"*Wu Mao*" (15 cents), he replied.

"That's too much," I bargained but seldom won.

"Okay, give me three *gene*," I murmured reluctantly.

Bending over his oranges on the ground, I would choose the softest, shiniest ones and pile them high into his pan. Then, using a simple but workable hand scale, he weighed them by placing a three pound weight on one end of a metal rod and the pan of oranges on the other. When he held up the scale, if it didn't balance evenly, he added or took away some of the oranges.

After the market, large silk factories appeared on my left, their huge, brightly tiled arches standing as stately as an emperor before his honor guards. In the past, arches announced palaces and temples, but today they belong to factories and schools.

I always felt sorry for the employees working and living behind these factory walls. Their stark, concrete apartments appeared as bare as state

prisons--no trees, no flowers, only loud speakers blaring out commands and unit leaders telling them what to do. (Nanchong is famous for its silk. The farmers provide the factories with silk worms from their mulberry plants.)

When I reached the outskirts of town, the road widened. But there still wasn't much traffic, reminding me of a deserted street in a western town at dawn. In Nanchong, no one owned a car. Cars belonged only to organizations.

Occasionally, however, a noisy truck or crowded bus would swish by, honking boldly at us cyclists or at the two wheeled carts at my side, pulled by men with straps over their bent shoulders. Beads of sweat covered their foreheads from hauling immense loads of either pipes, cement blocks or sacks of rice.

As I passed these over-burdened men, pity always overwhelmed me. In this ancient town, with few trucks or animals, human transport was common. If people were not tugging at carts, they were trudging along with heavy loads on their backs or at the ends of poles slung across their strong shoulders.

I could always tell when I was approaching the town; artisans and merchants cluttered the sidewalks with their small businesses resembling exhibits at a country fair. Busy tailors sewed with treadle machines, hanging their finished garments on stands for every passerby to see. Talkative barbers clipped men's hair in front of small mirrors dangling on the outside of store walls. Quiet librarians exhibited their postcard-size comic books on metal racks in front of wooden benches. Customers, after paying a few cents, could read them for a short time.

Across the street sat the herb doctor next to his piles of dried plants, bark, snake skin and other strange looking ingredients which he recommended to anyone who stopped by.

And next to him was the young cobbler. While his customer waited on a tiny stool in his stocking feet, he stitched his shoes with a hand-turned machine, stacks of rubber heels at his side.

Even the bicycle mechanic worked near the curb. Once my brakes fell off, and I just coasted to a sidewalk repair man. In minutes, he replaced my brakes, and I was on my way.

When I reached the center of town, the casual curbside businesses disappeared, and replacing them were open-fronted, state-owned stores

that appeared as rigid (and boring) as Communism itself. Each displayed identical merchandise. Heavy, black bicycles guarded the entrance, blouses, sweaters and jackets hung limply from ceiling hangers and in glass cases sat a conglomeration of pots and pans, soap, envelopes or whatever you'd see in a general store. One seldom found luxuries, only essentials.

Sometimes the whole town ran out of the same item at one time. Flashlight batteries vanished once for two weeks, a serious lapse where electricity was not always dependable.

Whenever possible, I avoided shopping in these government stores. The rude salesgirls bothered me, often ignoring my requests. After all, why should they be courteous or attentive? The government pays their salaries, regardless of store profits or the service they offer. Usually, I cycled to a side street to the independently run "free market " stalls. Like booths at a Halloween carnival, they lined the edge of a street, their colorful clothes draped over metal frames--no exciting styles, but definitely more appealing merchandise than in the state-owned stores.

One day, at a clothing stand, I bought a pair of men's jeans; women's pants were too small, even though I wear a size 12. "Where can I try these on?" I asked the salesgirl who had just pulled out my size from a pile on the table.

"Over here," she answered, yanking open a curtain in the back of her booth to create a simple but adequate dressing room. The jeans fit, and I bought them for only three dollars. Clothes in China are cheap; the styles, however, are all the same. Since I didn't want to look like my men students, I bought few.

Once downtown, I threaded my way to my favorite street, where Chinese life was boldly on display. I loved immersing myself in the crowds and culture I didn't understand. Jammed with hawkers, *pedicabs* (bicycle taxis), cyclists, shoppers and wagon pullers--disorder assaulted my eyes and nerves. A cart rumbled by, piled high with multicolored long underwear; a noodle man pushed his way through, his fresh noodles waving high above his head from a long stick; a woman plopped her basket of apples on the cement, attracting eager customers like bees seeking honey. Even the "night soil" collector wove in and out, his pails swinging gently by his side. Bike bells rang, hawkers shouted, oriental

music blared out over the humming, swirling crowd, dressed mainly in royal blue, a hangover from the Cultural Revolution.

When dusk filled the sky, this noisy street donned its evening cloak.

The feather-duster merchant disappeared to make room for the sofa man who wheeled his black plastic sofa on a long cart, un-loading it next to a sugar cane hawker and basket vendor.

Across the street, the clothing stalls vanished as peasant women in blue aprons arrived on their bikes. They pulled carts stacked high with tables and collapsible glass counters, which they used for displaying roasted meat, illuminated with faintly burning candles. If they sold pork, instead of roasted duck, every piece was visible--feet, ears, head, innards and skinny, crunchy tails. If you are the daring type, as I sometimes am, you'd find the tails very tasty with cold beer.

In the pearl, gray evening other food vendors set up complete restaurants. Large hunks of pork, cold noodles, assorted chopped vegetables and peanuts awaited the hungry customer.

When I could no longer resist this array of appetizing food, I sat down at one of the tables and ordered some... trying not to notice how they washed their dishes they simply dipped the plates into a pail of cold water. While eating, a hundred pairs of eyes stopped to stare at me, mostly farmers from the countryside who probably had never seen a foreigner in this "closed city" of Nanchong.

"*Sulian*? (Russian)," they yelled curiously.

"*Bu Shr maiquo ren* (No, American)," I answered, hoping this information would make them vanish. But it didn't. They only stared more.

On my way home, before the sky turned a dark blue, I always rode along the winding river to look at the long barges docked along its banks. Men with baskets at the end of poles busily unloaded the stones gathered up the river, taking fast, mincing steps to ease the heavy weight. Under the arched bridge, *sampans* (small boats) floated leisurely by, and a tall pagoda dominated the hillside across the river. This scene thrilled me no matter how often I gazed upon it.

By following the river bank to the left, I reached the old section of town that I loved.

Long, gray buildings with overhanging roofs bordered the cobblestone streets, their doors and windows dividing them into separate apartments. In the open doorways, smells of cooking wafted from charcoal braziers, and people busily washed their clothes at public water fountains or worked on cottage industries in the street.

I especially liked watching the quilt maker. The twang of his strings echoed through the crooked streets. With a harp-shaped instrument, he thumped his tight string against a mound of cotton in order to fluff it up. Then, he spread the snowy white mountain over a bed of strings stretched out on a wooden frame, enclosing it later into a muslin sack. The cover was made from a piece of bright silk, actually the only use the farmers had for Nanchong silk.

Before night settled in, I always headed back to the campus, but never without seeing something special on my way.

One time, I saw a tall man in a long mandarin robe, strutting proudly down the street, leading a goose with a rope around its neck. He couldn't have been happier if he had a lion on a leash. Another time a street medicine man was holding a flaming torch to a man's shoulder- -thank goodness for the damp cloth against his skin; otherwise he may have burst into flames. I also watched a chicken enjoying a bike ride pinned down under the rear bike rack, blissfully unaware of its impending fate.

These scenes and more belonged to Nanchong, a town that kept modernization at arm's length, a town I loved for its simplicity and old world sights.

BAFFLED BY CHINESE CUSTOMS

Chinese customs, for me, were as confusing as reading an IRS manual upside down. In fact, if there hadn't been a shortage of English teachers at the University, I might have been a "cultural" drop-out.

The hardest custom to understand (and follow) is the way they avoid the truth. "Saving face" is what counts. As far as I could figure out, this meant skirting around the facts that might embarrass someone.

Since my childhood was grounded in George's cherry tree fable and the beliefs of Honest Abe, getting used to this, and NEVER calling a

spade a spade, threw me often into a whirling tailspin. Here are a couple of incidents:

One morning after my English class, I asked Professor Yang Lin, a student of mine, "Can you come over tonight and show me how to play *chuan pie* (a Chinese card game)?" His wife, my best friend, said he was willing to teach me.

Yang Lin didn't seem very enthusiastic about my request but agreed to drop over. "What time?" he asked politely.

"About seven-thirty. I'll invite the other American teachers, too."

It was hard to find someone who played *chuan pie* here at the University, because it is a worker's game; educated people play *mah-jong*. Yang Lin had learned it while supervising workers in a factory.

I became interested in *chuan pie* from my weekly bike rides into Nanchong. Sitting on tiny stools in front of open doorways, old men played it all over town. They always seemed to be having such a good time that I wanted to learn the game, too. Besides, I needed something to do in the evenings. Watching complicated Chinese films in the amphitheater had become extremely tedious. Only once did they show a foreign film that I understood. And guess what it was? *Rambo*, of all choices. For Yang Lin's lesson that night, I bought a bottle of wine, some cookies and a deck of *chuan pie* cards that looked as strange as the Orient itself. Long and narrow, they were decorated with red and black dots, instead of numbers, and had figures of men in gorgeous, flowing gowns.

I didn't use any of these, however. When I returned to my apartment after dinner, I found a note on my door from Yang Lin, saying, "Sorry, tonight I not come. I help students."

Feeling very disappointed, I stopped by my friends' apartment to tell them the bad news. Together we tried to guess the *real* reason for Yang Lin's cancellation, but we didn't have a clue.

Two weeks later, though, we figured it out. The next time Yang Lin came, he brought with him a worker from the car pool unit, and he taught us the game. Yang Lin only translated. Probably he felt unsure of the rules, and that was why he canceled the other lesson.

My second "save face" story involved Li Wong, a good-looking, young physics assistant who lived in a dormitory across from my

apartment. Often in the evening, he'd accompany me on my walks along the river. I liked to watch the sampans drift quietly by.

"Sorry, I not go with you tonight," he said. "I prepare my lecture."

His response surprised me. Never did he lose a chance to practice English. "Your lectures?" I probed, "You don't teach until the end of the week." I knew his Physics classes were all on Friday, and it was only Monday. "You can work on them tomorrow," I added.

"No, I work now," and no amount of persuasion would change his mind.

While strolling alone along the river in the balmy night air, I wondered what his refusal really meant.

Then, one day on campus I saw Li Wong walking with an attractive, young girl and that gave me a clue. He had found a girlfriend and didn't want to tell me.

Catching all the double meanings floating around continued to be a problem. Finally, I asked an American colleague, who understood them better than I, for his help. He agreed that when I missed the point he'd give me a sign. For instance, at banquets (and we attended many) he would kick me underneath the table!

With my colleague's "considerate" attention, I gradually made progress. Occasionally, however, I'd hear an excuse that I couldn't decode, like the following:

One day I asked Zhao Chun, a computer teacher, if she could come over for dinner on Saturday. The previous weekend she had cooked a lavish meal for me on three charcoal braziers in the hall way of her dormitory, and I wanted to return the invitation before she left for a computer conference in Boston. Zhao Chun was a beautiful girl with clear white skin and small, even features that made her look as delicate as a Chinese doll.

"I not want to trouble you," she said.

"It isn't any trouble," I assured her. "My cook does all the work."

She kept repeating the same excuse, until feeling exasperated I blurted out in a firm tone that probably surprised her, "If you don't want to come that's OK, but I wish you would." After a few more rounds of invitations and refusals, she accepted. I'm sure she never regretted it. For dinner, my cook served us a delicious Sichuan meal of stuffed dumplings, tofu in hot sauce and chicken with cashews!

Later I asked another American, who had lived in China longer than I, why she thought Zhao Chun was so hesitant in accepting my invitation. She speculated that if she had done so without my insisting she might have appeared too anxious.

I knew this rule. I had experienced it when serving guests a cup of tea. Before they'd accept my offer, I always had to repeat it at least three times. Consequently, I never knew if they really wanted the tea or if I had just won the last round. I also couldn't tell if my guests liked the tea or not. Chinese etiquette says, "Always leave some tea in the bottom of your cup," so no one ever finished it. Throwing away green tea didn't bother me much--it seemed rather tasteless anyway--but I was annoyed to see expensive, imported brandy left in the bottom of their glasses. Imagine, having to pour good brandy down the drain!

Dinner parties had special rules as well. For example, a proper hostess had to prepare many different dishes of food--at least ten for four persons. The Chinese explained that they wouldn't know if their guests had enough if they didn't have leftovers. Makes some sense, do you agree?

When I dined at Professor Yang Lin's house, I always told his wife, "If you prepare more than four dishes I won't come." I knew she was extremely busy with her children and teaching, and I didn't want her to have extra work. She never listened, though. When she brought extra dishes to the table, she always explained, "These don't count."

Another surprising custom is the way the Chinese eat. Their table manners would have put Emily Post into a state of shock, especially if she had seen the people throwing bones on the floor in a restaurant or making noise as they ate. I wish my mother had known slurping my soup was proper. I would have spent less time in my room.

Most of the mealtime noises come from trying to eat rice with a pair of chopsticks. To get the tiny grains from the bowl to your mouth, you have to hold the bowl close to your lips and shove in the rice, sucking in the grains like a vacuum cleaner. If you think this isn't a noisy affair, just eat in a restaurant full of hungry Chinese.

The Chinese handle compliments in a unique way, too. They simply deny them. This shows humbleness, a highly esteemed trait. If someone told me, "You speak Chinese well,"--even after I uttered only two words like *knee how* (hello)--I mustn't say, "Thank you very much." No, never!

With eyes lowered and voice soft, I had to reply, "No, my Chinese is very bad." Actually I didn't mind saying this, because for once I could tell the truth.

I also found it confusing to relate to men, but it's possible that's my problem in any culture. Here, I couldn't figure out if they were attracted to me or not. They never showed any special attention--no long eye contact, no tender smiles, no touching or holding hands. As unemotional as they appeared, you wonder how China's population ever swelled to over a billion.

Once, I was attracted to a tall, slender teacher named Li Jien. He had beautiful, dark, piercing eyes, a charming smile and a quiet sense of humor. Thoroughly perplexed about what to do, I asked my friend, Zhao Chun, "Do you think Li Jien likes me?" I felt like a teenager again—God forbid—but I needed her advice.

"I don't know," she answered, sipping a cup of green tea as we chatted. "How does he look at you?"

"What do you mean?"

Smiling, she gave me two different looks, one special and one normal. They seemed identical to me.

"I guess I'll need another clue," I added somewhat discouraged.

"Well, did he give you much attention?"

I thought for a moment about the times we had gone places together, but we were always with friends so I couldn't tell.

"Another zero," I replied. "Any more clues?"

She paused, searching for another question. "Did he give you gifts?"

"Yes, I nodded remembering the hand-carved letter-seal he made with my initials on it and the cassette of romantic Chinese ballads. "But we always keep the score even," I explained. In China each gift is returned with another of equal value, and I started the exchange by giving him some photos that I took of our group.

At last Zhao Chun suggested that I get a go-between (match maker) or learn to be more indirect.

"I'll take the indirect route," I concluded which meant to back off a little.

The next time we watched TV together in his room, I made a special effort to ignore him, talking mostly to his friends. By the end of the

evening things had changed. Li Jien was paying more attention to me than usual.

As we were putting on our coats to leave, he popped the question.

"You want to play soccer with me tomorrow?"

"Soccer!" I shouted in amazement. I never expected our first date to take place on the soccer field. I suppose he thought since I ran the track daily and played badminton, I knew how to kick a ball. I wanted to tell him I had never played the game and didn't care to learn, but that would have been the truth. By now I had learned to avoid it at all costs.

"OK, I accept," I told him, hoping that soccer might lead to more pleasurable activities. But it didn't. All it led to was black-and-blue shins.

In retrospect, I wish I had adapted more easily to Chinese customs, for I loved living in China. My main fear was that if I continued to say the opposite of what I thought, how would I remember what I originally felt? Well, maybe it wouldn't have mattered. I always said, "If it didn't make sense it was Chinese."

LEARNING CHINESE

To reduce culture shock, experts say you should learn the language of the country.

In a culture that seemed to run backwards, I needed all the help I could find. Immediately I began memorizing some survival phrases, a task comparable to climbing Mt. Everest with your tennis shoes on.

My first phrase of five simple words was: "How much does it cost?" Daily, I practiced it with the vendors, who clustered outside the campus gate, selling pencils, handkerchiefs and olive-green Mao hats decorated with red stars. After a month, though, I still didn't know the prices.

Pronunciation was the problem. It wasn't my fault, though; it was the fault of the guy who devised *Pinyin*, the official phonetic system. He translated Chinese sounds--my chart showed 235 different ones--into our English alphabet and got them all mixed up. For example, he wrote "cost" as *qian* and it was actually pronounced "chee-en".

"Where is the toilet?" was my second survival sentence. It wasn't any easier, though. Written as *tsu suo*, you know it was "wringer" to

pronounce. The first time I used it, I was visiting a friend. When I asked to use her bathroom, guess where I ended up? In her shower room!

After more practice. I attempted *tsu suo* again. But with even more disconcerting results. Here's what happened: I was jostling along on a bus through a peaceful countryside of green terraced rice fields when suddenly the driver jerked to a stop outside a small, dusty village. Ahead of us, workers in blue jackets were pouring hot sticky tar on the dirt road; until it was covered with small pebbles, we weren't allowed to pass. Since all the passengers piled off the bus, I took the chance to search for a rest room.

At the edge of the road stood a thatched-roof cottage with an open door. Inside the dark interior, a chubby peasant woman was stirring soup in a large black wok.

"May I use your *tsu suo?*" I asked hesitantly.

Whatever she answered I didn't understand but headed in the direction she pointed. Pulling open the door, I found a barn full of squealing pigs!

Completely stunned, I stood there motionless, wondering what to do. Should I return and repeat my survival sentence? No, I reasoned philosophically, maybe I would end up in a WORSE place than a pig pen! Spotting a large pile of dirty straw in the corner, I decided to squat down on it, ignoring the large, pink eyes staring at me. Of course, I wished I were somewhere else.

Even if I had learned *tsu suo* correctly, I might not have been able to use it elsewhere. Each province in China has its own dialect. In Nanchong, for instance, we used three dialects.--Mandarin, spoken by the professors and on TV; Sichuan province dialect; and the dialect of the farmer who switched certain Mandarin sounds to either "s" or "z". For me to figure out which sounds to convert would probably have taken years.

To add to the confusion, some Chinese sounds are almost impossible to make. Imagine, for one sound I had to first put my lips in a smiling position--letting lots of air escape from the side of my mouth--then, utter a French nasal sound (the 4th one, I think), and eventually change it to a short German "oe". Now who, except a Chinese, could remember to do all that?

Although I complained a lot about pronunciation, the four Chinese tones were even tougher to remember. As in the Thai language, each syllable in a word has a different tone. From experience, I knew these were VERY important. One day, to my embarrassment, I hit the word *ma* with a rising tone, instead of a sustained high tone, and called a boy's mother a "horse."

Though I practiced the tones relentlessly, my friends continued to correct me. They complained that "my high, straight tone" fell at the end; "my bottom tone" wasn't low enough; "my rising tone" didn't rise at all and "my falling tone" petered out at the end.

This explains why I failed my childhood music lessons....no ear for tones.

Wrestling with Chinese vocabulary wasn't a "picnic", either. Each dynasty seemed to have coined its own expressions--and since they dated back 3000 years, duplicates were around every corner. For "bedroom" I knew four words, and I'm sure many more were lurking about.

I really wished people could have spelled words that I misunderstood. But almost no one knew *Pinyin*, the official phonetic system. Not even my graduate students could transpose their names into our alphabet. Taking roll in my classes, therefore, was out of the question.

The way the Chinese explained words to me was extremely unique. They simply pretended to draw the character in the palm of their hand. I certainly must have looked *a lot* smarter than I am, because they assumed I could read "make-believe" Chinese characters backwards and upside down! (At least, they looked that way to me!)

The truth was I didn't know any Chinese characters.....Well, hardly any. Actually, I recognized two: one for "men" and one for "women". They helped me with my *tsu suo* problem.

Even the four "survival-phrase" books I had complicated matters. None of them used the same phonetic system. For example, "thank you" was spelled four ways: *xie xie, chihsie chihsie, sye sye,* or *shieh shieh.* Not liking any of these, I devised my own way to remember "Thank you". I wrote it <u>SHEE</u>-A <u>SHEE</u>-A. The underlining reminded me to swallow before I made the air sound, otherwise I'd spit in someone's eye.

What I really needed was a good Chinese dictionary with a better phonetic system than *Pinyin*. Naturally, none existed. That would have made learning Chinese too easy!

Finally, I decided to look around for a grammar book. Remembering that my alma mater, the University of California at Berkeley, had a Chinese department, I sent my request to the campus book store. And guess what they sent me? Their concise grammar book of *542* pages entitled *Easy To Learn Chinese!*.

By this time, I knew better than to believe the title. The first part of the book contained an introduction of 150-pages! Yes, that's right: 150 pages of pronunciation rules. I was sure that memorizing all of them such as "retroflex initials," "silbilants," "disyllabic tones,"--in place of vocabulary--would never get me out of the local bus station. Consequently, I skipped right to the section entitled "Special Hints to the Learner." It suggested that I revert to my childhood--something I'm prone to do anyway--and think in Pidgin English. If I said, "You looking for who talk" and translated it into Chinese, I would be asking, "Who are you calling?" Or if I said, "Good long no see," it meant, "I haven't seen you for a long time." Clever, huh?

For the slow learner like myself, I thought of another hint. I could look for a Chinese boy friend who didn't know a word of English and attack the language from a more exciting angle. But big brother, known as the government, would have probably frowned on such a frivolous, romantic approach, and if discovered, I'm sure I would have landed immediately back on my Mother's doorstep. Heaven forbid!

In spite of all these obstacles, you might be pleased to learn that I didn't give up learning Chinese. I often wondered, however, if the person who coined the phrase "Where there's a *will*, there's a way" ever studied Chinese!

A CHRISTMAS PARTY

Have you ever given a party that turned out differently from what you expected? My Christmas party certainly did.

One evening I invited a few of my students over to share some holiday festivities. No one knew what to expect (they don't celebrate Christmas in China), not even me!

"What's that funny thing hanging outside your door?" they commented as they removed their heavy coats in my entry way.

"A wreath," I answered proudly. "I made it." Feeling a twinge of Christmas spirit, I had snatched some scrawny branches from the park below--when no one was looking, of course--and tied them in a circle with a big red bow.

"A what?"

"A wreath", I enunciated carefully, realizing they found the word strange. "We make all kinds of Christmas decorations. I bragged. We EVEN decorate whole towns."

When they stepped into my living room, the decorated tree in the corner didn't arouse much comment. A few nights before, some had helped me decorate it.

It wasn't really a Christmas tree, but some sort of potted plant from the university nursery that our Foreign Affairs Director had kindly sent over.

One night, instead of holding class in the freezing language lab, we met in my cozy living room and made decorations.

I taught them how to cut out snow flakes, string popcorn and make garlands of red and green paper loops. Everyone seemed to have a good time, though progress was slow. For a while, in fact, I thought we might not finish before Christmas--two days away; but after serving my Christmas grog--a mixture of hot water, whiskey and orange juice powder (more flavorful than you'd think!)--production flowed.

Like most Christmas trees, ours looked colorfully cheerful, though I hated the lights. They blinked off and on like a flashing Pepsi sign.

"Can't we take the 'blink' out of those lights?" I pleaded.

"No, we like them that way." I gave in and said no more.

For our Christmas party, I planned a variety of activities. First, a present exchange. In class, I had told them how the wise men brought gifts to Jesus and requested that each student buy an inexpensive gift for a classmate whose name they had chosen.

To make the occasion more authentic, Santa Claus was to appear. An American teacher living down stairs promised to dress up in his red long johns and pass out the gifts from a white pillow case.

Unfortunately, I had to cancel his illustrious visit when I noticed that all the presents they brought were labeled for me! My table had a bigger pile of boxes on it than on my wedding day! I wanted to tell my guests that their English comprehension was lousy but restrained myself

The river in Nanchong

Me posing in front of statues in a Buddhist temple

admirably. In a sweet voice, I thanked them for their generosity and *asked for their permission* to open the packages in front of them.

You see, in China, presents are always unwrapped in private. In that way, you won't embarrass the giver if you don't like his present. Clever, huh?

What I received were mostly trinkets, nothing Chinese looking or ethnic, which I would have liked, except for one present from Chen Li-Xin, a tall, handsome student whom I had a slight crush on. He handed me a hand-painted scroll.

With everyone watching, I carefully unrolled it on the floor, admiring the bold, black calligraphy which I hoped would say something pleasantly sentimental.

"What does it mean?" I asked.

"It says, 'may our friendship last forever.'"

Friendship! I thought. Chen Li-Xin certainly didn't know much about friendship. At the last minute, he had cancelled most of our dates, always with the same excuse, "I have an important Communist meeting." As an enthusiastic Party member, he felt it his duty to constantly help others.

Considering his Party loyalty, I guess I was extremely lucky the scroll didn't say, "May Communism bless your life forever."

After seeing the results of our present exchange, I knew my next activity was probably doomed, too. In class, I had asked everyone to bring a *homemade* Christmas card for a classmate. To give them some ideas, I showed them old cards, suggesting that they draw religious scenes, Santa Clauses or snowy landscapes.

No one understood. They brought cards, all right, but all were scenic postcards of China with "*Mary* Christmas" written on the back of them.

In addition, **all the cards were addressed to me.**

When tradition says, "honor thy teacher", I suppose they couldn't comprehend bearing gifts for a classmate.

After two failures in a row, I had no hope for my Christmas caroling around campus. Nevertheless, I was determined to try it. "It's now time to go caroling," I announced trying to sound cheerful, but feeling very unenthusiastic. "Let's go put on our coats."

No one budged. I could understand. Why confront the cold, when you're sitting in a cozy, warm room? Actually, I didn't want to leave either.

Nevertheless, after some "high powered" persuasion (I think, I mentioned grades) I gathered a hearty handful of volunteers. Bundled up from head to toe, we headed for the apartments of three Chinese English professors who lived on the 6th floor of different buildings. After trudging up the cold, gray cement stairs and catching our breath, we began singing behind closed doors. I had wanted to surprise my colleagues, so nobody was expecting us. A giant mistake!

Not one professor was home!

Each time, after singing, a person I didn't recognize would open the door and stare at us in amazement; offering no smiles, no invitations for punch and cookies, no clapping. (Later, I heard that all the professors were attending an English Department meeting that night. How unlucky can you get?)

Some students waited on the ground floor and refused to climb the stairs. "Why don't you want to come with us?" I admonished.

"We don't want to disturb the people," they explained.

In a way, I could sympathize with them. Our carols did sound rather bad, even though they could recite the words as well as those of their national anthem.

"Jingle Bells" was their favorite. Our school band played it at all our dances. In fact, it was the only fast number the band ever played so we jitterbugged to it. Imagine!

After returning to my apartment and thawing out from the icy winter chill, I started my party games. Sitting around in a circle, I introduced the simplest one first, "Button, button, who's got the button". As you can probably guess, it didn't work! Why? Because no one followed the rules. Everyone helped one another. In less than five minutes, it fizzled out completely. "You guys are carrying Communism too far," I complained. But no matter how thoroughly I explained the "competitive spirit" they couldn't grasp it. At last, I gave up and *kept all the prizes for MYSELF.*

At refreshment time, I served a variety of drinks: Chinese wine (sweet, like vermouth), beer, and some Chinese champagne (slightly bubbly with a low alcohol content). To my surprise, they drank only one

glass and no more. In class the next day, I asked them why. "We drink alcohol only with a meal," they explained.

The cookies and candy were hardly touched either, though the peanuts and sunflower seeds vanished quickly. In fact, the shells covered my ENTIRE floor. What they couldn't swallow, they dropped on the floor. I tried not to look shocked--a bit hard to do--but I remembered seeing the same phenomena in countryside restaurants. What people couldn't eat, bones, gristle or watermelon seeds, simply landed on the floor.

At the end of the evening, I had a dance in my entry way, removing all of the furniture before hand. I knew that rock and roll music was too fast for them so for the first number I played a slow fox trot. When no one got up to dance, I began insisting. And what happened? The girls danced with girls, the boys with boys!

Stopping the music, I shouted, "No, no. You can't dance that way. It's an American party, remember?" I probably embarrassed them, especially the shy, young girls. Nevertheless, I persisted and after a while they were dancing in couples. This time holding one another at arm's length. It was clear that there would be no cheek to cheek nonsense that night--too frivolous, probably, for Party doctrine.

I had hoped my party would last until eleven, but by ten o'clock all my guests had disappeared. It was as if the loud speakers--that woke us up every morning at 6:OO--had warned them to be off the campus walkways early.

Feeling forlorn, I sat down alone in front of my blinking Christmas tree lights and sipped a glass of champagne. I thought about my evening, the surprises I had, and the mistakes I made, and wondered if any of my students had had a good time.

Then, I concluded philosophically, that maybe my Christmas party wasn't a complete failure after all. I'm sure I learned as much about their customs as they did mine!

TIBET & THE SILK ROAD & INNER MANGOLIA

During my school vacations I traveled around China to the tourist sights like: Xian (the warrior statues), Guilin, Shanghai, Beijing, and

the great wall. I also climbed Mt. Huang Shan, took a boat down the Yangtse River and flew to Tibet. I traveled alone, but when other backpackers found out that I spoke Chinese, they soon joined me One traveler was Pierre, whom I noticed on the train. When he got off at the same place as I and began following me in his bicycle rickshaw, I asked him if he'd like to share mine since we were both going to the same hotel. Soon we discovered that we were very compatible and later traveled together for several weeks, climbing Huang Shan, and taking a river boat overnight down a canal.

Eventually, we parted because we were going to different places. I had heard that they were now opening up Tibet for backpackers and not only for tourist groups as before. Therefore, I rushed immediately for a visa and plane reservations.

Our plane landed in Lhasa and they directed us individual tourists to a very primitive hotel with showers and toilet facilities outside in the patio. For the first few days all of us lay around on the roof, trying to overcome altitude sickness. When I recovered, I rented a bike and rode to the monasteries outside of town to see all the monks in maroon-colored robes performing rituals. I also visited the Portola on the hill where the Dalai Lama once lived. I was even allowed to enter his bedroom.

I found Lhasa a very spiritual place. It seemed whatever I wished for appeared: When I needed to change money, a man appeared at my side in an isolated place, to exchange it for me. Another time I wanted to meet a particular tourist again, he appeared at night in the same bar. Whatever I wanted seemed to come to me just by wishing it.

Though I liked living in China, I wanted to see other parts of the world. So after I resigned I made one last trip on the silk route near the border of China and Russia. I first took a train from Lanzhou where I stayed a few days to arrange the trip. Then I boarded the train to Urumqi which was packed. I had a seat but many people were standing in the corridors. When I had to transfer trains in the middle of the night, I had to crawl out the window.

In Urumqi the people were not Han Chinese, but Ughurs with different shaped eyes and faces. There wasn't much to see in Urumqi, a desert-looking town, so after a few days I took the train to Hohhot in Inner Mongolia. From here I joined a tour to the desert to stay in a yurt,

a large, round, white canvas tent. About 10 of us slept on cushions on the floor in pie fashion with our feet facing the center.

One night I went partying with a fellow tourist to another yurt, and when I was ready to return to my yurt I had trouble finding it, because they all looked alike. Once inside I couldn't recognize my cushion in the dark. Without waking up too many people I finally found it. After that, I vowed to drink less beer!

From Urumqi I rode the train to Beijing where I stayed two weeks to get my reservations for the Trans Siberian Railway to Moscow and my visas for Warsaw, Prague and Budapest.

The busses in Beijing were so crowded that I rented a bike and rode in the bike lanes to all the embassies and palaces. My best ride one evening was around the grounds of the Hidden Palace. Not a soul was there to tell me it wasn't allowed.

LEAVING CHINA ON THE TRANS-SIBERIAN RAILWAY 1987

In the early evening, with the air soft and cool, I boarded the Trans-Siberian Railway at Beijing for Moscow. As I stepped into my deluxe, two berth compartment, a stern looking Russian man was busily piling immense cardboard boxes on top of *my* reserved seat. "Excuse me," I said politely, "but you're occupying MY seat!" Ignoring me as if I were invisible, he continued arranging his fifty-or-so boxes.

I repeated my sentence with no results, never imagining my long-dreamed-of-train ride would begin this way.

With considerable disappointment, I lugged my heavy suitcases into the corridor.

Shortly, a tall, young American walked toward me. "Hello, I'm John," he said in a friendly manner. "I've been looking for a conductor. My compartment looks like some guy raided a discount store. It's full of large boxes."

"Really!" I laughed.

Comparing tickets, we discovered that we had been assigned the same berth! My reservations were made from Beijing, his from Hong Kong.

While waiting for a conductor, we squatted uncomfortably on our suitcases and watched the train slowly slide out of the busy station, passing hordes of travelers standing along the platform.

We both felt excited about being on board. John was headed for London to do research in international law, and I was traveling to Paris, after teaching in China for a year and a half.

About twenty minutes later, a large, husky woman conductor in a gray uniform came by and asked to see our tickets. Since neither John nor I spoke Russian, we did the best we could to explain our predicament.

Without hesitating, the conductor entered the "box man's" compartment to confront him. I could tell his Stalin-like arrogance hadn't changed.

Confused, the conductor spoke a few words to us and disappeared. Upon returning, she motioned for John and me to follow her into another car where she gave us a narrow, dingy, uncomfortable-looking compartment with padded, black plastic seats. "This is only temporary," she assured us in Russian, using her hands to help explain. "In Harbin, I'll move you back to the deluxe car."

I felt relieved to have escaped the strange "box man". I knew John would be a better roommate for a week-long train ride. Not only did he seem extremely intelligent, but he had a good sense of humor, too.

For the next few days, our long train zipped through Manchuria. After the beauty of Tibet and the Silk Road, the scenery of fields, factories and towns seemed uninteresting. Instead of gazing out the window, I read John's books about Russia and sipped hot lemon tea prepared by our motherly coach attendant. Then three times a day, John and I would wander into the dining car. Even though the food was about as tasteless as cardboard, we still looked forward to meal time.

After 600 miles of speeding through China, we arrived in Russia. And what a change!

At the border, gruff officials demanded that we quickly empty the train. Why? Because every carriage had to be hoisted up with a crane and fitted with a new set of axles and wheels. Not trusting their neighbors, the Russians had installed broad-gauge tracks to avoid any sneaky Chinese invasion by rail.

During our "conversion", we stood around for two hours in a cold, bleak train station with less charm than a warehouse. It did, though, give us time to meet the other European passengers: three middle aged Austrians and an Australian couple from Hong Kong.

While in the crowded waiting room, we also had the opportunity to exchange our money. The clerk, however, insisted that I have a dollar's worth of Chinese coins before he would accept them. Presuming other passengers had the same problem, I circulated through the crowd like an official and collected left-over change. Business was good. Soon I had enough to buy three bottles of wine from the souvenir shop..... perfect for the "happy hours" that John and I later shared with the fun-loving Australians.

At the time I bought the wine, I didn't realize what a wise investment I had made. Once inside Russia, no alcohol was sold anywhere along the way, not in the train, nor in the stations. A new Gorbachev-rule, they told me. Needless to say, it didn't add to his popularity, especially with me.

Shortly, after we were rolling along on "new wheels", something scary happened. Two uniformed officials carrying a ladder and a tool-set invaded our compartment and began unscrewing everything in sight, searching for smuggled goods. They looked like sinister characters from an espionage movie.

My heart began to pound. What if they discovered the black market rubles I was hiding inside my shoe? (I had changed 200 dollars into rubles in Beijing.) Would I be thrown into a dark, damp prison like Solzhenitsyn described in his *Gulag Archipelago*? Or perhaps something worse?

Sitting as rigid as a stone statue, I stared at the two men taking apart our vents, light fixtures and heater with the precision of a surgeon. John was nervous, too. With his concealed legal papers, Russian books and current magazines (as well as a few pairs of jeans for a lucrative Moscow street sale) he thought they might think he was a spy.

Fortunately, though, these investigators hardly examined our luggage or personal belongings. I'll never understand why. Maybe "box man" saved us. They might have gotten behind schedule while searching through all his cartons. Who knows?

Barely recuperating from this ordeal, another grim-looking controller stomped into our compartment. This time the investigation was worse.

"Passport," the serious looking official demanded standing directly in front of us.

John handed over his first, including a special paper, and the controller seemed pleased.

Next, I showed him my passport.

Thumbing back and forth though my passport pages, obviously searching for something, he shouted, "Voucher!"

"Voucher?" I repeated in surprise. "*No* voucher!" I affirmed, shaking my head.

"Voucher!" he screamed at me again.

I knew that individual travelers to Russia were supposed to prepay their trip, as John had done in Hong Kong. But the Russian Embassy in Beijing couldn't accept money for my hotel reservations. When I asked about a voucher (after hanging around the embassy for three weeks), the secretary simply replied, "Don't worry. You won't need one. An Intourist employee will meet you at the station in Moscow." (Too bad officials don't know the government's rules.)

"*No* voucher!" I yelled back, wishing somehow I could explain I had entered Russia by China's back door. "Voucher!" he roared once more.

Our shouting match continued for another five minutes as I desperately struggled to hold my ground. Finally in a state of rage, he slammed the door and left.

Feeling like an arctic wind had just whirled me around, I sat stunned.

Three days later, at Irkutsk, John and the other foreigners left the train to spend a couple days at Lake Baikal, the largest lake in Siberia. I thought about joining them, except I wasn't sure if I could change my travel plans which had taken so long to make. To be honest, I really didn't want to leave my motherly attendant and luxurious compartment with its soft, gray velvet upholstery.

I was surprised that I wasn't lonely when my friends left. In fact, I loved my leisurely days and gradually established a routine as one does on a cruise ship.

Part of the time I spent gazing out the window at Siberia's immense forests. Even though it was only September, many of the trees, mostly birch, were wearing their vibrant fall colors. Entire hillsides were ablaze with leaves of yellow, orange or red. It was breathtaking. Occasionally we'd pass a tiny village, always just a cluster of small, wooden houses (usually green, yellow or blue with white trim) inside a fringe of forest. Over their pointed roofs hung a terrible feeling of isolation and loneliness.

At other times I met my North Korean neighbor in the corridor, a pencil-thin man with alert, intelligent eyes who was on his way to a lawyers' conference near Moscow. He liked to teach me Russian from a Berlitz book John had left me. I don't know how well he spoke the language, but I didn't much care. To learn Russian with a Korean accent, I reasoned, was better than no Russian at all.

Afternoons I would stroll through the train for some exercise. In third class, in a crowded, six berth compartment, I met five young Europeans and a chubby Chinese girl from Hong Kong, named Jane Min Li. Both of us shared a love for adventure, so we quickly formed a traveler's friendship.

Rarely did I step off the train. Not knowing the schedule, I feared I might be left behind. However, every time we chugged to a stop, I popped into the corridor to look over the new passengers.

One morning, near Novosibirsk two dark-skinned Turkish-looking gentlemen climbed aboard. Using hand gestures, we began conversing. I was surprised at what a good time we had, laughing and joking like old friends. When they got off at the next train station, I actually missed them. They were so different from the serious Russians I had met so far.

After a week of traveling 6,000 miles, Moscow flickered into view through a misty drizzle, its skyline looking impressive under the gray clouds. Together, Jane Min Li and I got off the train, expecting to see an Intourist representative on the platform.

Unfortunately, not a soul was there to meet us.

Drenched with rain and disappointed, Jane Min Li and I joined the long taxi line that snaked around the Moscow train station.

In my past travels, taxi drivers had often solved my dilemmas with the tenacity of bill collectors. This time, though, our driver acted as if

he wished we were in someone else's taxi. When I requested politely, "Please take us to the Intourist Office," he simply frowned and looked confused. From his expression, I could tell that neither he nor Moscow welcomed stupid, lost travelers who didn't even know where their hotel reservations were. After he realized that we weren't moving from his back seat, he started his engine. Cruising around the city for the next hour, he stopped at various offices. Then, by accident, as most good things often happen, he dropped us off at an Intourist office that had heard of my name. I felt as happy as a child finding a brass ring in his Cracker Jacks!

My reservations were at the Kosmos, a 1,700 room hotel on the fringe of Moscow. By the time we arrived, half of Moscow had passed before our eyes. We drove down wide boulevards, around immense turnabouts and in front of enormous, sturdy buildings, that loomed up like huge battleships in a sea of drab concrete. Moscow struck me as a no-nonsense city, interesting, though, to a first time visitor.

With its crowds and commotion the lobby of the Kosmos reminded me of a London railway station. I was glad to see so many people milling around, though, because it meant sneaking Jane Min Li into my room that night would be a "*hunk* of cake" (nothing is small in Russia).

I wanted to help my adventurous friend. As a young Hong Kong tourist, she was traveling on a skimpy income as I once had done. For her to pay $125 for a room--the nightly rate--would have blown her budget for a week.

I tried to check into the Kosmos quickly, but it was as impossible as talking a cop out of a speeding ticket. (I know, I've tried.)

"You need a cashier's receipt," the receptionist demanded. My old *voucher* problem had returned once more to haunt me .

I pulled out a wad of rubles from my money belt (I had moved them from my shoe after customs), and joined another line, my seventh in the last three hours. When I arrived at the cashier's window, the lady shook her head and said, "Sorry, only dollars, please."

"Dollars...!" I exclaimed, suddenly realizing that my plan to pay expenses with black market rubles was about as useless as patching a rubber raft with a piece of scotch tape. Feeling that I'd been thrown up against a wall of bureaucracy (or was it Communism?) I signed a stack of traveler's checks. Then with *voucher* in hand, I returned for my key.

We dumped Jane Min Li's backpack in my room and hurriedly taxied back into town to see the Red Square. Looking at its beauty quickly wiped away the frustration of our arrival. In one corner, loomed into the sky St. Basil's cathedral with its multi-colored onion domes decorated with fairy-tale- like designs. Beside the Kremlin wall sat Lenin's mausoleum a flat building of pink stone. In the front of it were crowds of people and large red and white flowered wreaths. Nearby was a huge, stately, red brick tower, ornamented with 19th century pointed spirals, all trimmed in white. Surrounded by such famous buildings, I felt like history was shaking my hand.

After night's greedy fingers grabbed up the remaining gray sky, we strolled through Gorky Avenue's back streets in search of a typical restaurant. All we found was a dreary cafeteria with white, plastic table tops where everyone glared at us as we entered. In spite of feeling terribly out of place, we grabbed a tray and stood in the line anyway. Our dinner of watery stew, hard bread and sticky yellow pudding was so tasteless, it made American fast food seem like gourmet cuisine. Now I understood why Mac Donalds is one of Moscow's most popular restaurants.

Later that night, we decided to return to the Kosmos Hotel by way of the subway, a decision about as stupid as not feeding a parking meter in front of a police station. (I've done that, too.) Inside the station every sign was written in the cyrillic alphabet, tougher to read than Greek.

While standing in a large, white-tiled corridor, wondering what to do, a wisp of good karma intervened. A short, pudgy man weaved through the crowd to greet us. Smiling as if he had just finished off a pint of vodka (or maybe two), he inquired in broken English where we wanted to go.

"Hotel Kosmos," I replied, returning his smile. He then led us down a long flight of stairs, and together we boarded the same crowded train.

As we roared along, our jolly companion kept repeating the only few English words he seemed to know, evoking cold stares from all the passengers. You'll never guess what they were? "America! Russia! Peace!" He shouted continuously. I prayed his government felt the same way. (Remember these were "pre-peristroika" days.)

We descended together at our destination and walked through long, bleak corridors where women were selling bunches of flowers. With

surprising generosity, our companion bought us each a big bouquet of white chrysanthemums. To show our appreciation, we bought him twelve pink roses, which he immediately handed back. We had no idea why.

Anyway, the more vendors we passed, the more flowers he bought us. By the time we said good by and thanked him, our arms were loaded with so many bouquets you'd think we'd robbed a florist shop. Back at the hotel, our maid brought us a *bucket* for our bouquets. She had no vase large enough for so many flowers.

The next morning, under another gray sky, Jane Min Li left on the train. I remained in Moscow for a few more days for more sightseeing. Two things impressed me about the city: the immensity of everything: buildings, plazas, parks, etc. and all the long lines. Even to buy a cup of coffee at a kiosk, you had to cue up.

After seeing the sights of Moscow I boarded the train for Leningrad to visit first the Hermitage, a famous museum, and then the summer palace with its many elaborate fountains.

Then from Leningrad, I took the train to Warsaw, Poland. I was in a first class compartment by myself. When we reached the border I showed the conductor my passport with my Polish visa and he insisted that I open my luggage. In examining it, he found my old Peace Corps passport. Having two passports made me look suspicious so he took both passports and disappeared.

Was I nervous! I was the only person in my section and there was no one around to talk to in the entire first class part of the train.. I prayed fervently. Finally after about fifteen minutes, the conductor returned and handed back my two passports. What a relief!

POLAND

My next challenge happened in Warsaw. I arrived late at night and hadn't been able to make hotel reservations from Moscow. As usual I planned to rely on a taxi driver to find me a hotel. But this time my plan didn't work. All the hotels he took me to were full. As a last resort, I showed him an address of a student dorm outside of town near the university which a backpacker on the Trans Siberian Railway had given

me. The driver phoned the hostel and they had one bed available in the woman's dorm. What luck!

Every morning from the dorm I rode a street car to the center of Warsaw to go sightseeing. The monuments and parks were attractive, but the town's buildings were drab. One cab driver I had told me I couldn't leave Poland without going to Krakow, a historic town, and former capital, which I had never heard about.

We agreed on a price and the next morning he picked me up at my hostel Our trip took eight hours, passing mostly through farmland. In Krakow I had no trouble finding a modest hotel and loved seeing the town with its many attractive churches and castles. Only one thing was wrong. By coming here, my visa for Poland had expired.

"No problem," I thought. "I'll just have it extended." Therefore the next day I went to the police department but an extension was so expensive and complicated that I tore up the form they gave me and left.

That night before my departure, I was walking around the main plaza in town and met an English lady. I told her I was worried about passing the border with my expired visa. "Don't worry," she said. "I know what you should do. Just buy a bottle of rum and before you get on the train, drink some and you'll feel all right." In the plaza she took me to a special liquor store for a pint of rum.

Later on the train platform I met another American, Craig, who was also going to Prague. He was just returning from visiting his Russian girl friend in Novosibirsk, where he once lived while doing research at the university. He told me about some of his experiences there: Before he left Novosibirsk someone entered his apartment and deleted all his research on his computer.

Fortunately, Craig was in the same compartment as I. His bunk was on the bottom, mine on the top. (I vowed never to go first class again after my experience on the Russian border where I was all alone.) When the conductor came into our compartment to check our tickets and passports, he discovered that Craig had been to Russia and demanded that Craig open all his luggage. This inspection took so much time that the conductor barely had time to glance at my passport and handed it back without even mentioning my expired Polish visa. What luck!

VIA PRAGUE & BUDAPEST TO FRANCE

In Prague I stayed in a hotel near the center of town and after seeing the famous bridges, castles, and churches I left on the train for Budapest. At the railway station in the tourist information office I was given the address of a room available in a private home of a professor. It was a comfortable place to stay and daily, I took a bus to the center of Budapest, an interesting city, especially the old part of the town.

My next train trip was through Austria to Paris, and then on to Aigrefeuille, a village near the Atlantic Coast. There I stayed with Chantal and her family who had been my neighbors in Flers, when I taught there. She had a large house and gave me my own bedroom. Chantal sold clothes in open markets in the small towns in her area. Every morning we'd leave early for a different town, and I'd help her set up her booth and wait on her customers until the market closed at !:00 p.m.

I stayed with Chantal for two months. While I was there Norman, whom I met in China, phoned me frequently from England and if he had a conference in London, I flew from the Nantes airport to meet him. Our passionate romance continued.

Eventually, I got a job through a special teacher's magazine, to teach English in Peru. Before I left, I took two trips: One to Morocco, to see Casablanca, Rabat, Fez, and Marrakech. and the other to Liverpool, to say goodbye to Norman, the visiting professor I met in Nanchong and whom I fell madly in love with.. I intended to end our relationship, before I flew from London for Peru, but he insisted that we continue it, which I did.

THE BIG SWITCH

LEAVING EUROPE FOR PERU, AUSTRALIA, NEW ZEALAND, COSTA RICA & SOUTH AMERICA

My plane left from London via Frankfort for Lima. I had been in Lima before when I visited Machu Pichu and Cuzco but knew very little about the current political situation. I remember how surprised I was when my seat companion told me about the current revolution. "My father is a lawyer and carries a gun at all times," he said.

When I arrived in Lima a school administrator met me. He took me to a family who rented me a room with one meal a day. The school was in the outskirts of town and the students were mostly adults who came in the evenings. I didn't like the school. It was disorganized and dirty. The only time the floor was washed was when the toilet overflowed.

While I was there, I heard about another language school in the center of Lima called, *Instituto de Idiomas* (institute of languages) a section of the prestigious Catholic University. I applied for a job there and when I was hired, I moved to a room with another family near the center of town. I liked teaching there. I was also given free enrollment in a Spanish language class at the school.

What I disliked about living in Lima was all the political tension. Two soldiers with long machine guns stood at the school entrance and another two guarded the school patio to protect us against the rebels, called the *sendero luminosos*. Frequently they blew up the electricity

power plants, causing blackouts and making it dangerous to even ride in an elevator. I seldom went to the center of town because it was infiltrated with young boys trained as thugs. Without warning they would grab your watch or bag. If I did venture there, I wore old clothes and no jewelry.

While in Lima, I took several interesting tours. One was to see the Nazca lines in the desert that are still visible by plane after thousands of years. Another trip was down the Amazon River by boat where I stayed in a rustic lodge and visited the native tribes.

Even though I liked teaching at the school, I found living with all the political tension affected my health. Frequently, I had infections, digestive problems or didn't feel well.

Therefore, I was ecstatic when Norman, the visiting professor from England, whom I met at the petroleum institute in Nanchong, China. sent me a ticket to spend a month with him in Australia. He had a summer professorship there at the University of Melbourne.

Since there was no Australian embassy in Lima, I had to obtain the visa either in the States or in Chili. I chose the embassy in Los Angeles. For a few days I stayed with Claudio's friend while I went back and forth to the embassy and to the airline office for reservations.

It was a long flight to Australia. When I arrived in Melbourne, Norman was waiting for me at the airport. We were as much in love as ever and though he worked most of the time at the university, we still had time to take hikes, walk on the beach and attend the opera.

When Norman returned to Liverpool, England I flew to New Zealand to visit my friends, Marge and Alex, whom I met in Nepal on the Anapurna trail. While I was there Marge showed me the main sights of the South Inland, including the Melford trail on the coast and the glaciers and ice fields.

COSTA RICA

From New Zealand I flew back to Melbourne and then to the States. I didn't stay long in California before I left for Costa Rica. My friend,

Susan, a student at UCI, was studying Spanish at the University in San Juan and invited me to visit her.

In San Juan I thought I might teach English, but most people already spoke English and they didn't need English teachers. To keep busy, I enrolled in a Spanish class sponsored by the American library.

On the week ends Susan and I traveled around Costa Rica visiting Lemon on the east coast, known for its Rastafaris and Reggae music, the jungle to see exotic, colorful birds and rare yellow frogs, and volcanoes.

While in Costa Rica, I decided to travel to South America. I first flew to Santiago, Chili. Even though I speak Spanish I had trouble understanding their Spanish. In the guest house, where I stayed, a young Spanish-speaking-traveler accompanied me and translated everything into the Spanish that I understood.

From Santiago I took a freighter to the tip of Chili, called Tierra de Fuego, a desolate, cold place, then rode a bus through Patagonia to see Iguazu Falls, the longest falls in South America, and Buenos Aires in Argentina. From here I flew to Rio de Janeiro in Brazil and on to Manaus. There I joined a two day boat tour down the Amazon. River.

When I returned from this trip, I began to feel sick. I returned to Costa Rica and while at Susan's I had all kind of medical tests taken, but with no results. Finally I returned to the States and eventually I got well, never knowing what illness I had.

SECTION FOUR

BIKE TOURING

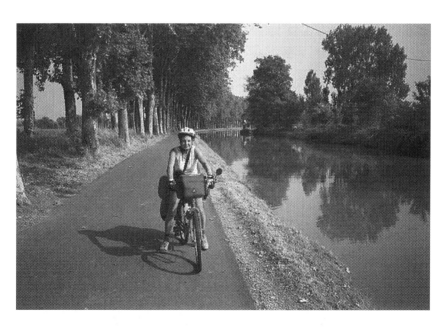

Riding along a Canal in France

My Life

When I returned home in 1988 after living in Costa Rica and traveling around South America, I began bike touring. It was something I had always wanted to do, but knew nothing about. I friend of mine who had cycled in France and South America became my mentor. He taught me how to box my bike for the plane, what to take for camping and the way to plan my route on country roads with a detailed map The editor of a Laguna Beach newspaper published my journals.

The following is a list of my biking trips..

Trip No. l 1989 France: Paris to the Atlantic Coast

Trip No. 2 1990 Oregon Coast: Flew to Portland & rode along the coast.

Trip No. 3 1991 Northern California: Flew to Eureka & cycled along coast.

Trip No. 4 1993 England, Holland & Switzerland

Trip No. 5 1994 Ireland, Austria, along the Danube, & Italy

Trip No, 6 1995 Seattle, San Juan & Gulf Islands to Vancouver, Canada

Trip No. 7 1997 Denmark & Sweden

Trip No. 8 1998 Scotland

Trip No. 9 2001 Prince Edward Island & Nova Scotia, Canada

Trips No, 10-15 1999-2006 Canals in France

PART 1

JOURNAL EXCERPTS FROM
DIFFERENT COUNTRIES

FRANCE 1989
My First Bike Trip

The 10 hrs. flight from LAX to Paris was without problems. Air France accepted my bike box as easily as a back pack. If I had known it was so effortless, I might have gotten off the beach sooner in Laguna.

Arriving in Charles De Gaulle Airport in Paris was the scary part. I hadn't the slightest idea how I would get my bike box into Paris. I was simply going to rely on American ingenuity and my status as an ex-French teacher. Thank goodness I didn't need either. Just as I was pushing my Vons-like shopping cart through the customs door I spotted my former Laguna neighbors who now lived in Paris. They came to the airport to surprise me.

Dog Trouble
On the Route from Paris to the Atlantic

As I was speeding down the road surrounded by lush green foliage, I suddenly spotted a small castle, so charming with its round tower and quaint draw bridge that I bet even Goldilocks couldn't have resisted it. "I'll just investigate it for a few minutes," I said to myself. I turned down a gravel road and just as I was entering the open gate, a ferocious, barking dog ran toward me. I screamed and turned my bike around, but

it was too late. The dog bit my leg. It happened so fast, I couldn't believe *it*. The wound wasn't serious—only a little blood—but this incident changed my style. After that I obeyed all Private Property signs.

IRELAND 1994

Riding in the Rain toward the Coast

What makes bike touring adventurous is that it constantly requires making decisions about things you know nothing about. Oups! … sounds like my life in general. In addition, one wrong decision can make you wish you'd never left home.

That's the way I felt today. Shortly after two o'clock just as it began to rain, I arrived at Schull, an attractive beach town. If I had one kilogram of common sense and wasn't a type A personality, I'd have checked into a cozy hotel and spent the afternoon stuffing myself with savory scones topped with thick, fluffy cream. But no! Thinking the weather might change, I made one of those "uninformed decisions" I mentioned. (Actually, "stupid" is a better word) I donned my rain gear and rode on.

All the motorist must have been in one of those cozy hotels because no one was on the road except me. Shortly, I descended into Castletownbere, my evening destination. According to my tour book, it was a quaint fishing village on the coast. I found it, though, an ugly, run-down town that I wished I'd never seen. "You mean, I've climbed all those mountains for this?" I said harshly to myself, as I headed for the nearest pub. While drowning my disappointment with a tall Guinness at the bar, I stood up and asked anyone listening, "How do I get out of this place?" A fat man in his fifties sitting nearby answered. "I'll take you."

Surprised at such a sudden response, I shouted, "You will? Where to?"

"Allihies, I have a pub there."

I knew that the village had a hostel and campground so answered, "OK, I'll go," thinking anyplace would be better than where I was and maybe I might even like Allihies. In fact, his pub was so much fun at night with all the fiddlers and friendly people, that I hung around for four days.

SEATTLE TO SAN JUAN & GULF ISLANDS TO VANCOUVER 1995

Without Camping Fuel

While I was on my way to the Manchester campground from the Seattle airport, I realized that I didn't have a canister of camping gas for my stove. I was not allowed to carry one on the airplane and I had forgotten to buy one upon my arrival. "Oh well" l mumbled to myself, "I'll buy one along the way." But that didn't happen. There was no store along the way. "Guess I'll just have to gather up some wood and make a fire" when I arrive.

Just as I was returning to my tent after exploring the campground, I noticed a sign in big black letters saying BEWARE OF BEARS (This explained why no one was around but me.) Probably I should have been frightened but I knew no bear, with an ounce of common sense, would be interested *in attacking my tent.* The only the food I had was a package of dried noodles and an envelope of soup powder. But another sign, however, bothered me even more. It read: *No CAMPFIRES ALLOWED.* Now what do I do? I wondered. Then an idea popped into my head. "I'll just dine in the shower tonight. For a quarter I can take a shower and use the hot water for my soup and noodles." Grabbing my pots and pans, I headed for the washroom. To my disappointment, though, the water was only lukewarm. Nevertheless having lumpy soup and crunchy noodles, I concluded, was better than going hungry.

The next day just as I was ready to pack up my camping gear and take off, the morning's gray sky darkened and it began to rain. Quickly I dashed inside my tent. For five long hours I listened to a downpour that was so heavy it sounded like my tent was sitting underneath the shower. To keep warm, I snuggled inside my warm sleeping bag, but I couldn't relax. With my dirty socks I had to keep soaking up the puddles inside my tent. My North Face tent wasn't the problem. I had set it up the wrong way. Instead of selecting a flat piece of turf, I had chosen "a slope with a view!"

Macho Man

Puget Sound, Washington: At the next campground I met Jack, a sturdy man in his 50's. From his maps and itinerary I could tell he was the kind

of cyclist I usually meet: the 75-a-mile-a-day "macho man" on a quick two-week ' relaxing' vacation who loves to announce how many miles he rides daily. It never bothers me to hear about "their miles" because if I ever succeed in riding 75 miles a day on my loaded bike—or dumb enough to try it—I'm sure I'd brag too. As it is, I keep "my miles" a secret, just like my age.

<p style="text-align:center">Mark, the Kayaker</p>

One late afternoon, after cycling around several islands I stopped at a campsite on Orca Island. Shortly a tall, slim, gray-haired man docked his kayak on the beach nearby and placed his backpack on an adjacent table. "Where are you coming from?" I asked. "Near Seattle" he replied. Then he told me his name was Mark and that he had planned this trip around the islands for about a year. During the next few days we shared all our meals together, and the more we got acquainted, the more infatuated I became. We liked the same sports (I have two kayaks) and we had a similar attitude about life. Then the day he got ready to leave, I accompanied him to the shore to say good-bye and confessed that he was the man of my dreams. His comment was equally as romantic: "Martha you've changed my life forever I'll always remember you," And with those parting words, he paddled into the *distance to meet his wife on Victoria Island.*

DENMARK 1997

<p style="text-align:center">Camping next to the 'barbecue man'</p>

From Copenhagen I cycled north along the shore watching the kayakers and windsurfers play in the water. About 7 o'clock I began looking for a campground. The only one I found was a shabby, private one with strange looking people, rated about a minus five stars. I chose a camp site next to a bearded, middle aged man who was barbecuing. Recognizing my hesitation in unloading my bike, he approached me. "What's the matter?" He asked.

"I don't know if I want to stay here or not. Do you think it is safe?"

"You'll be ok" he assured. "I've lived here for three months."

Slowly I set up my tent and he appeared again. "Come over for dinner when you are finished."

He must have read my mind for I was starved. When I entered his tent I saw a plate already set for me filled with roasted corn, a baked potato and spare ribs. I couldn't have been more pleased. While eating, I suddenly heard a tremendous roar and the table began to shake.

"It's the train," he said, noting my surprise.

"How do you stand all that noise?" I asked thinking I wouldn't be able to sleep that night. His answer surprised me.

"I like the train." And that remark taught me an important lesson. From then on if something displeases me, I say to myself, "If you change your attitude, you'll be all right!" And it works. That night I slept really well.

SCOTLAND 1998

A Close Call

While cycling along a narrow canal from Glasgow, something frightening happened. I almost had a serious accident. Another cyclist headed straight for me. Why doesn't he get out of my way? I wondered as he rode closer and closer. Finally at the last minute, I swerved to the left to avoid a nasty collision. Only afterwards did I realized that in Scotland motorists drive on the left side of the road and obviously, cyclists do, too! Something I hadn't known.

Almost Stranded

In Pitlochry I stepped up to the ticket window and confidently asked for a one-way ticket to Inverness.

Noticing my bike leaning against the wall, the solemn-looking clerk asked, "Do you have a reservation?"

"A reservation?" I exclaimed in surprise.

"You need a reservation for your for your BIKE." He added emphatically.

I couldn't believe it. After all, this wasn't busy Glasgow but a folksy village with only a handful of people standing on the platform.

"Why a reservation?" I asked, struggling to control my annoyance.

"There's only room for four bikes in the baggage compartment," he explained.

I wanted to ask what was wrong with the aisles. After all, in Denmark bikes have about the same status as humans. If a train was over crowded, the conductor would gladly hang your bike out the window to avoid turning you away.

"Just a minute," he said. Then turning to his computer, he typed in so much data for Scot Rail, you'd think he was booking a round-the-world ticket for me.

Anxiously, I waited for his verdict.

"Space number four is still available," he finally announced.

I grabbed my three tickets-- two for my bike-- and headed for the platform What luck!

A Big Surprise in Inverness

After a two hour journey through barren hills and deserted grasslands I felt excited to be in a lively city again. Since the International Hostel was full my reservations were in the Ho Ho Hostel. I was curious if it would be a suitable place for a woman in her "wisdom years". (I use the term loosely, of course.) Or would it be too noisy? Since I'm often attracted to the 'unusual' (not always an asset} I was willing to give it a try.

I parked my bike in front of an old Victorian House with pointed windows and climbed up the hostel's narrow staircase. A pretty, young receptionist showed me to my room.

Then came the BIG surprise!

She had assigned me to a bunk bed in a large COED dormitory.

"Well, maybe it will be all right." I said to myself. "At least, fifteen dollars a night fits my budget better than sixty for a B&B.(Bed & Breakfast). After seeing all the cute, young male backpackers roaming around the place I decided to give the HO HO a chance. And fortunately everything turned out fine!

PART 2

JOURNAL EXCERPTS FROM ALONG FIVE FRENCH CANALS

From my book: *Canals on Wheels*

THE NANTES TO BREST CANAL

The First Day along the Canal
Day 1: Pontivy to Rohan

This morning when I awoke, I could hardly wait to begin my 128-mile bike trip along the Brest to Nantes Canal. That is, until I peered out the window and saw sheets of rain pouring down from a dark, gloomy sky, turning my cheerful anticipation into grim disappointment. I always avoid cycling in the rain, but today I had no choice. At 10:30 a.m. the hostel locked its doors, and everyone had to evacuate until 5:30 p.m. An absurd rule, if you asked me.

Dressed in my mismatched green and purple Gortex rain suit and orange, garage-sale poncho, I headed out in the storm. Before I began my canal trip, I needed to complete several errands in Pontivy.

The most important one was getting rid of my large *housse* (bike sack required on TJV fast trains). Originally, I planned to send it by general delivery to Nantes, the last town of my canal trip, so I could use it again on the train to Bordeaux. But now I changed my plans. Since I had

learned yesterday that local trains have bike compartments, I vowed to ride only the slow trains. Not needing my large *housse* for further trips, I wanted to send it to my friend's apartment in Paris. My only concern was whether I would find enough of these slow trains everywhere or would I get stranded along the way and never see Paris again? It was a risk I was willing to take.

At the post office a helpful clerk assisted me with my project. She filled out all the complicated forms for me, stuffed my *housse* into a large box and folded the lid down in the right way, so I needed neither tape nor string to keep it closed. A clever invention, I thought.

My second chore was to shop for a two-day supply of breakfast and lunch groceries that I always keep in a fanny pack on top of my duffle bag. Only my long, skinny *baguette* has a different place. To imitate the locals, I carry it on the side of my handle bar bag, sticking straight up *a la style francaise.*

While I was looking for a market, I passed the town square. Bright red and yellow banners caught my attention. They were advertising *paella* (rice with fish and chicken) and *ratatouille* (egg plant with tomatoes), two of my favorite dishes. Behind a stand, two men in white aprons were cooking in immense, iron skillets. Unable to resist such delicacies, I stood in line and ordered two portions for my dinner, which they sealed in plastic containers to help me carry them on my bike. Discovering this delicious cuisine at a small, open market proves my theory: gourmet food is found everywhere, and it's worth a trip to France just to try it.

By the time I finished my chores in town, the drenching rain had subsided. I cycled back to the hostel and after eating a picnic lunch under the weeping willow trees, I collected my saddlebags and duffle bag from the outside storeroom and was on my way.

I hoped I would like this canal trip as much as my English-biking friends had liked it. "It's a beautiful and easy ride," they assured me, "and there are campsites everywhere." In fact, they liked it so much that they rode it twice.

In spite of their recommendations and reading two, excellent guidebooks, I was still apprehensive about starting, which I usually am on any trip.

By the time I left Pontivy, it was already 2:00 p.m., much later than I usually leave. I intended to ride to the next campsite in Rohan, 30km

away, but I had no idea how long it would take on a bumpy, dirt path with a heavy load. I only hoped I would arrive by nightfall. Otherwise I would have to camp in some farmer's smelly, muddy field. Eeek!

There was one thing I was sure about: I. couldn't get lost—which I often do—as long as I stayed along the waterway and resisted ALL temptation to explore quaint villages in the distance. A formidable challenge I must say!

I found the towpath entrance easily by following the signs out of Pontivy. Bordered by a steep, grassy bank, the path was about eight feet wide and originally used by horses, oxen or mules to pull barges up and down the waterways before motorized boats came into existence in 1925.

The first part of my ride was quiet and serene without a soul around. I loved the solitude and pastoral scenes. Shady 100-year-old plane trees bordered the banks with branches extending over the water and golden wheat fields peeked through the tall trees. I felt that I had left the real world behind.

Later, I heard the first signs of life. A houseboat came chugging slowly by with a family standing on the front deck. They waved and I waved back. Their cabin sat on the deck and on top of the roof lay four bikes. Since no Frenchman can survive without his daily fresh *baguette*, they use these to cycle to the nearest village bakery or in the evening to romantic country inns, scattered throughout France. The rent for one of these pleasure boats is about a $1000 a week—ideal for vacationers who love being with nature and who can stand to become so relaxed!

Soon I arrived at the gatekeeper's house, a small cottage decorated with flower boxes of red geraniums. When a boat blasts its horn, the gatekeeper dashes out the door and adjusts the water level inside the lock—a technique similar to matching the Caribbean with the Pacific in the Panama Canal. In this case, the water on the north side of the gates was lower than on the south side.

A boat was about to enter the lock, so I stopped and watched. The process was fascinating: Before a boat enters the lock, the front gates are open and the back ones closed. Once the boat is snuggly inside, it is moored by a rope to a side pillar. Then the gatekeeper climbs up on a ramp on top of the gates and turns a long metal rod to close the heavy metal doors. Next he opens a valve and lets the water flow in, which

takes about l5 minutes. When the level inside the lock is the same height as the water outside of the end gates, he opens them up using his metal rod again. As the boat leaves the lock, someone stands on the side deck and with a long bamboo pole pushes it away from the side wall. If the gatekeeper is in charge of several locks, he immediately jumps on his bike or motor scooter and heads for the next one. There are 103 locks from Pontivy to Nantes.

That evening I arrived in Rohan about 8 p.m., sooner than I anticipated. Fortunately it was still daylight, because in France in the summer the sun doesn't set until about 10 p.m. The campground sat along the towpath and was easy to find. First I went to the office to register and pay a fee, then I chose a campsite along the canal bank. That evening while church bells chimed from the village church and boats floated leisurely by, I sat in front of my tent and ate my *paella and ratatouille* I bought along the way.

"Life can't get any better than this," I said to myself. My friends were right: this is a wonderful bike trip.

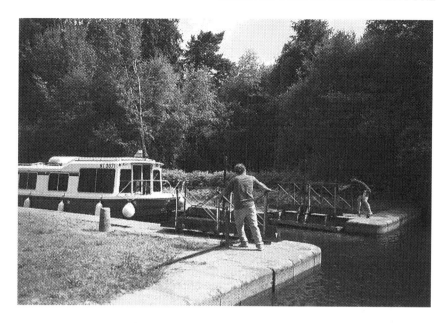

Lockmen opening gates so boat cn enter.

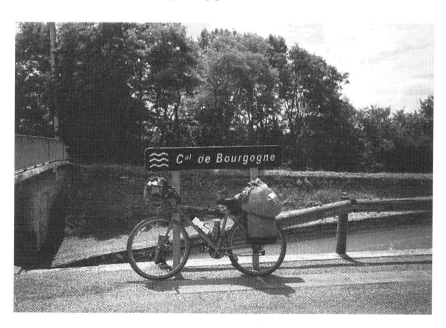

A sign along the towpath

THE MIDI CANAL

The Tour de France (Annual Bike Race)

Days 4 & 5: From Moissac to Castelsarrasin

This morning from Moissac was breathtaking. Bright sunshine filtered through the tall trees and dark shadows danced on the water. As the boats streamed by, a special sense of excitement hung in the air. Everyone was headed for Castelsarrasin to see the Tour de France, just like me.

I cycled along the canal until I noticed buildings draped with red, white and blue flags. Then I knew that I had arrived in Castelsarrasin. I crossed over a bridge and entered a section of narrow, cobbled streets where I found a bike shop. "Excuse me," I said to a young man standing in front of it. "Can you direct me to the campground, please?"

"Sure," he answered. Just as he was giving me directions, a man with a gray moustache and goatee walked by. "I wouldn't go to the campground," he advised, "It's out of town and may not be safe. Why don't you come and stay at my house? I live close by."

A vision of no tent, no sleeping bag and a comfortable bed for a night flashed through my mind. His offer sounded enticing, but would it be safe staying with someone I just met? He told me his name was Michel, and when he assured me that his wife, Annie, would like to meet me, I accepted his invitation, never imagining what I was about to experience.

I followed Michel to a wide avenue with a center island of leafy trees. Bordering the sidewalk stood a row of plain-looking, two-story houses, each with several rows of shuttered windows and sharing connecting walls.

We stopped in front of a royal blue door, and Michel rang the bell. A kind-looking woman, with a charming smile answered. Michel introduced us and explained that I had come to see the Tour de France and needed a place to stay.

After we stepped inside Annie led me down a long hallway passed a living room, dining room and kitchen to an inviting garden at the end of the house. We sat down beside a pond among flowers, trees and bushes and became acquainted. I learned that they had four grown children, that Annie was an artist and when Michel was an army officer, they had lived in Africa and Germany. It was surprising how many things we had in common. For several years I had lived in those countries, too.

Before Annie served us lunch in the garden, she insisted that I take a hot shower and give her my dirty clothes to wash. Such warm hospitality made me feel like a long, lost relative.

That afternoon I took a brief rest in a small, attic room and afterwards explored the surroundings by bike. Castelsarrasin was an unpretentious town of 12,000 people whose main attraction was an eleventh century church, built entirely with red brick.

After sightseeing, I sat down in the town square's sidewalk café and read the local newspapers. They were filled with articles about the next day's Tour de France. One article displayed a full-page picture of Lance Armstrong in his yellow shirt. (The winner of each day has the honor of wearing the yellow jersey for the next race.) "At 32, this American is a phenomenon," they wrote. "Not only is he about to be the winner for the third consecutive time, but he has also conquered cancer." The second article quoted him saying: "Cancer is one of the best things that ever happened to me. It taught me to be humble." In his book, *It's Not about Biking*, he gives details of his miraculous recovery, which is an inspiring story.

In another newspaper they described some interesting details of this yearly, three-week bike race around France, which I had not known. For instance, Castelsarrasin had to pay around 30,000 Euros ($40,000) for the privilege of hosting the departure of the 16th *etape* or stage. (There are a total of 20 stages.) Also they listed the sponsors of the 21 different teams, with the names and nationalities of each of their nine members. This year the United States' team, sponsored by the US Postal Service,

Bikes for the Tour de France in Castelsarrasin

Boats waiting at oval shaped lock

had an international team: five Americans, one Russian, two Spanish and one Norwegian.

When I returned to Michel and Annie's we sat in the garden and visited with an American couple who had dropped by. They had come to France just to see the Tour de France. How they selected Castelsarrasin was an interesting story: The wife, Barbara, a retired Latin teacher, met Annie and Michel's son on an internet chat room for Latin teachers. When Barbara mentioned that she loved the Tour de France, he invited her to stay in his house while he and his family went on vacation. It's amazing what the Internet can do!

The night before the race I was so excited thinking about it, that I hardly slept. At 8:00 the next morning, Anne woke me up and after serving me breakfast, Michel led me through the town's crowded streets, buzzing with the commotion of a carnival.

In front of the canal, among crowds of people, we watched a stream of pre-race events: First, a parade of official team-cars inched by, each carrying two or three extra bikes standing up erect on top of the roof. Next, bands marched by, interspersed with cars decorated like floats. For instance, the *Festina* team (a watch company), displayed a big, rubber clock on top of the hood.

While standing there, something unexpected happened. One of Michel's friends, a town official, came by. After learning that I was from the States, he handed me a special-events card that gave me the freedom of a flying carpet.

With this pass, I quickly darted over to a private party held in a roped-off plaza that was filled with booths and cafes, all serving free beverages, rolls, cheese, fruit and pastries. Here I had the opportunity to meet some of the cyclists. One was Chris Jenner from the *Credit Agricole* team who autographed my brochure for me.

Afterwards, by flashing my pass at the guards, I was allowed to walk down the empty, blocked-off street to the stage, where all the cyclists had to come, one at a time, to sign in. Among hundreds of spectators, I waited anxiously for Lance, the last one to register. When the loud speaker announced his name, he rushed up to the podium wearing his yellow jersey. Because he had so many photographers and bodyguards surrounding him (one was even on the roof) I only got a brief glimpse of him. I felt extremely disillusioned.

Shortly, the cyclists in their multi-colorful jerseys lined up in the street in front of us ready for the day's 137-mile race to another town. Seeing almost two hundred bikes glistening in the sunlight was an amazing sight. We all waited impatiently. Then suddenly everyone became silent and tension filled the air. Exactly at 11:00 a.m. the race began. A gun blasted off, and the cyclists disappeared so rapidly that it seemed that someone had waved a magic wand.

Feeling sad when all the events were over, I ambled down the deserted street toward the center of town. On my way I passed a huge tent where a band was playing jazzy tunes. Another VIP party? Super, I thought. Displaying my pass again and smiling at the officials, I stepped inside to treat myself to an assortment of appetizers and several glasses of wine. I liked mingling with all the important persons!

Later, I continued my stroll toward town. In the main plaza, near the fountain, I noticed three cyclists with American flags on their bikes. I walked over to them and introduced myself as a fellow compatriot, and they invited me for a drink in a café. For an hour we sat together, talking about how thrilled we were to see the race and sharing information about our own bike trips. One cyclist was riding the same route as the Tour de France. Imagine his stamina!

About 2:00 p.m. I returned to Annie's and Michel's. While I was gone they had prepared a special lunch for me of *magret de canard* (roasted duck). Sharing this sumptuous meal was a perfect way to celebrate the day's events and the end of my stay.

When I reflect about the time I spent in Castelsarrasin, it's hard to decide which was the best: meeting Michel and Annie or seeing the Tour de France. Both were fantastic!

THE BURGUNDY CANAL

A favorite Place

Day 17-19: Pouilly

On my way to Pouilly I stopped in a tiny village to visit an 11th century church, built to protect St. Thibault' relics. Near the entrance, I saw two

small boys chasing lizards. One was Caucasian and the other African. "We almost got it!" They shouted excitedly.

Hearing English spoken—*especially* with an American accent— astounded me. Were Americans living in this isolated village? To satisfy my curiosity, I walked over to the boys and began talking to them.

"Hi," I said in a friendly voce, "Where are you both from?"

"Pennsylvania," they answered politely.

"I'm from California. How come you two are here?"

"We're visiting my uncle for the summer," the blond boy replied.

I continued asking questions and eventually pieced together an interesting story: Fifteen years ago his uncle came to France to train crews for the pleasure boats on the canal. Later, the uncle changed jobs, and currently he and his Swedish wife run a hot-air balloon business in Dijon. Recently, he had a serious accident and was never expected to walk again. Miraculously, though, he partially recovered and now walks with crutches. Impressed by hearing this, I asked if I could meet his uncle, but he wasn't at home.

By late afternoon, I arrived at Pouilly, my destination for the day. The campground near the canal was run by a friendly, young couple, Brigitte and Pascal, whom I liked a lot.

Every night during my stay Brigette served me dinner in their small, outside snack bar and introduced me to all of their friends who dropped by. The most unforgettable person I met was Pierre, a short man in his forties, with black hair and a "I-can-do-anything" attitude. For hours, I listened to him talk about his world adventures and his memories of the Sudan, where I also had once lived.

Pierre's life style was as unusual as his personality. In the winter he lives in Madagascar and fishes, and in the summer he returns to France to run a hot air balloon business, just like the boy's uncle in St. Thibault.

One evening, while I was in my tent, I heard someone shout, "Pierre is here!" I looked out from my tent and saw him drive by in a van full of clients from a nearby luxury golf hotel.

A group of us rushed out to the field at the end of the campground to watch him set up his equipment. From a small trailer attached to his van, he unloaded his immense multicolored balloon that we helped spread out on the grass. Next, he began inflating it by using a fan

connected to a noisy generator. Slowly the balloon became bigger and bigger, at times resembling a huge monster lying on the ground. When it reached the height of a four-story building, Pierre placed a roaring fire below the mouth of the balloon. Then the passengers climbed into a wicker basket, and when the cords were released, off they went, soaring into the blue sky. I only hoped that Pierre had a few extra matches in case the fire went out!

While in Pouilly I took two excursions: One was a boat ride through the canal's two-mile tunnel, 50 feet under the ground. It was built to avoid a series of locks over an incline on the canal. They worked for seven years on this tunnel and when it was completed in 1826, it was considered to be an amazing job of construction.

The second place I visited was the nearby Chateau Neuf, perched on top of a hill. During the 12th century this military-styled castle, enclosed by a wall and tall towers, defend the surrounding area against invading enemies.

The day I entered this castle a medieval festival was taking place, which gave me an idea of what life was like 700 years ago: Musicians played strange-looking instruments, men wore tights with long blousy tunics and women dressed in long skirts with pointed, dunce-like hats. The most amusing of all were the geese herders guiding their herds through the narrow streets.

I had such a good time in Pouilly that I hope I can return there someday.

THE RHONE TO THE RHINE CANAL

A New Canal & New Friends

Day 31: St. Jean de Losne and Besancon

When my Burgundy trip ended in St. Jean de Losne, I began cycling down the Rhone to Rhine Canal, a canal that leads to Germany. Unlike on my other trips, I had little information about this canal and

didn't know what to expect. In fact, all I had was a road map and an enthusiastic recommendation from three bikers whom I met last year along the Midi Canal.

Even the VNF (boat information office) couldn't tell me about the towpaths. They simply said that they were for authorized vehicles only and trespassers could be fined, something I already knew from reading the signs and which I ignored like everyone else.

In spite of feeling nervous about these uncertainties, I chose to ride along the canal anyway—a good example, I suppose, of my "I'll-do-it-regardless" personality that my sons often complain about.

Consequently, the trip was full of surprises. The biggest one came on the first day when I discovered that the Rhone to Rhine Canal <u>wasn't</u> a proper canal at all. It was the Doubs River. I still don't understand why they called it a canal. There were only a few of them along the banks of the river where the rapids were too strong for boats to pass.

I was disillusioned by the towpaths, too. Most of them were rutted or covered with weeds and almost impossible to follow.

As you can imagine, I complained a lot about this "rough" riding, especially when I had to grind up steep hills on detours. Gradually, though, in spite of the hardships, I realized that I was having a good time. To my amazement, all the mystery about where to find a passable towpath added to the excitement. Besides, I grew to love the Doubs River. Its gentle spirit and the way it meandered slowly between the tree-covered hills captivated me.

One day, when it was raining heavily, my towpath petered out completely. Frustrated as if I had missed a freeway exit, I turned around and, by taking a detour, got lost. While trying to figure out where I was, I noticed a middle-aged couple in yellow raincoats strolling along the village road. Immediately, I stopped. "Excuse me," I said in French, "Could you tell me where the canal is?" (I felt really stupid having lost an entire canal.)

They recognized my American accent and answered in English. "It's over there," pointing to my left. I followed them, and as we walked along, we introduced ourselves. Their names were Kathy and Sheldon, and they were from San Francisco. Every winter they leave their yacht in a European port and return to it in the summer. Then, for three months,

they cruise around the Mediterranean or along some of France's 5,000 miles of waterways. It's just the kind of life one dreams about, right?

When we reached their luxurious yacht, they invited me aboard. It was so comfortable sitting in their warm cabin that I never wanted to leave. I had always dreamed about hitching a ride on a canal boat, so after some hesitation, I got up enough courage to ask if they would mind taking me to the next town. I'm sure picking up wayward bikers was something they didn't usually do. However, because it was pouring down rain, they offered to take me to Besancon on the canal. I felt as happy as when I located my car in a crowded mall parking lot after a two-hour-search.

Together we lifted my bike onto the boat deck and motored off. Floating down the river, without any effort, was pure luxury.

When we came to an automatic lock, they asked me to help them. Fortunately, they gave me the job for "dummies". At their command all I had to do was to turn the ignition key on and off!

Here's how the automatic lock system worked: As we approached the lock, Sheldon pointed his telecommand at the red light on top of the lock door and waited. When the light turned to green, the lock-doors opened up by themselves, as if he had said: "open sesame". Once we were inside the lock, and the doors were closed, I turned off the engine, and Kathy jumped onto the dock. Next Sheldon threw her the ropes, which she tied around the dock-drums in order to steady the boat as the water level changed. Then, just before the end lock-doors opened, Kathy untied the ropes and jumped back on the yacht. Now it was my turn again. I turned the key to start the ignition, so Sheldon could steer us safely into the canal.

I never realized "yacht-hopping" could be so complicated.

THE MARNE CANAL

Beauty and Romance

Day 6-8: Saverne & Luzelbourg

The rain continued all morning and when it finally stopped in the afternoon, I crawled out of my tent and coasted down the hill to look at Saverne and to have my loose handlebars repaired.

I rode around until I found a small, dingy bike shop on a side street. I told the mechanic about my problem. He immediately began taking my handlebars apart and examining the pieces that lay on the ground. Then he commented, "Whoever assembled this bike didn't know what they were doing. They put the washer upside down and now it's damaged." Of course, I knew who he was talking about. Darn details! They always get in my way! Even though his remarks left me depressed, (For some reason, I thought I was mechanically inclined.) I continued cycling to the center of town. I found Saverne an attractive town with a Medieval-Renaissance atmosphere and a Germanic flavor. (Germany's border was nearby.)

The first place I visited was the 12th century, brick church with a square Roman bell tower. Then I wandered down the pedestrian-only Grand Rue, festively decorated with pink and red Geraniums flower boxes in front of all of the buildings that had gables and pointed roofs.

Along the way, I also stopped to admire the well known Katz Tavern. Its entire façade was covered with sculptured, dark wooden beams and at the entrance stood a six-foot, tin statue of a cat in an upright position, wearing a top hat, of all things! This funny-looking cat was in honor of the original owner, Henri Katz (*Katz* means "cat" in German). He lived here in 1605, when he worked as the receiver general for the bishop.

Later I rode to the canal to see Saverne's imposing, red sandstone castle near the towpath with its manicured gardens of small shrubs bordered by colorful flowers. In 1790, the Bishop of Strasbourg lived here as his second residence, and today it's used as museum and youth hostel.

After three days in Saverne, I joined the towpath again. This time it lead me through a pretty valley between the Vosges Mountains and to Luzelbourg, a picturesque village snuggled between forested foot hills. I spent some time here taking pictures of the scenery then continued three miles down the towpath to a campground. As soon as I chose a campsite, I pedaled up the hill to Arzviller, famous for its "barge

transverse-elevator", an ingenious invention. In 1969 they built it to join two different canal-levels and replaced seventeen locks, which used to take 12 hours to pass through.

I bought a ticket for the tourist boat that sat at the top of the canal in order to descend on a barge-elevator to the lower canal. I wanted to see how the system worked: First, our boat entered inside an adjacent, barge-size, metal tank. Once we were inside and floating like in a bathtub, they closed the tank's heavy, metal doors. Then the tank slid slowly down two tracks while our boat was facing sideways. Two counter weights, connected by cables and drawn by electric winches, made this decent possible. After we reached the bottom of the 132 feet, 41% degree incline, they opened the tank's lock-doors, this time on the opposite end, and our boat exited onto the canal. When we returned from a short excursion, we entered the water-filled tank again and ascended to the top canal by the same method as before. It was so much fun being in a boat on an elevator that I rode it up and down several times.

That evening, when I returned to the campground, I found I had a new neighbor whose inflatable kayak was sitting beside his tent. I am also a kayaker (I once kayaked by myself down France's Dordogne and Cele Rivers) so I walked over to his tent to talk to him. He was a handsome, middle aged man named Marcus from New York, but born in Switzerland, and was kayaking to Paris via the Marne canal. The more we talked, the more we discovered that we were kindred spirits with the same outlook on life and the same lust for adventure.

During the next few days Marcus and I dined together in the campground restaurant and had a romantic meeting in a café in Luzelbourg, sharing stories of our adventures. I told him about living in the jungle of Africa, and he entertained me with the details of his four-month kayak trip from Lake Constance in Germany to Spain, by way of the Rhone River and Mediterranean. Being with him reminded me how delightful life can be, when shared with someone you really like, regardless of the age difference.

Not only did I admire Marcus's inspiring zest for life, but also his easy-going attitude toward things: One morning, for instance, when I complained about the trains running next to campground and waking me up at night, he said, "I love trains. They don't bother me at all."

After that I realized I didn't need a pill to go to sleep but only a change of attitude, the same lesson I learned from the 'barbecue man' in Denmark.

Marcus was thoughtful, too. The morning of my departure, he surprised me by appearing at my tent with fresh croissants and an offer to help me pack.

I liked Marcus so much that it was hard saying good-bye, but he promised to keep in touch. I hope he does.

PART 3

EXCERPTS FROM A CYCLIST'S DIARY ALONG 4 FRENCH CANALS: Loing, Nivernais, Lateral & Briare

From my Book: *Canals on Wheels*

Day 3 Campground to Fontainebleau Castle

About 11:00, after coffee and croissants at the campground café patio, I left for the Fontainebleau castle, about 12 miles away. Along the way, I asked a lot of people instructions so didn't make too many mistakes. (France has roundabouts everywhere, and they always confuse me). Once, a man stopped his car from the other side of the highway just to tell me I was on the wrong road. Next time I vowed to read all the round-about signs more carefully! The first view of the castle in the distance was incredible, an enormous building with 40 chimneys extending into the clear blue sky. I cycled around the castle's' lakes, ponds, gardens and courtyards. What a wonderful ride! At the main building I stopped to buy some post cards and a history book: King Francois I began the castle in the 1500s and every king after him added to it. Even Napoleon I was here after he escaped from Elba Island, about 1815. I decided not to visit the interior, instead I slept in the cool shade along a canal to avoid the heat. On my way back I tried to return the same way as I came, but I couldn't remember all the turns at the roundabouts. Finally, I gave up and took, N6. a national highway, similar to a freeway. I felt fairly safe even

239

though there was a lot of fast traffic, because of a wide shoulder. When I saw a sign, saying Veneux les Sablons, where the campground was, I turned off and arrived at my tent sooner than I expected. To cool off, I took a swim in the pool, then had pizza and beer in the bar. It was full of people watching the soccer game on TV between France and Brazil. Since France won there was a lot of shouting and celebrating everywhere until late at night. (Soccer is France's national sport.)

Day 8 From Auxerre to Vincelles

Since there were many tourist attractions in Auxerre, I stayed an extra day and continued sightseeing. My favorite sights were the Gallo Roman crypts (tombs) from 841-859 displayed under glass in an abandon abbey basement and also an old barge warehouse. A lady I met in one of the museums explained why there were so many churches everywhere. She said each section of the city wanted their own church, to represent their prosperity. During the 1789 revolution, however, many were destroyed and the Pope later helped finance their reconstruction . The weather became overcast, so I returned to my tent and packed up. About 3 o'clock I headed for the Nivernais tow path at Vaux. When it began to rain and the pot holes filled with water, I took the main highway instead. There were many cherry stands along the way, so I bought lots of delicious cherries. When I arrived at Vincelle's campground, Christian, whom I met last year at another campground, greeted me cordially and seemed glad to see me. Since I was dripping wet, he insisted I stay in one of his trailer-cabins instead of in my tent. It was like a palace to me: two bed rooms, a microwave and balcony. In the evening he invited me to a banquet to celebrate an employee's birthday. It was a sumptuous meal, including hors d'oeuvres and custard with strawberries for desert What a good day!

Day 10 Vincelles to Bailly

About five in the afternoon, when it was a little cooler, I rode along the towpath to Baily, famous for its *crement,* a type of sparkling wine. The caves were formed from digging out stone transported to Paris for their buildings. On a tour inside I saw many ornate sculptures and learned how *crement* was made: During one week every 24 hours, the bottles, which were on stands, were turned automatically. Afterwards

the bottle were uncorked and all the debris on the top were discarded. The temperature inside the cave was very cold, 12 degrees Celsius, and there were 5 million bottles inside. Imagine!

That evening at the campground, we had a delicious barbecue with four kinds of meat, salad and French fries, celebrating the "coup du monde", a championship soccer game between France and Italy. It ended in a 1-1 tie so they played an extra half hour, and eventually had to kick the ball five times to determine the winner. Italy won by one point. At 11p.m. we watched fireworks and the whole sky filled with lights. It was a fun evening, especially meeting all the other campers.

Day 15 Chaumont to Chatillons

Today I passed sixteen locks. Since the towpaths are on the banks of the canal, the locks don't slow me down, but the boats have to wait in the hot sun until the green light comes on which means the water level behind the heavy metal doors is correct to enter. Once a boat is inside the lock, it has to wait until the water level changes again and the lock doors open on the opposite end. I liked watching this process and also talking to the people on board as they waited their turn. About 5:00 o'clock I reached the place where the camp ground was suppose to be and discovered it had been moved 4 km away. I was unhappy about this because I was already hot and tired from cycling all day and didn't want to continue. I sat down in a café to think about my choices. After a cold drink and dish of ice cream, I decided to continue on to the next campground 5 km away. The tow path was fortunately paved all the way and I actually enjoyed biking in the cool evening. When I finally arrived at the Chatillon campground about 7:30 pm, I took a hot shower to revive myself and while I was pitching my tent by a stream., my neighbors from Brittany, invited me for a Kir (made with wine and liquor) to celebrate Bastille Day. After a couple of these, I forgot all about dinner and stayed with my neighbors to watch the town's fireworks celebrating France's independent day. It was good decision to come here!

Day 23 Charite to Cosne Sur Loire

I followed my German neighbor's advice and took a small country road to Sancerre, instead of the rough tow path. As I was gliding along

the countryside by myself, a group of cyclist suddenly surrounded me carrying a large sign that said, " La Loire Vivante." (long live the Loire River). They were as surprised to see me as I was to see them. They were on a seven day mission to bring the public's attention to the danger of polluting the Loire River and to stop development along its banks. They invited me to join them. Our first stop was at Pouilly to see a sign, indicating the 1000 km point (half way) on the Loire River and also to buy some special wine there. In front of the sign we took pictures together and after a picnic we parked our bikes and rode in a truck to Sancerre, a hill top village with a breathtaking view of the Loire and valley below. Before we descended we visited a cave where they sold a special kind of wine with no preservatives. Later we returned to our bikes and cycled to Cosne sur Loire for camping and a barbecue. I liked everyone in this group of all ages, especially Roberto and his wife, outstanding organizers and leaders. I felt fortunate they included me so cordially in their group.

The End

CONCLUSION

In reminiscing about my life, I feel satisfied that I accomplished my goals of seeing the world and of having many exciting experiences, including several storybook romances. I was also lucky to work or live in beautiful places. In Germany I lived in Heidelberg, in Japan my job was in Kyoto, and in Africa I taught in the jungle of the Sudan. Now that I am retired I live in Laguna Beach, California, near a gorgeous beach. During my life unpleasant things naturally happened. While in Africa I experienced a civil war and in Peru, a revolution. I also had a divorce and several serious illnesses, including: e-coli, malaria, a stroke and cancer. Nevertheless, it was a life full of adventure like I wanted, and I feel fortunate to have lived my dream.